Japanese Paintings

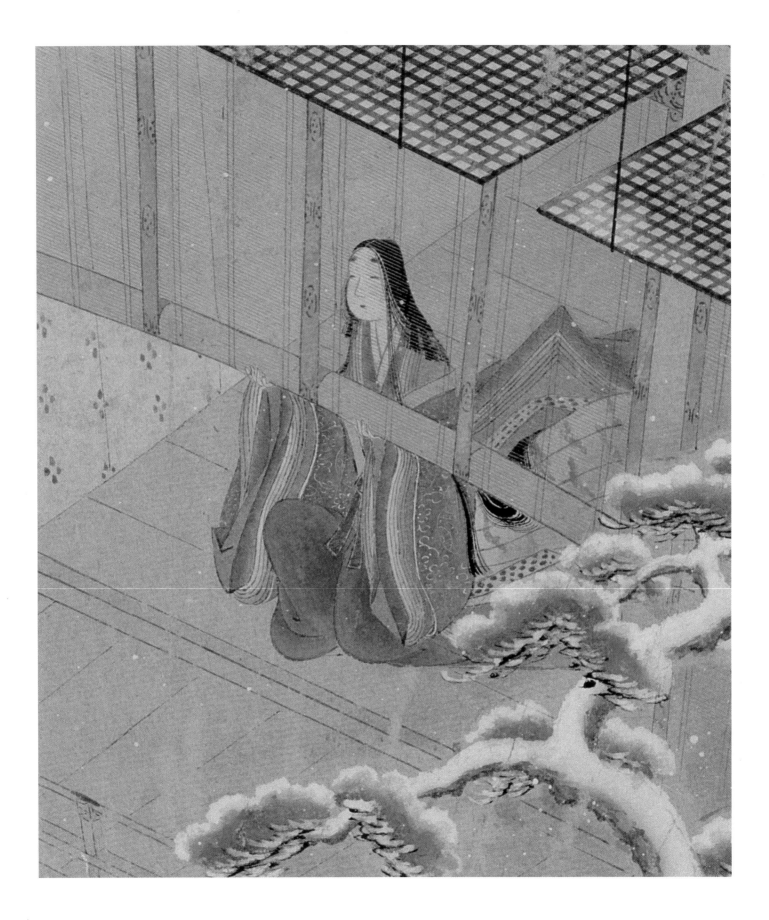

JAPANESE PAINTINGS

in the Ashmolean Museum, Oxford

Janice Katz

With an Introductory Essay by
Oliver Impey

ASHMOLEAN MUSEUM, OXFORD

Front jacket: HIRADA GYOKUON, *Obon Festival Scene*, detail of cat. no. 37.
Frontispiece and back jacket: ITAYA HIRONAGA, *Sei Shōnagon*, detail of cat. no. 46.

ISBN 1 85444 189 2

Publishing consultant: Ian Charlton
Copy editor and proof reader: Helen Kemp
Designed and typeset in Photina and Tiepolo by Behram Kapadia

Printed and bound in Singapore by Craft Print International 2003

Contents

Director's Foreword

As in many areas of the Ashmolean's rich collections, only the British Museum in this country has a comparable holding of Japanese paintings. Individual paintings from the Ashmolean have been included in exhibition catalogues and in surveys of Japanese art but this is the first catalogue of the Museum's Japanese paintings. It has been undertaken with great skill and sensitivity by Janice Katz who was with us in Oxford for two years as holder of the Sackler Fellowship at Worcester College. She has now joined the staff of the Art Institute in Chicago. We are immensely grateful to Mortimer and Theresa Sackler for their support of this Fellowship by means of which a scholar comes to Oxford to work on an aspect of the Ashmolean's collections and enjoys the privileges of a graduate member of Worcester College. Ms Katz has made a selection from the Ashmolean's 430 Japanese paintings, presenting the sixty finest in detail and illustrating and commenting on a further one hundred in order to invite study by other scholars.

I would also like to record my gratitude to Oliver Impey, who is retiring this year, having served with immense distinction as Curator of Japanese Art at the Ashmolean since 1968. The collection of Japanese paintings is just one legacy of Oliver's devoted service to the Museum. He has acquired two-thirds of all the paintings catalogued in this volume as well as an enormously important group of screens which are not included here as he himself has published most of them in his volume, *The Art of the Japanese Folding Screen*. I know that Janice Katz has benefited from his great knowledge of Japanese painting and his wise advice in the compilation of this catalogue.

DR CHRISTOPHER BROWN
Ashmolean Museum, Oxford, July 2003

Preface
and Acknowledgements

This catalogue is the culmination of a two-year Sackler Fellowship administered through Worcester College, Oxford University. Its publication coincides with the exhibition 'Japanese paintings: Legend and landscape', in the Eric North gallery of the Ashmolean Museum from October 2003 to January 2004, which provides an opportunity for many works not previously shown to be put on display.

The Ashmolean's collection of Japanese paintings numbers in total about 430 including screens, hanging scrolls, fan paintings, albums, album leaves and other matted paintings. To include all or even most of the works in a comprehensive catalogue would have limited the size of the plates as well as the space for description. Notably, a significant portion of the paintings were added to the collection during Oliver Impey's tenure as Curator of Japanese Art. Building on the solid foundations of his research, approximately sixty of the finest paintings were then chosen to be reproduced as full page colour plates with explanations. In deciding which paintings to include, the main criteria were overall quality, art historical importance and rarity. In addition, it was felt that an effort should be made to include works not previously published. Please note that the comments on the paintings are not meant to be the final word in the authenticity or otherwise of each painting, as that would require years of further study as well as resources for comparison with works in several of the world's museums and private collections. It is hoped, however, that these comments will raise questions and suggest further avenues of research. In addition to the sixty main entries, a supplementary section of about a hundred additional works is included to give the reader a greater understanding of the breadth of the Ashmolean's holdings. This section also serves to conveniently bring together into one volume works that have been published in other sources. Folding screens have not been included as the majority have been beautifully reproduced in Oliver Impey's *The Art of the Japanese Folding Screen*.

On a personal note, I would like to thank those who made this project possible for giving me the opportunity to study such a wonderful collection in the most warmhearted of environments:

Mortimer and Theresa Sackler, Worcester College, Oxford, Oliver Impey and Christopher Brown.

The amount of work that goes into a project of this kind done in a brief time is of course too much for one person. I am therefore also indebted to the many other individuals who generously gave of their time and expertise, some on multiple occasions:

John Carpenter, Ian Charlton, Timothy Clark, Romain Garbaye, Alexandra Greathead, Sarah Guernsey, Shulla Jacques, Ephraim Jose, Kano Hiroyuki, Behram Kapadia, Helen Kemp, Kobayashi Fumiko, Kobayashi Tadashi, James Lin, Cary Liu, James McMullen, Philip Meredith, Sue Moss, Noriko Murai, Nakatani Nobuo, Flora Nuttgens, Hiroko Oda, Mavis Pilbeam, Susan Rossen, Joyce Seaman, Shimohara Miho, Sue Stanton, Mitsuko Watanabe and the staff of the Department of Eastern Art, Ashmolean Museum.

Janice Katz
Sackler Fellow, Ashmolean Museum

Chronology

JAPAN			CHINA	
552–710	Asuka Period		618–907	Tang Dynasty
710–794	Nara Period		907–960	Five Dynasties
794–1185	Heian Period		916–1125	Liao Dynasty
1185–1333	Kamakura Period		960–1127	Northern Song Dynasty
1333–1573	Muromachi Period		1127–1279	Southern Song Dynasty
1573–1615	Momoyama Period		1115–1234	Jin Dynasty
1615–1868	Edo Period		1279–1368	Yuan Dynasty
1868–1912	Meiji Period		1368–1644	Ming Dynasty
1912–1926	Taishō Period		1644–1911	Qing Dynasty
1926–1989	Shōwa Period			

Introduction

The formation of the collection of Japanese painting in the Ashmolean Museum

OLIVER IMPEY
Curator, Japanese Art, 1968–2003

The Ashmolean Museum holds the collections of art and archaeology of Oxford University. The Museum was originally founded to house the Cabinet of Curiosities of the two John Tradescants, father and son, acquired by and given to the University by Elias Ashmole. A building was erected in Broad Street and opened to the public in May 1683, probably the first public museum in Europe. It functioned as an all-purpose 'musaeum', used for teaching within and without the University, with a varying degree of usefulness to the University, for some two hundred years. The University Galleries, a neo-Grecian building by C. R. Cockerell, was built in Beaumont Street in 1851–4 to hold the growing art collections of the University. In 1894, the collections of the Ashmolean were subsumed into the University Galleries, the building enlarged for the purpose, losing in the process the collections of naturalia to the University Museum (of Natural History) and the collections of ethnographica to the Pitt-Rivers Museum. The name Ashmolean Museum was retained for the art and archaeology, as it is today. The old Ashmolean building in Broad Street eventually became the Museum of the History of Science.

The new Museum was at first operated as two Departments, Antiquities and Fine Art. In 1961, a separate Department was set up for the Heberden Coin Room, and a new Department of Eastern Art was created. This new Department took the collections that had formerly been housed in the Museum of Eastern Art, itself set up in 1946 in the old Indian Institute building in Broad Street by William Cohn, while absorbing some material held in the Department of Fine Art (now renamed Western Art) and some from the Bodleian Library. The move was partly stimulated by the great gift of Sir Herbert Ingram of his vast collection of Chinese ceramics in 1956.

The move to the Ashmolean Museum meant that Eastern Art was to be taken seriously as a discipline by the University, and the collections properly regarded. Housed on the ground floor immediately opposite the entrance, the collections now hold a prominent position within the Ashmolean building. The Department has four sub-departments: China and Korea; Japan; the Indian sub-continent and South-East Asia; and the Islamic world, and the displays within the Department reflect this as far as is possible in a listed building.

Before the move the Japanese collection had been small, and the pride of the collection was perhaps the collection of sword-guards (*tsuba*) formed by the eminent scientist Sir Arthur Church, transferred from the Bodleian Library; but Ingram had collected Japanese objects, mostly the small *netsuke*, *inrō* and sword-furniture and other things, including contemporary crafts, some purchased on his travels in Japan in 1908, which also came to us in 1956. The collectors seem to have bought no painting.

This was entirely in accordance with British collecting of Japanese Art in the late nineteenth and early twentieth centuries in general. There was almost no serious collecting of either early Japanese fine art, such as sculpture or painting, or, indeed of the minor arts of any period before the Edo period. The only exception to this rule was the collecting of Ukiyo-e prints, available in Europe since the early nineteenth century. Only those who lived in Japan for any length of time, such as Arthur Morrison,[1] formed collections of anything but these small and exquisite arts of the Edo and early Meiji periods. One of those who knew Japan well was the great historian of Japan, Sir George Sansom, who in 1956 gave the museum a group of reproductions of classic paintings, an early painting of a thousand Benten (Supp. 3) and a hanging scroll of Mount Fuji, signed Sakai Hōitsu (Supp. 57), apparently the first proper paintings to be acquired.

Within Britain, Japanese art was generally considered as vastly inferior to Chinese art, derivative and of poor quality. And in this there was some justification, for the vast flood of inferior goods, mass-produced to satisfy western demand, swamped the high quality of those goods made for the International Expositions that were such a feature of the time. Few collectors looked carefully enough. Those that did were those to whom craftsmanship appealed, for the craftsmanship of the late Edo period, passed on in different formats into the Meiji, was unsurpassed anywhere. It is a measure of European taste that even after the banning of the wearing of swords in 1876, *tsuba* were being made especially for the international market, as were *netsuke*.

The collections thus formed were of variable quality. The best, including that of Sir Arthur Church, were catalogued by Henri Joly,[2] just as the best contemporary collections of Chinese Kangxi blue and white porcelain were being catalogued by R. L. Hobson. Unfortunately, Ingram did not have his fine collection of *kozuka*, knife-handles for the sword, catalogued by Joly, for the standard is very high. Ingram also gave *netsuke*, *inrō* and *ojime*, as well as some other lacquer, metalwork (including the superb box by Kajima Ikkoku II, bought as 'after Seitei' [Watanabe Seitei; see e.g., Cat. 56]) and even needlework, all the sort of thing available either from dealers in Japan who specialised in the upper end of the tourist trade or in London.

Two exceptions to the 'unseeing tourist' view, that reflection of the lack of interest in painting, were to benefit the Department; the first was C. W. Christie-Miller, in Japan in 1906, who bought contemporary ceramics and cloisonné, but also, from the dealer Nomura in Shinmonzen, a pair of very good screens of the *Taishokan* story (that did not, alas, come to the Museum) and an equally good *Ukiyo-e* painting, then attributed to Miyagawa Chōshun, which did (Cat. 52). He also bought the series of seventeenth-century albums, of good but not fine quality, that form a guide to the Tōkaidō Road, then attributed to Tosa Mitsuoki and considered of more interest than the 'Chōshun' and so more expensive (Cat. 51).[3] The gift of these marked the second serious acquisitions of Japanese painting by the Department. Another tourist to buy screens in Japan, a few decades later, was Gerald Reitlinger, in Japan in the 1930s, who left us several screens, and of whom more later.

A sketchbook of an Utagawa artist (1961.126) and a book of *shita-e* (preliminary drawings for prints), mostly by Kunisada (1961.127) were among gifts from Georges van Houten in 1971. He was to give more the next year, two good sketchbooks, one by Mori Tetsuzan (Cat. 28) and another attributed to Katsushika Taitō II (Supp. 20), the first such things in the collection. The founder and first Keeper of the Museum of Eastern Art was William Cohn, an authority on Chinese painting; in 1962 he

bequeathed two parts of an ink triptych, *Kanzan* and *Jittoku* (Supp. 1), then attributed to Dōan, to be followed by the bequest from his widow of the centre picture, *Daruma* (Supp. 1), ambitiously attributed to Sesshū.

One of our finest paintings is by the great Meiji period artist Yokoyama Taikan (Cat. 58), given by the artist to the poet and writer on Japanese painting, Laurence Binyon, probably in 1929; this was presented by his daughter, Helen Binyon.[4] In view of the fact that Taikan is so much forged, this is good provenance. Also in 1964 was our first purchase (from an unrecorded source) of a group of paintings, including several albums, notably one by Yamamoto Baiitsu (Cat. 5) featured by Janice Katz in this catalogue, and some other paintings, including a painting by Oda Kaisen (Supp. 47), and a handscroll, also by Baiitsu (Supp. 87); another album in this group is by a series of mostly Osaka artists collected in 1799–1805 (Cat. 29).

The album of paintings of the *Tale of Genji*, by an unknown artist working on the edge of the Tosa tradition (Cat. 44) was presented by R. Somervell, of Kendal; this, a very fine work, is discussed in this catalogue by Janice Katz. In the same year, a group of paintings were bought at Sotheby's (sale 14.6.1965), including paintings of cherry-blossom viewing by Miyake Gogyō (Supp. 36), a heron by Morikawa Sobun (Supp. 41), *Bon-odori* by Kawanabe Kyosai (Supp. 22) and a landscape by Suzuki Shōnen (Cat. 57). Another purchase was of the possibly dubious Nagasawa Rosetsu screen of cranes (1965.259). Screens are specifically excluded from consideration in this catalogue as they have been catalogued elsewhere (Impey, 1997);[5] they are, however, included in this introduction as an essential part of the painting collection.

1966 was to prove a most important year for the Department's collection of Japanese paintings, for it was then that we acquired the first part of Jack Hillier's collection, the Nanga paintings (the Maruyama and Shijō school paintings were to be bought in 1973).[6] The 1966 purchase was made possible by friends of Peter Swann, as a tribute to his Keepership, with the assistance of the Higher Studies Fund and the Fund administered by the Victoria and Albert Museum. But before that purchase, a hanging scroll of mynah birds fighting, a picture of great interest, by Kumashiro Yūhi (Cat. 13) had been purchased from a Japanese dealer in England.

Hillier's collection had been built up over many years, with a body of knowledge of Japanese painting hitherto unavailable in Britain; he, and a group of other collectors (including Ralph Harari, see below) found many of their paintings at the dealer Kegan Paul, to whom most had been sent from Japan by the *Ukiyo-e* specialist Richard Lane. Hillier's was avowedly a study collection; he was learning by buying and studying what he had bought. He must have decided early to concentrate on the Nanga and Maruyama school artists, who appealed less to the more affluent collectors. His many books demonstrate his learning, and his collection has stood up remarkably well to later, more informed, criticism and connoisseurship. In the first Hillier collection purchase, we list fifty-six accession numbers.

No further paintings of note were acquired until 1969 when a pair of two-fold screens, formerly four sliding doors, by the late Nanga artist Tanomura Chokunyū (1969.13), dated 1865, were purchased in London. In 1970 we bought the magnificent pair of six-fold screens firmly attributed to Watanabe Shikō (1970.174,5), of Flowers of the Four Seasons, our first purchase of paintings in Japan and perhaps the finest paintings in our collection. In the same year Prince Paul of Yugoslavia presented the fine Tosa school album leaf of a scene from *The Tale of Genji* (Cat. 43). In 1971, with the Derick Grigs

collection of Japanese prints, came the extraordinary coloured drawing of Hekirekka Shimmei attributed to Utagawa Kuniyoshi (Supp. 79), in the format of his *Suikoden* series of 1827–30; and in 1972 Mrs Cohn bequeathed not only the Daruma figure from the triptych (see Supp. 1), but also some fan paintings including two by Takenouchi Garyū (Supp. 69, 70).

The Maruyama/Shijō collection formed by Jack Hillier, much of it featuring in his *The Uninhibited Brush* of 1974,[7] was the second part of his collection acquired by the Museum; his collection of printed books eventually went to the British Library. We bought these paintings in 1973, with the aid of the Friends of the Ashmolean, for such a generous price that we list Mr and Mrs J. Hillier as donors. These paintings had been acquired concurrently with his Nanga collection, but he had continued to collect after 1966. Again, a wide ranging collection, it is primarily a study collection, wholly suitable for a university museum, containing some very fine works, notably paintings by Goshun, Rosetsu, Nanrei, Chinnen and Zeshin.

Acquisitions in the later 1970s were of screens; the ink landscapes after Kano Tanyū (1977.24) and the Tosa screens of the *Tales of Ise*, the latter with a spurious attribution to Mitsuoki, but of very fine quality, were purchases. Gerald Reitlinger, among his vast collection of ceramics from Japan, China, Islam and Europe gave us several screens that he had acquired on his travels in Japan; of these, the finest are the *Acrobats* screen (1978.2532) and the small-size pair, the *Thirty-six poets* (1978.2533).

The Museum had held on loan the collection of Japanese paintings formed by Ralph Harari, much of it on the advice of Jack Hillier, for some years.[8] When the collection was dispersed (much of it going to the British Museum) we were generously offered, by Dr Michael Harari, our choice of two things. We chose the great Hokusai painting *Pilgrims at the Kasuga Taisha Shrine* (Cat. 53) and the albums of fans (x5362 to x5461) that comprise such an important addition to our collection. We were later able to purchase from the estate, under generous terms, the screen of the *Dog-chasing game* (1983.25) a very fine example of this well-known subject, the right-hand screen of a pair where the left-hand screen is lost.

Since then we have thought it appropriate to acquire more screens than other formats of painting, awaiting the chance that we now have to have a specialist catalogue the collection, now of considerable size, and second in importance in Britain only to that of the British Museum. In this we have been fortunate to acquire the expertise of Janice Katz on a two-year Fellowship, generously sponsored by the Sackler Foundation, through Worcester College. In the intervening years, we have bought screens by Kano Jōshin (1988.2), Yokoyama Seiki (1991.123), Hasegawa Shiei (1996.131 and 2000.178), Kishi Ganku (2002.61) and Komai Genki (2002.62). In the case of the Shiei, we were fortunate enough to find the second of the pair some time after purchasing the first. We have also bought some westernising works; an album leaf attributed to Kawahara Keiga (2002.55), of potters, very like his work of the 1820s for Franz von Siebold, and some paintings by the Edo-Meiji transition artist Watanabe Seitei (Cat. 56, Supp. 85), well known for his collaboration with the *shippō* maker, Namikawa Sosuke.

This catalogue raisonné of the collection of paintings of the Department of Eastern Art in the Ashmolean Museum conforms to the University's programme of specialist catalogues of the Museum's collections. After presenting what we consider the finest sixty paintings (not including any screens, most of which are published elsewhere)[9], Janice Katz has most adventurously chosen about one hundred further paintings which in her opinion may arouse interest or controversy, rather than playing safe and choosing only those whose authenticity is sure. Thus, in this catalogue, while there

may be paintings that will prove on further examination to be false or misattributed, so there are certainly a considerable number of perfectly genuine but relatively unimportant works in the collection that are not here included. And, of course, the Department intends to acquire further examples of Japanese painting, to reinforce its position as the holder of the second collection in Britain.

Notes and references

1 Arthur Morrison, *The Painters of Japan* (London and Edinburgh, 1911).

2 [Henri Joly], *Japanese Sword Guards, Some Tsuba in the Collection of Sir Arthur H. Church* (Reading, 1924). A complete catalogue of the collection in typescript, unpublished, by Henri Joly, is held by the Department.

3 Photocopies of some of the invoices are held by the Department.

4 Laurence Binyon was Keeper of the Department of Oriental Antiquities in the British Museum, and author of *Painting in the Far East* (London 1908). He was in Japan in 1911.

5 Oliver Impey, *The Art of the Japanese Folding Screen* (Oxford, 1997).

6 See Jack Hillier, 'Japanese Nanga paintings at the Ashmolean Museum Oxford', *Oriental Art XIII*, no. 3, 1967, 161–9.

7 Jack Hillier, *The Uninhibited Brush* (London, 1974).

8 Jack Hillier, *The Harari Collection of Japanese Paintings and Drawings* (London, 1970–73), 3 vols.

9 Impey 1997, see note 5.

Compact Treasures

Thoughts on two Edo period albums in the Ashmolean Museum

Janice Katz

Albums of paintings or *gajō* underwent a dramatic increase in popularity in Edo period Japan. They never quite attained the same artistic and critical recognition as other forms of Japanese art, however, for instance hanging scrolls or folding screens. As one critic of the time wrote, somewhat sharply:

> Collecting many small works of calligraphy and paintings in albums to bring out and show people for their praise is something that has become very widespread recently. Doing this, common people and vulgar people become fashionable. Everyone is saying, 'Calligraphy and painting albums, calligraphy and painting albums.' I think it is only a pile of manure or a pile of rubble. I could not bear the annoyance of being entreated for this kind of work ...[1]

Although this is referring to the vogue for 'assembled albums' (*yoriai* or *shūshū gajō*), it illustrates the contempt that albums in general elicited by the end of the Edo period. This relegation of the format to loathsome, 'low culture' status has continued in modulated form to the present. Painted albums came to be associated with frivolous, poor quality paintings because of the great quantities in which they were produced for anyone with the interest and the finances. Works by painters for albums were long regarded as secondary, not actual masterpieces worthy of the same attention given larger format works. Likewise, in recent scholarship, they have been eclipsed in favour of their similarly bound cousin, the printed book. In the few cases when albums are discussed, it is often within the confines of one school or one artist's work, and the album as a format is rarely commented upon.

However, as this essay proposes to show, the album deserves our attention for its distinctive characteristics. More than any other type of Japanese painting, albums naturally lend themselves to artistic collaboration. One small portable object may incorporate several paintings ranging from a few to hundreds. It is often the product of many artists who have travelled to different cities to be together. Likewise, the inclusion of the work of calligraphers in poems, prefaces or colophons may enhance the painted images. A patron who assembled the pieces together may also be involved. In addition to its collaborative nature, the painted album stands apart because of the time element involved: individual paintings within an album may have been produced entirely independently of one another on different occasions, or images by several artists could have been brought together and mounted years or even decades after they were first painted.

The purpose of this essay is to explore the production of *gajō* by focusing on two previously un-published examples from the collection of the Ashmolean Museum featured in this catalogue. As

they come out of different traditions within Japanese painting, each has its own particular set of circumstances related to its production and its intended audience. First is the story of an unusual *Tale of Genji* album dateable to the late eighteenth to early nineteenth century. Next, I discuss an early work by the Nanga artist Yamamoto Baiitsu (1783–1856). The reasons why they were produced: as a gift for a girl or a new bride, or to show affiliation with Chinese painting traditions, are as marvellously diverse as the paintings on each of their pages.

The *Tale of Genji* album

The earliest painted albums known to be produced were those that illustrated chapters of the *Tale of Genji*. Murasaki Shikibu's (c. 978–1016) tale of Heian period court life is, to say the least, epic. The novel probably gained attention during the author's lifetime, when it began its meteoric rise in popularity that has lasted until this day. It follows the life of the protagonist, the 'Shining' Prince Genji, through the romantic exploits of youth and fatherhood before turning its attention to the life of his son. In all, the book contains fifty-four chapters filled with details of the daily life and ceremonies of the court. Murasaki's highly descriptive language easily lent itself to illustration and the novel became a popular subject to be depicted in painting, the earliest known being a handscroll, or *emaki*.[2] Each of the chapters of the tale could be represented by a painted scene or scenes, and the accompanying text could be written next to it so that the text and the image could be viewed at the same time.

In contrast to a handscroll, an album would have the image and text on pages opposite one another, and had the added advantage that any chapter of the already well known story could be opened up to instantly. An album of 1509 by Tosa Mitsunobu (1435–1525) and several accomplished calligraphers in the Harvard University Art Museum is the earliest extant complete *Genji* album. It is made up of individual *shikishi* poem and picture sheets that had been previously pasted onto a screen.[3] While poem sheets meant to be pasted on folding screens and handscrolls showing scenes from the tale predate the albums,[4] in the Edo period the painted album became the most characteristic way to enjoy the famous exploits of Genji.

Almost from the time it was conceived, critics have speculated on the meaning of the novel. Was it a way for Murasaki to pass the time or did she have some real purpose behind it? Was the author trying to teach her audience Buddhist or Confucian principles? Was she making moral judgements on her characters? Though these questions are still up for debate, what is known is that by the Edo period, *Tale of Genji* albums were seen as appropriate gifts for a young woman or bride, meant to inform her of the refined manners of a past golden age.

The Ashmolean's *Tale of Genji* album deviates from the pattern of such albums, and by doing so highlights its didactic purpose. It is a fairly late example which can be dated to the late eighteenth to early nineteenth centuries (based on the identification of one of the calligraphers, as discussed below). It was given to the Ashmolean as a gift by R. Somervell of Westmorland in 1965. The album is accordion-folded with twelve non-sequential scenes from the *Tale of Genji*,[5] prefaced by two pages of calligraphy at the beginning and followed by two pages of calligraphy at the back. The pictorial images are technically accomplished miniature paintings by a single artist or studio done in mineral pigments

on paper with a generous use of gold leaf and dust and bear no visible seals or signature. The calligraphy that accompanies the images are not excerpts from the tale as one might expect, but poems based on four of the five Confucian virtues of filial piety or *gojō*, namely *jin* (benevolence), *gi* (justice), *rei* (duty) and *chi* (wisdom). In contrast to the scenes, each poem was written by a different hand on red and green dyed silk decorated with a young pine and mist motif in gold paint and cut gold leaf. The frontispiece and finispiece of the album are paintings of the three friends of winter, that is pine, plum and bamboo, done on paper and also decorated with gold dust (Figure 1).

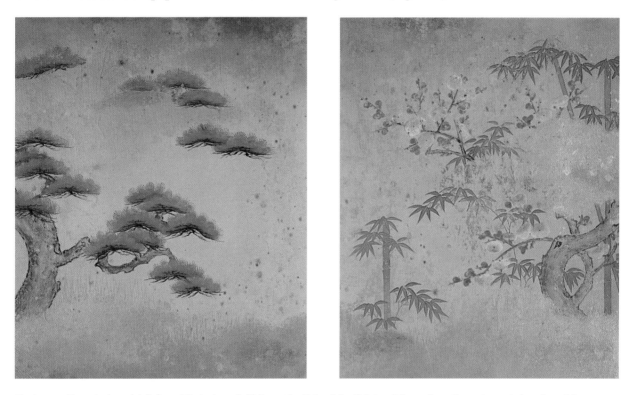

FIGURE 1: Frontispiece (right) and finispiece (left) from the *Tale of Genji*, late 18th–early 19th century. Ashmolean Museum, 1965.69. Gift of R. Somervell.

The album underwent extensive damage at some point in the past at which time the leaves were removed and put into the current mounting, and areas of loss in the paintings were repaired.[6] The current album was also extensively damaged by water, which has warped the outer covers and damaged the back of the accordion-folded paper coated with a wash of indigo and mica, but seems not to have affected the painted images or calligraphy. The brocade on the front and back covers (Figure 2) was lifted off the previous album, backing paper and all, and placed on the current album. It was probably already in a damaged state when this was done since the gold threads, lacking any support from deteriorated warp threads, have been glued down to prevent even further loss. It seems, therefore, that to make the current album, the paintings, calligraphy and brocade were taken from a previous album or albums, and not from a screen. Perhaps at that time only the current twelve leaves were in good enough condition to salvage, which is why we are now left with twelve seemingly random scenes

Figure 2: Brocade cover from the *Tale of Genji*, late 18th–early 19th century. Ashmolean Museum, 1965.69. Gift of R. Somervell.

from the tale. It is likely that there were more than twelve painted scenes in the original album or albums as the insect damage to adjacent images in the current album does not match up.[7] Damage could also be the reason why there are only poems for four of the virtues of filial piety and not five, however it is likely that four was the original number of the calligraphy pages since symmetry is an important factor in the compilation of albums. Having two poems at the beginning and two at the end may have been the original intention. It should also be noted that the calligraphy may be of a later date than the paintings and contemporary with the pre-modern repairs evident on the images, though this is not likely.

Stylistically, the delicate paintings can be said to be the work of an artist versed in the methods of the Tosa school of *Yamato-e* painting. This school's speciality was figure painting of Japanese literary or legendary themes. Its founder Mitsunobu (c. 1434–1525) was employed as *edokoro azukari*, the chief of the Imperial Painting Office. In subsequent generations for little more than a century many of the Tosa school would hold this post. However, by the seventeenth century Tosa artists no longer held this title and the school was badly in need of an injection of new ideas and talent. Although Tosa Mitsuoki (1617–1691) was an innovator in larger format works,[8] other artists trained in Tosa school techniques continued their work in miniature. Painted *Tale of Genji* albums were produced by Tosa artists for centuries, and recent discoveries have enabled us to attribute these paintings to specific Tosa artists and therefore set up a chronology. Aside from Mitsunobu, later generations of direct descendants such as Tosa Mitsuyoshi (1539–1613) and Mitsunori (1583–1638) produced Genji albums, including those now in the Kyoto National Museum and Tokugawa Art Museum.[9] In the sixteenth to seventeenth centuries, several Kyoto ateliers not part of the Tosa school were producing Tosa-style *Tale of Genji* albums as well, a practice that continued into the eighteenth century.[10] The Ashmolean album is probably the production of such a studio or of a branch of the Tosa school different from the main lineage. There are some notable inconsistencies with other Tosa-style *Tale of Genji* albums, however, as discussed below.

An easily identifiable scene from the Ashmolean's album is an image from chapter 23, Hatsune (The First Warbler) (Figure 3). On New Year's day, Genji, his daughter and her ladies look over gifts from his daughter's mother, Lady Akashi. We see inside the young girl's rooms, which are depicted in the traditional manner for interior scenes of the *Tale of Genji*, known as *fukinuki yatai*, or blown-off roof. Genji reads the note that came attached to the present of an artificial warbler on a pine branch seen in the centre of the room. His daughter bends her head and looks at the writing box while thinking of a reply to her mother's note. A group of young girls outside carry newly gathered seedling pines while others comment on the blossoming plum tree in the garden. Behind them, a jewel-like landscape of green hillocks and a blue winding stream is laid out. The ladies wear several layers of brightly coloured robes

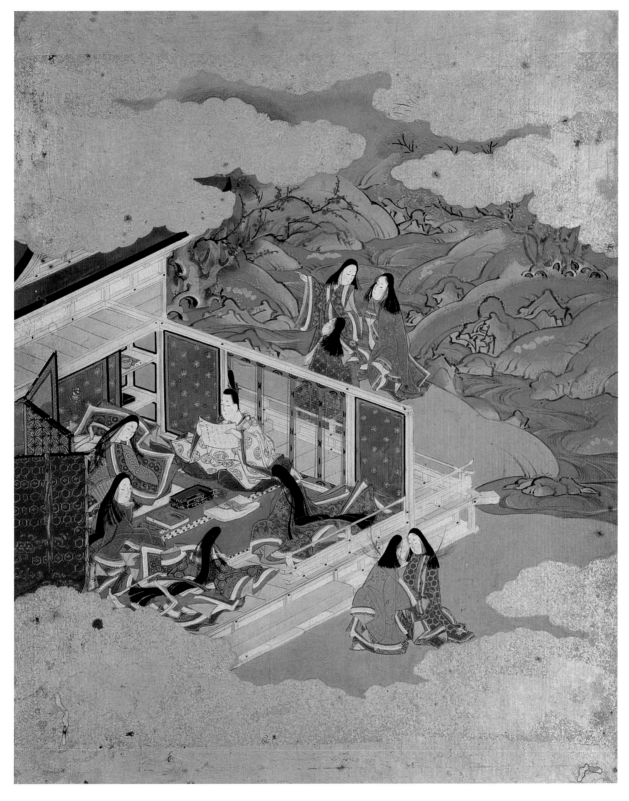

Figure 3: Hatsune chapter from the *Tale of Genji*, late 18th–early 19th century. Ashmolean Museum, 1965.69. Gift of R. Somervell.

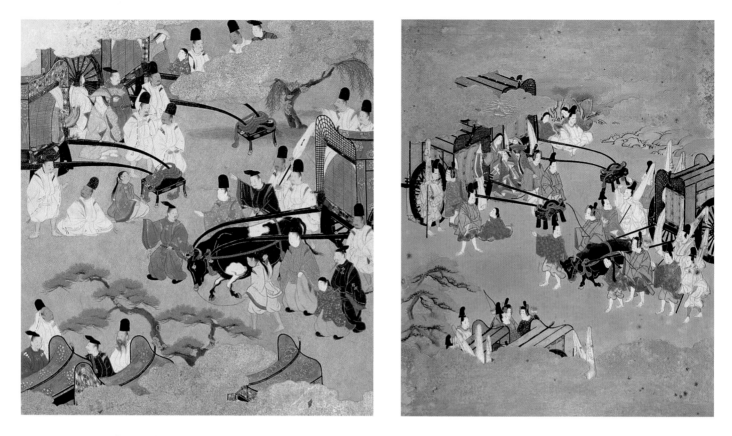

detailed with patterns painted in gold with the thinnest of brushes. (The method of thickly applying mineral pigments to 'build-up' the painting surface is another characteristic *Yamato-e* painting method known as *tsukuri-e*.) Their black hair glistens as much as the gold elements due to a thin layer of animal glue applied over it. Gracefully drawn lines with taut curves articulate the individual threads of the ladies' hair, each slat of the bamboo blinds, and other minute details. Above and below, the edges of the scene are covered with gold clouds made up of cut gold leaf and dust, another convention often seen in *Tale of Genji* paintings to soften the transition from one scene to another (on folding screens) and focus the viewer's attention on the main elements of the composition. Looking at reproductions, it is easy to forget that this complicated and crowded scene is painted on a sheet that is merely about 28 cm high and 23 cm wide.

Certain stylistic features set the Ashmolean museum's album apart from other Tosa-style works. The figures' eyes are clearly delineated and their pupils can be seen. This is not the *hikime kagihana* style of traditionally rendering the faces of the nobility with slits for eyes. In addition, the faces of the figures are elongated with very high foreheads. The elongated faces, seen in a small number of *Tale of Genji* illustrations, can best be said to be a kind of Tosa-style painting concurrent with more standard-shaped faces. The 1509 Harvard album's figures have elongated faces, as does an incense wrapper of the eighteenth century in the Sannmaru Shozokan.[11] The latter closely resembles the type of elongation seen in the Ashmolean album.

Compositionally, some scenes in the album do conform closely to Tosa school models. For example, the scene of Aoi (Heartvine) is very similar to that in the Tokugawa Art Museum by Tosa Mitsunori (1583–1638) (Figure 4). The placement of the carriages, the pose of the bull, Lady Rokujō's hand holding a fan protruding from the carriage at the left, and the pointing attendant at the centre all signify that the painter of the Ashmolean album must certainly have been familiar with the Tosa album, the model used for the Tosa album, or a model done after it. Regrettably, this is the only scene

FIGURE 4: Aoi chapter from the *Tale of Genji*, Tokugawa Art Museum, Nagoya (above left). Same chapter from Ashmolean Museum, 1965.69 (above right). Gift of R. Somervell.

with such striking similarities to the Tokugawa Art Museum work.

Scenes in the Ashmolean album that are compositionally inconsistent with Tosa school norms are in the majority, however.[12] In chapter 17, E-awase (A Picture Contest) (Figure 5), two factions of ladies compete in front of Genji, Tō no Chūjō and the Suzaku emperor seated behind the curtain. Other depictions of the scene in the Tosa school's oeuvre show the scrolls as having painted images,[13] but the Ashmolean's scene shows the women looking at calligraphy, perhaps the textual portion of tales or of Genji's record of his exile at Suma, though this is not specifically mentioned in the *Genji* text. Also, in chapter 2, Hahakigi (The Broom Tree) (Figure 6), a sixteen-year-old Genji, Tō no chūjō and two others sit and read letters Genji has received from various women. According to the text, two young courtiers soon enter the room and join the discussion.[14] In the Ashmolean scene, however, four figures are inside the room and two more men are approaching outside. It is unclear who these two additional figures are. While it was not unusual for the artist to render his illustrations based to a degree on his own interpretations of the text, it seems that the artist of the Ashmolean album strayed from standard depictions of scenes to such a great extent that at times the illustrations have no basis in the *Tale of Genji* itself.

Undoubtedly the rarest aspect of the Ashmolean's album is the inclusion of poems based on the Confucian virtues of filial piety. Confucianism began in China with the teachings of the philosophers Confucius (551–479 BC) and later Mencius (372–289 BC) to provide an instructive framework for the individual as he or she navigated relationships with superiors or inferiors in an effort to create a peaceful system of government. It became official government policy and was codified during the Southern

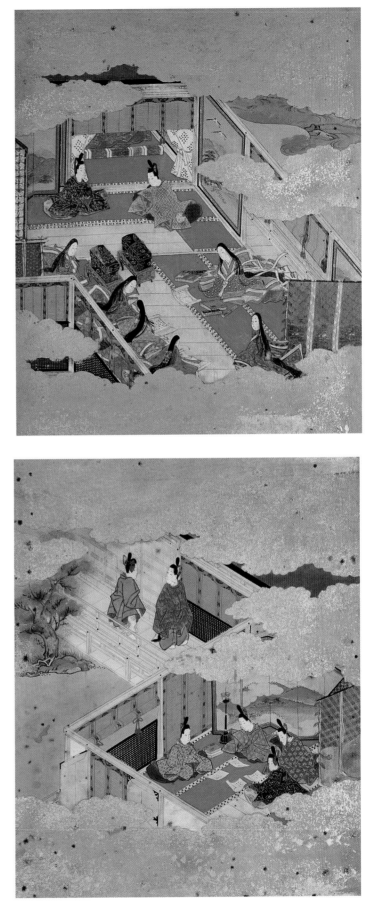

FIGURE 5: E-awase chapter from the *Tale of Genji*, (top) late 18th–early 19th century. Ashmolean Museum, 1965.69. Gift of R. Somervell.
FIGURE 6: Hahakigi chapter from the *Tale of Genji*, (bottom) late 18th–early 19th century. Ashmolean Museum, 1965.69. Gift of R. Somervell.

Song dynasty (1127–1279) by Zhu Xi (1130–1200), and it was this school of thought that was transmitted to Japan and became the basis of Neo-Confucianism in the Edo period known as Shushigaku. The philosophy was used by the ruling Tokugawa shogunate to instill societal harmony and order through a rigid caste system made up of four groups: Samurai, farmers, craftsmen and merchants.

In the Ashmolean's album, the distinctive mannered script of the calligrapher of the poem on politeness, or *rei* (Figure 7) can be identified as Reizei Tameyasu (1735–1816) on stylistic grounds.[15] Tameyasu was the sixteenth-generation member of the imperial Reizei family descended from Fujiwara Teika (1162–1241) whose calligraphy was the most sought after by daimyo of the Edo period to adorn the alcoves during a tea gathering. As a living inheritor of this much-admired line of calligraphers, Tameyasu's work would have been highly valued and obtainable only by a select few. His inclusion in the Ashmolean's album implies that it was produced for someone from the shogunal family or a powerful daimyo family.

The poems themselves originally come from the *Shūgyokushū*, a fourteenth century compilation of the writings of Jien (1155–1225),[16] a Buddhist monk of the Tendai sect and a member of the imperial Fujiwara family. They read:

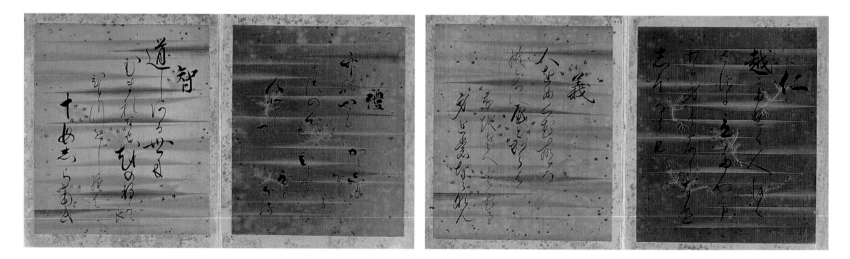

FIGURE 7: From right to left: *Jin* (benevolence), *Gi* (righteousness), *Rei* (politeness) and *Chi* (wisdom), poems from the *Tale of Genji*, late 18th–early 19th century. Ashmolean Museum, 1965.69. Gift of R. Somervell.

仁	Benevolence:
越えて行く	Others pass
人をばさきに	and set out ahead of me
たつたやま	on Mount Tatsuta,
わが身は露に	while drenched with dew,
なおしをるとも	I fall behind others.

義 Righteousness:

人をめぐむ If you inhabit a place

こころのみちに along the path

やどからば of kindness to others,

名をさへとむる you, too, will be among those

身ともならん whose reputation will remain.

禮 Politeness:

竹のやも Just like a hut of bamboo

まつの心も or a stand of sturdy pine,

人として when it comes to people,

かみしもをしる we see strong versus weak

ひとぞひとなる in a person of true character.

智 Wisdom:

道しある If born into a world

世にむまれなば that adheres to the Way

おのづから as a matter of course,

ひとつをしらば if you understand one thing

十もしりなむ you will grasp all things.[17]

As mentioned above, a fifth poem entitled *shin* (loyalty) is not included in the album. The *gojō* are not known to appear in painted *Tale of Genji* albums with the exception of the Ashmolean album. What might have been the intent behind combining poems on Chinese Confucian virtues with a quintessentially Japanese court tale of romance and decadence? Reference to the *gojō* does appear in commentaries on the *Tale of Genji* going back to the *Sairyūshō* of 1528 by Sanjōnishi Kin'eda,[18] a text known for its Buddhist interpretation of the novel. The five poems were undergoing a burst of popularity in the late seventeenth and eighteenth centuries, as evident from their inclusion on a series of prints by Suzuki Harunobu (1724–1770) in the Art Institute of Chicago (Figure 8).[19] Each of the prints illustrates a scene based on one of the poems written above. For example, in the print for *chi*, or wisdom, a young girl is being taught how to write characters as the teacher gently guides her hand. In the scene illustrating *shin*, or fidelity, Murasaki Shikibu herself sits on a verandah with brush in hand thinking of the next lines she will write. The *gojō* are instructions telling a person how to behave in society, and therefore entirely in keeping with what was seen as the intent of Murasaki's novel during the Edo period. In contrast to today, her writing was viewed as a statement on the morals of those whose daily life she described. The *Tale of Genji* was written by a woman, for women, and in a beautiful language that

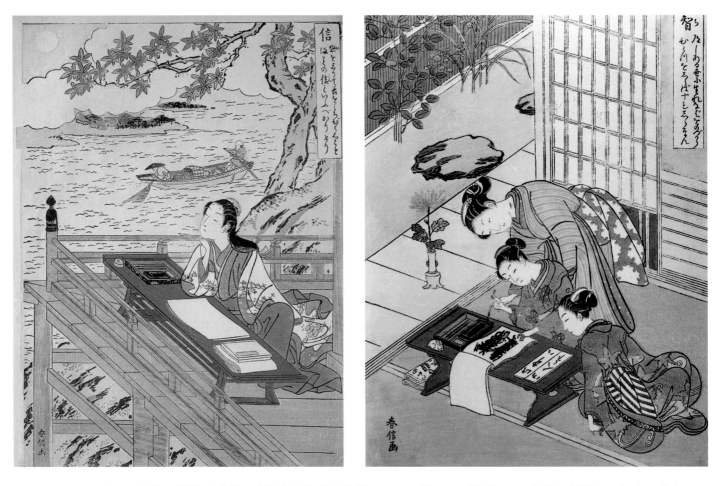

FIGURE 8: *Shin* (fidelity) (left) and *Chi* (wisdom) (right) from a set of five woodblock prints by Suzuki Harunobu issued about 1767. The Art Institute of Chicago, 1928.924–5.

would make enjoyable reading for educated and uneducated women alike. Its topic was one women could understand, matters of love.

Albums of the *Tale of Genji* were often *kazaridana bon*, decorated books regularly included in *daimyo* women's wedding trousseaus (*konrei chōdō*) that were displayed in the home on shelves specially made for that purpose. An album would probably have had its own decorated lacquer box that could have formed a set with other lacquer items that made up the bulk of the trousseau. *Tale of Genji* imagery in general is also featured on many items such as shells for the shell game (*awasegai*) and on incense wrappers (*kōdzutsumi*). Perhaps the most famous use of images from the tale for *konrei chōdō* is a set of sixty lacquer items in the Tokugawa Art Museum known as Hatsune, decorated with motifs derived from that chapter of the *Tale of Genji*. The set was made in 1639 for the marriage of the third Tokugawa shogun's eldest daughter by the premier lacquer artist of the age, Kōami Nagashige (1599–1651).

Several commentaries on the *Tale of Genji* praise Murasaki's intent and declare that it is the most proper sort of tale for women to read, despite having indecent elements. The most prolific of these commentators was the samurai Kumazawa Banzan (1619–1691), author of the *Genji gaiden*, a Confucian reading of the tale and its intent.[20] Banzan saw the novel as describing an ideal Confucian world wherein the characters are confronted with moral lessons. In his commentary, we not only learn his views of the novel but how it was perceived by society in general. In the preface to the *Genji gaiden*, he writes:

A certain woman said, 'In the many books that have been written over the ages for the edification of men, there are no doubt examples which a woman would do well to emulate, but when one has no education they are difficult to understand... The Genji monogatari depicts the most indecent doings. But it is written by such a brilliant woman, and in such lovely language, and moreover it appeals to a woman's heart, and there are so many things to be learnt from it that—well, it seems to me that in spite of the sort of book it is, it could not but be edifying for an ignorant woman.

I replied, ...The reason the novel was written is this: the author was saddened to think that the refined manners of ancient times would, as time passed, decline and lapse into vulgarity. She realized, however, that people would shun a frank and proper sort of book, that its readers would be few, and it would not be widely known. ...But in the guise of a tale of amorous dalliance, she has left us a detailed record of the refined manners and customs of the ancient nobility.[21]

This popular idea of the novel as an instruction book on ancient ways, though not necessarily Confucian, continued into the eighteenth century, a time when the scholar Motoori Norinaga (1730–1801) was the leader of the *kokugaku* (national learning) movement that revived the study of native Japanese works of literature. He wrote a commentary on the *Tale of Genji* called *Tama no Ogushi* (*Precious Little Combs*) in 1796. In it, Norinaga tries to break free of past Buddhist and Confucian readings of the Genji to focus on Murasaki's views on writing and novels as gleaned from episodes in the text. Still, the new emphasis on national learning guaranteed the *Tale of Genji*'s popularity and the story was considered more appropriate than ever as a guide to young women and brides.

The Ashmolean Genji album, with its poems based on Confucian virtues, is a rare exception to the norm for Edo period albums of the same theme. In its differences, however, its purpose as a type of instruction manual for young women is made all the more apparent. In terms of figure style and composition, the Ashmolean album has its basis in Tosa school models. However, the deviations from those models discussed above, specifically the inclusion of the Confucian *gojō* written by renowned calligraphers, may point to the involvement of a patron with specific tastes. The early repairs and remounting in themselves are evidence of the importance placed on the album in the pre-modern era. As an album is an intimate format, it was meant for display in the home and could be brought out to impress a small group of visitors. Alternatively, it could have been lovingly studied for hours in private by its owner.

Yamamoto Baiitsu's *Ancient Masters*

The album of paintings by Yamamoto Baiitsu (1783–1856), comes out of an entirely different context from the previous album, that of Chinese literati painting and its manifestation in Japan as the Nanga movement. The pages contain nine carefully conceived images of vegetables, fruits, flowers and landscapes that have been modelled on Chinese paintings. The paintings as well as a title page and colophon were most probably mounted into the accordion-folded album at some date after the sheets were first conceived of as a set. In order, the subjects painted are a peony; orchid and rock; chrysanthemums and rock; lilies; grapes; monkshood and rock; a landscape with a hut; a boat returning to shore; and lastly a medley of lotus root, lotus pod, watercress, water caltrop and arrowroot. Despite its title, no specific

models are mentioned in the album itself, though stylistic similarities make it possible to point to a few likely sources which are mostly works by Ming dynasty artists. The artist's inspiration from China should not suggest that he rendered mere slavish copies, for Baiitsu's extreme talent to learn and incorporate various brush modes into his own deftly executed paintings is almost beyond compare.

The Ashmolean's album illuminates Baiitsu's use of certain Chinese models as earlier than previously thought. In addition, the album is datable to c. 1815–19, the period around Baiitsu's first stay in Edo, and is evidence of the cultural circles with which he associated. Its early date among Baiitsu's known works makes the album a significant contribution to our understanding of the artist's career. Lastly, in the album we see his early handling of themes that would become pronounced in his later compositions.

Baiitsu formed part of the third generation of Nanga artists. The Nanga (lit. Southern painting) movement, characterised by imaginative and often idyllic landscapes, was named for the Chinese Southern school style of amateur literati artists which the Japanese artists initially emulated. The movement began in Kyoto, had its practitioners in Edo and, by Baiitsu's time, had a strong foothold in other areas such as Baiitsu's native Nagoya. Although Nagoya was a breeding ground for Nanga artists, most still went to Kyoto to seek their fame. Sakaki Hyakusen (1697–1753) and Niwa Kagen (1742–1786) were two early Nanga painters from Nagoya who were pioneers in the style Baiitsu would come to inherit. That inheritance, the Nanga manner, actually had many elements to it by Baiitsu's time. Printed painting manuals from China such as the *Hasshū gafu* (*Eight Picture Albums*) and the *Kashien Gaden* (*Mustard Seed Garden Manual of Painting*) were copied by artists to learn brushstrokes and painting techniques, not to mention the range of common literati subjects in China. The practice of sketching actual scenery to produce so-called 'true views' was less widespread, but nonetheless seen as an essential pursuit for any serious artist. In addition, a strain of realistic and colourful bird and flower painting came into Japan by way of the Chinese visitor to Nagasaki for two years, Shen Nanpin (fl. mid-eighteenth century), as well as through prints from Suzhou. These are the most significant elements of the Nanga style, however, the mindset, lifestyle and theory behind its execution was a serious matter to its proponents in Japan. Its Chinese practitioners upheld the ideals of the study of poetry and calligraphy as well as painting for self-cultivation and awareness. Painting to sell one's artwork was considered incompatible with the literatis' morals. In Japan, however, no such taboo was attached to the selling of paintings.

Baiitsu is best known today as a painter of large-scale bird and flower compositions which were mostly done for sale. Examples of his complex and decorative works in this genre are included in this catalogue (Cat. 6). In addition to these however, Baiitsu also produced a large number of paintings of classic literati themes such as chrysanthemums, orchids or landscapes. The publication of *Ancient Masters* is timely in that our understanding of Baiitsu as a serious student of Chinese literati painting and culture in general has been expanded by recent studies and exhibitions on the artist.[22]

Baiitsu's first teacher was probably Yamamoto Rantei, an artist of the Kano school. His second, Chō Gesshō (1770–1832) was a Shijō school painter, whose well-developed creativity and wit served Baiitsu well. It is known that Baiitsu also admired fellow Nagoya resident Tanaka Totsugen (1760–1823), leader of the *yamato-e* revival, one of whose fan paintings is included in this volume. In addition to Nagoya and Kyoto, the Western coast city of Kanazawa played a significant role in Baiitsu's fortune.

After successfully managing to impress many well-known cultural figures there during his first trip, he was asked back later in 1809 to decorate Kanazawa castle. Here he met the artist Tani Bunchō (1763–1840). Baiitsu was but twenty-seven at the time, and this meeting may have prompted his visit to Edo as well as guaranteeing his success while there.[23] Although Baiitsu's name seems to have been known by this date, he becomes a major figure in literati circles beginning in earnest with his time in Edo from 1814–15.[24] This is the period to which the Ashmolean's album belongs.

Before his time in Edo, Baiitsu had several chances to study Chinese paintings, both indirectly through printed manuals and directly in temples and private collections. The artist's knowledge of literati painting techniques developed over time into an impressive repertoire of styles. He was very familiar with the *Mustard Seed Garden Manual of Painting*, which he copied in full in one night.[25] In fact, most of the compositions in the Ashmolean's album can be found in similar form there. Artists of Baiitsu's time had greater access to Chinese paintings (and to a greater variety of well-known and unknown painter's works, genuine images as well as copies) than earlier Nanga painters and did not have to rely solely on the printed manuals from China. For his study of actual Chinese paintings, Baiitsu relied on Kamiya Tenyū (1710–1801), a wealthy merchant in Nagoya who dealt in miso and soybean products. Tenyū had about a dozen Chinese paintings which he encouraged Baiitsu to copy.[26] He is also believed to have given Baiitsu his artist name, or *gō*, after the artist admired a painting of a plum by Yuan dynasty artist Wang Mien (1287–1359). In 1802 Baiitsu left his home and travelled with painter and friend Nakabayashi Chikutō (1776–1853) to Kyoto, where it is said Baiitsu sketched views of the city and surrounding areas. Although not as exclusive in his study of old Chinese paintings as Chikutō, Baiitsu probably copied several works in Kyoto temples at that time. In his later career he is known to have collected a number of paintings by Chinese artists, and would have seen many more in exhibitions and through his role as a connoisseur.[27]

The album is prefaced by a title page reading *Shiko* (Ancient Masters) brushed by Ōkubo Shibutsu (Figure 9). The title page is signed with one of his literary names, Kōzan Ōsho (written by old man Kōzan), and sealed 'Kōzan shidō' and 'Tenmin'. The colophon of the album is by Kashiwagi Jotei, a great friend of Shibutsu's in Edo.

FIGURE 9: Title page by Ōkubo Shibutsu, from Yamamoto Baiitsu, *Ancient Masters*, c. 1815–19. Ashmolean Museum, 1964.89.

The colophon (Figure 10) reads:

画不貴形似	In painting, form-likeness is not esteemed
今人合此言	and people today agree with these words.
山水及花卉	In its landscapes and flower paintings,
是帖寫根源	this album represents the origins [of painting].[28]

This same sentiment was later echoed by Baiitsu: 'Those who study painting must not concentrate on shapes. They should concentrate first on brushwork. Those people who emphasise form-likeness will produce sick and dead brushwork...'[29]

Jotei's death date gives us a *terminus ante quem* of 1819 for the album. He and Shibutsu were regarded as the foremost composers of Chinese poetry of their time in Edo. Together and separately, Shibutsu and Jotei inscribed a handful of Baiitsu's paintings from the mid to late 1810s. *Landscape with Figure in a Boat*, in the Nagoya City Art Museum, bears inscriptions by both Shibutsu and Jotei, though the painting itself was done in 1814 (Figure 11). Other works by Baiitsu from the period 1815–19 include a handscroll of *Literati Plants and Flowers* painted by Baiitsu in Osaka while traveling with Shibutsu in 1818 (Figure 12). Shibutsu added his own inscription to this in 1820. The handscroll has images of many of the same subjects as in the Ashmolean album such as a peony, lilies and arrowroot, and confirms Baiitsu's devotion to mastering these subjects early in his career.

Of the works of this period by Baiitsu, it should be noted that many are small format handscrolls or albums, perhaps a reflection of his constant movement at this time. It could also be taken as a confirmation of Baiitsu's enthusiasm for literati painting, whose Chinese proponents had tended to prefer small format works since the Ming dynasty. The reason for this is unclear, but it is likely that it reflects the amateur nature of the art of the literati in China. When painting in a small format, one need only have a suitable amount of paper at hand when the inspiration to compose a picture arose, perhaps for a departing friend or an unexpected visitor. Though such artists in China did not sell their works, they often exchanged them with like-minded acquaintances, therefore a small format would have been an advantage. There is also no denying the more private element involved in a painting of smaller size meant to be viewed by one person or a small group of close associates. Baiitsu may well have chosen to produce albums or handscrolls simply because his models were of roughly equal size, however, it seems unlikely that he was immune from attaching greater sentiment to his small format works of literati subjects. In the Ashmolean work, the inclusion of the calligraphy of two of his respected mentors in Edo also supports the view that Baiitsu saw this album as a personal statement rather than as an item for mass consumption like his larger bird and flower compositions.

Baiitsu's association with the pair of poets went beyond having the pair

FIGURE 10: Colophon by Kashiwagi Jotei, from Yamamoto Baiitsu, *Ancient Masters*, c. 1815–19. Ashmolean Museum, 1964.89.

inscribe his paintings. They were, in fact, good friends who enjoyed many similar interests. Shibutsu and Jotei were also painters, and Baiitsu undertook a number of pursuits including poetry (Chinese *kanshi*, Japanese *waka*), the *sencha* tea ceremony, calligraphy and the flute. Jotei was a member of a group formed specifically to promote the arts of both poetry and painting in each cultured individual.[30] Shibutsu and Baiitsu were particularly close, and though they met only a handful of times throughout their lives, Shibutsu often wrote of his admiration for his friend. In 1818, the pair set off travelling together for several months, meeting up with other prominent scholars, poets and painters, attending gatherings and drinking as recorded in Shibutsu's *Saiyū shisō*. A highlight of the journey was a voyage on the Yodo river from Kyoto to Osaka.[31]

The individual pages of the album point to the models on which Baiitsu may have been basing his work. The first painting in the album is that of a peony flower that has been clipped from its bush (Figure 13). The heavy flower sits atop its thin branch with delicate leaves. Baiitsu was a master colourist, and this is nowhere more evident than in this small image. The deep red of the centre of the flower fades to a light pink on the outer petals. These colours in turn overlie a darkened lead-based pigment that in its original condition of a gleaming bright white colour must have made the flower stand out against the ivory-coloured paper. Upon close examination, it is apparent that every aspect of the painting is methodically controlled, yet the finished appearance is one of movement and spontaneity. No two petals or leaves bear the same shape or direction. The leaves are painted with a mixture of green and pink pigment in the *mokkotsu* or boneless manner without outline. In its composition, this image is a standard depiction of a much-loved subject in Ming and Qing dynasty Chinese painting; however, Baiitsu's original handling of the theme makes it clear that he only relied on Chinese models as objects of study and inspiration. The peony would later become a mainstay in Baiitsu's more common large-scale hanging scroll and screen compositions.

FIGURE 11 (above): Yamamoto Baiitsu, *Landscape with Figure in a Boat* with inscriptions by Ōkubo Shibutsu and Kashiwagi Jotei, 1814. Nagoya City Art Museum, detail.
FIGURE 12 (below): Yamamoto Baiitsu, section of *Literati Plants and Flowers*, 1818 with inscription and poems by Ōkubo Shibutsu, 1820. Yabumoto collection, Amagasaki.

FIGURE 13: Peony, from Yamamoto Baiitsu, *Ancient Masters*. Ashmolean Museum, 1964.89.

The peonies done as part of a handscroll of 1835 in the Feinberg Collection (Figure 14) are similar to the one in the album in terms of the sense of weight of the blossom and the movement in the leaves. However, in the later work, Baiitsu has perfected a complex system of only using darker washes of colour near the centre of the flower for greater visual clarity. Models that Baiitsu could have used to develop his style of painting peonies include works by Chen Shun (1484–1544), a late Ming dynasty artist.[32] This artist's technique of painting flowers was much admired in Japan at the time, attested to by a handscroll by Tsubaki Chinzan (1801–1854) in the British Museum (Figure 15).

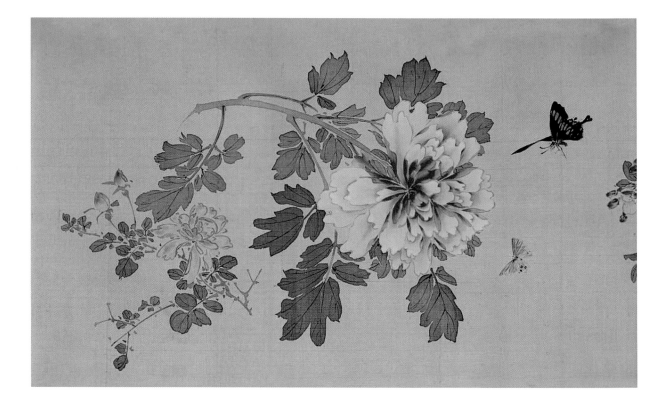

FIGURE 14: Detail of Yamamoto Baiitsu, *Handscroll of Flowering Plants*, 1835. Feinberg Collection.

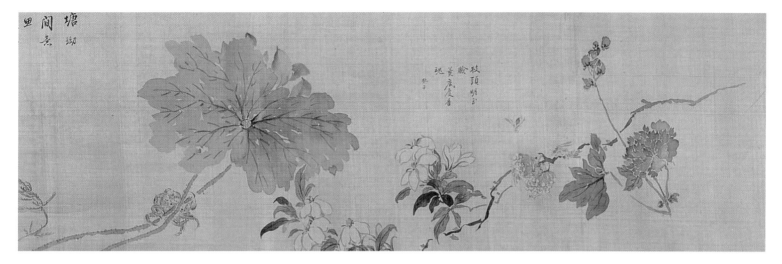

FIGURE 15: Tsubaki Chinzan, section of *Handscroll of Plants After Chen Shun*. British Museum.

One of the most striking images of the album is that of a small hut behind a cluster of trees (Figure 16) done in the unmistakable manner of Ni Zan (1301–74), the famous Yuan dynasty landscape painter. Baiitsu probably studied Ni Zan's manner indirectly through later Chinese artists such as I Fukyū (1698–after 1747) or Yang Wencong (1597–1645). In this image Baiitsu finishes using a dry brush to sketch the lines of the mountains and trees over more watery light grey strokes. I Fukyū was a Chinese artist, who had worked in Japan in the early eighteenth century, whose style revived the famous Yuan dynasty masters. A collection of Fukyū's painting designs were printed in 1803 under the title *I Fukyū Ike Taiga Gafu*, with an inscription by Ōkubo Shibutsu, the man who wrote the title for the Ashmolean's album. Through Shibutsu, Baiitsu would certainly have been well versed in Fukyū's compositions.[33] One of Baiitsu's most famous possessions was a landscape done in the style of Ni Zan by Yang Wencong.[34] Baiitsu is known to have had this painting, which he copied in 1848, since 1831. The landscape in the album has similar rock forms to the painting by Yang Wencong, but the landscape is altogether flatter and the tree forms are less varied. It is likely that Baiitsu's model for the album page was another painting. Baiitsu would later paint many Ni Zan style landscapes, most notably one in 1837 (Figure 17). However the painting in the Ashmolean moves up the date that Baiitsu started painting in this manner. The 1837 landscape and the one in the Ashmolean album are extremely similar and may point to a common model.

Baiitsu's *Ancient Masters* is the product of a specific time in the artist's career after he first became associated with exclusive cultural groups concerned with the study of Chinese painting and poetry in Edo. Through his choice of the format of an album, Baiitsu was able to show his affiliation with Chinese literati preferences for smaller, more portable works. Each of the images points to Baiitsu's familiarity with certain Chinese painting masters and brushmodes, but the choice of the album in general lent further credence to the paintings on its pages as the work of a truly refined individual. Added to this, the inclusion of a title page and colophon by two prominent Edo poets, Baiitsu's close associates, would have carried great personal meaning for the artist. Therefore, the audience of *Ancient Masters* was both the owner and a small group of like-minded individuals.

FIGURE 16: *Landscape*, from Yamamoto Baiitsu, *Ancient Masters*. Ashmolean Museum, 1964.89.

FIGURE 17: Yamamoto Baiitsu, *Landscape After Ni Zan*. Addiss-Seo Hanga Collection on long term loan to the Ruth and Sherman Lee Institute for Japanese Art.

Conclusion

The proliferation of painters and calligraphers in the Edo period, and increased communication among them through travel is no more evident than in these small, complex items. It is the combination of calligrapher and painter, in both cases, that makes the album's function apparent. In the *Tale of Genji* album, calligrapher and painter come together to produce a new Neo-Confucian twist on an old classic. In Baiitsu's case, the addition of a title page and colophon by two eminent Edo calligraphers lends increased value to the artist's role as a literatus in the capital despite his origins elsewhere.

The two albums discussed above highlight why albums increasingly became the format of choice in the Edo period. An album, because it could be studied in private or in a small group, was the most sensible form for the *Tale of Genji*'s didactic purpose. For Baiitsu's *Ancient Masters*, the album format signified the artist's knowledge of Chinese literati artwork and lifestyle that became synonymous with cultural sophistication. Interestingly, in both cases it is the album's intimate nature that makes it valuable as an object of status, to be brought out to show a select group of admirers on special occasions.

Notes and references

1 This is Hugh Wylie's translation of section LXI of Nanga painter Kanai Ujū's (1796–1857) *Musei Shiwa* (Talks on 'Silent poetry') in Hugh Wylie, 'Nanga painting treatises of nineteenth century Japan: Translations, commentary, and analysis'. (Ph.D. thesis, University of Kansas, 1991), 192.

2 The earliest extant illustrations of the *Tale of Genji* date to the early twelfth century, about one hundred years after the tale was written. The famous handscroll is divided among the Gotō Museum, Tokugawa Reimeikai Foundation, Tokyo National Museum and others in Japan.

3 See Anne Rose Kitagawa, 'Behind the scenes of Harvard's Tale of Genji album', *Apollo* (Nov. 2001), 28–35, on the story of how the prior format of these *shikishi* came to light.

4 We know that Genji pictures were painted on *shikishi* to be pasted on screens as early as the mid-thirteenth century from the *Chōshū ki*, which relates the story of a set of Genji paintings commissioned by a shogun. For a detailed account of this record, see Miyeko Murase, *Iconography of the Tale of Genji, Genji Monogatari ekotoba* (New York, Tokyo: Weatherhill, 1983), 13.

5 The scenes generally follow the tale from beginning to end, but there are gaps of several chapters between each. For a listing of all of the chapters represented, see the catalogue entry for this album, no. 44.

6 For example, areas of gold that underwent damage were filled in with gold leaf patches, and areas where the pigment was flaking off was reinforced with animal glue. The latter areas are now cracking because the application of glue was so thick.

7 I would like to thank Mr Philip Meredith of the Far Eastern Conservation Centre of the Museum of Ethnography, Leiden, for his assessment of the album.

8 For Mitsuoki's experimentation with the school's standard methods, see John M. Rosenfield, 'Japanese studio practice: The Tosa family and the Imperial Painting Office in the seventeenth century', in Peter Lukehart, ed., *The Artist's Workshop. Studies in the History of Art* no. 38 (Washington DC: Center For Advanced Studies in the Visual Arts, National Gallery of Art, 1993), 79–98.

9 The Tosa Mitsuyoshi album in the Kyoto National Museum is published in Takeda Tsuneo 'Tosa Mitsuyoshi to saiga – Kyoto kokuritsu hakubutsukan Genji monogatari zuchō o megutte', *Kokka* 996 (1976), 11–40. The Mitsunori album is reproduced in *The Tale of Genji/Tosa Mitsunori* (Tokyo: The Shogun Age Exhibition Executive Committee, 1983).

10 Rosenfield, 84. The Chester Beatty Library has a number of such Genji albums from the second half of the seventeenth century. See Sorimachi Shigeo, *Nihon eiribon oyobi ehon mokuroku: airurandokoku daburin chesutaa biitii raiburarii zō, Japanese Illustrated Books and Manuscripts of the Chester Beatty Library, Dublin, Ireland* (Tokyo: Kōbunsō, 1979) 27, 34, 36.

11 Museum of Imperial Collections, Sannomaru Shōzōkan, *Esthetic Sense of the Edo period – Tradition and Evolvement of Designs in Paintings* (Tokyo: Museum of the Imperial Collections, 2002), 57.

12 Tosa school depictions of the *Tale of Genji* were codified in a sixteenth century manuscript (most probably a copy of an earlier manuscript) in the Osaka Women's College, the subject of Miyeko Murase's *Iconography of the Tale of Genji*.

13 For example, Mitsunori's album in the Tokugawa Art Museum reproduced in Akiyama Ken and Taguchi Eiichi, eds, *Gōka 'Genji-e' no sekai: Genji monogatari* (Tokyo: Gakushū kenkyūsha, 1999), 86.

14 Edward G. Seidensticker. *Murasaki Shikubu: The Tale of Genji* (London: Secker and Warburg, 1976), 23.

15 Other examples of Tameyasu's calligraphy can be seen in *Teikayō: Tokubetsuten* (Tokyo: Gotō Bijutsukan, 1987), 188–92. I am grateful to John Carpenter for proposing this identification.

16 See Shinpen kokka taikan henshū iinkai, *Shinpen Kokka Taikan* 3 (Tokyo: Kadokawa shoten, 1983), 695. The *waka* of the five virtues of filial piety (also called the five cardinal virtues) are in section three of the *Shūgyokushū*.

17 The translations of the four poems were generously provided by John Carpenter.

18 Ii Haruki, ed., *Naikaku bunkobon Sairyūshō: Naikaku bunkobon* (Tokyo: Ōfūsha, 1975), 503–4. I would like to thank James McMullen for informing me about the contents of the *Sairyūsho*.

19 Margaret O. Gentles, *The Clarence Buckingham Collection of Japanese Prints* vol. 2 *Harunubu, Korysai, Shigemasa, their followers and contemporaries* (Chicago: The Art Institute of Chicago, 1955–64), 68–70. The poems on the prints are not entirely faithful to those in the *Shūgyokushū*.

20 For a detailed account of Banzan's view of Genji, see James McMullen, *Idealism, Protest, and the Tale of Genji: The Confucianism of Kumazawa Banzan (1619–91)* (Oxford: Clarendon Press, 1999).

21 This translation appears in Thomas James Harper, 'Motoori Norinaga's criticism of the Genji Monogatari: A study of the background and critical content of his Genji Monogatari Tama no Ogushi' (Ph.D. thesis, University of Michigan, 1971), 84–5.

22 For example, see Patricia Jane Graham, 'Yamamoto Baiitsu: His life, literati pursuits, and related paintings' (Ph.D. thesis, University of Kansas, 1983) and Nagoyashi hakubutsukan, *Owari no nanga* (Nagoya: Nagoyashi hakubutsukan, 1981).

23 This event is described in Yoshida Toshihide, 'Yamamoto Baiitsu kenkyū josetsu' in *Nagoyashi hakubutsukan kenkyū kiyō*, vol. 2, 1979, 19 and a full explanation is in Izumi Kan'ichi, *Kanazawa jō to Yamamoto Baiitsu no sokuseki* (Takaoka: Iwanami bukku saabisu sentaa, 1998), 124–32.

24 Graham estimates that Baiitsu was in Edo at least from the summer of 1814 to the spring of 1815, see Graham, 38–42.

25 Graham, 31.

26 The story of these ten Chinese paintings is related in Graham, 'Yamamoto Baiitsu', 27.

27 A catalogue for a painting exhibit in honour of Baiitsu's seventieth birthday lists many Chinese paintings Baiitsu would certainly have seen including many from his own collection, and a seventh year memorial exhibition after his death in which work from Baiitsu's collection was also shown is discussed in Graham, 'Yamamoto Baiitsu', 108–10. For a fuller description of Baiitsu as a connoisseur of Chinese paintings, see ibid. 101–3.

28 I would like to thank James Lin for his help in translating the colophon, as well as Cary Liu and Eugenie Tsai for their professional touch.

29 This is Graham's translation of a passage appearing in Kanematsu Romon, *Chikutō to Baiitsu* (Tokyo, 1910). Graham, 'Yamamoto Baiitsu', 149.

30 This was the Shōfukyū Ginsha (Small Society for the Preservation of Poetry Chanting), described in Wylie, 352.

31 The details of this trip are recounted in Graham, 'Yamamoto Baiitsu', 42–7. For a detailed account of Shibutsu and Baiitsu's relationship, see Izumi, 133–70.

32 See for example, his painting of peonies dated 1538 in the National Palace Museum, Taipei published in James Cahill, *Parting at the Shore, Chinese Painting of the Early and Middle Ming Dynasty 1368–1580* (Tokyo and New York: Weatherhill, 1978), plate 127.

33 An example of a work by I Fukyū in the Ni Zan style is *Quiet Hamlet* published in Steven Addiss, ed., *Japanese Quest for a New Vision, the Impact of Visiting Chinese Painters, 1600–1900: selections from the Hutchinson collection at the Spencer Museum of Art* (Lawrence, Spencer Museum of Art, University of Kansas, 1986), 17.

34 This painting is discussed in Yamanouchi Chōzō, *Nihon Nangashi* (Tokyo: Ruri shobō, 1981), 386–7.

The Widespread Nanga Movement and the Nanpin School

Impossible landscapes and ink-play flowers are the foundation of the literati painter's repertoire. In China, such literati 'Southern School' painting was practised by scholar-bureaucrats on an amateur basis as a means of self-expression. They fundamentally distinguished their own pure pursuit of the arts from that of the professional court painters of the Northern tradition in terms of class, morals and style. Though trade and travel were restricted under the Tokugawa regime in Edo-period Japan, a variety of Chinese paintings and painting theories flowed in, inspiring the formation of the Nanga (lit: Southern painting) movement. The Nanga style of painting carried no such class distinction as it did in China. It was embraced by Confucian scholars, merchants and

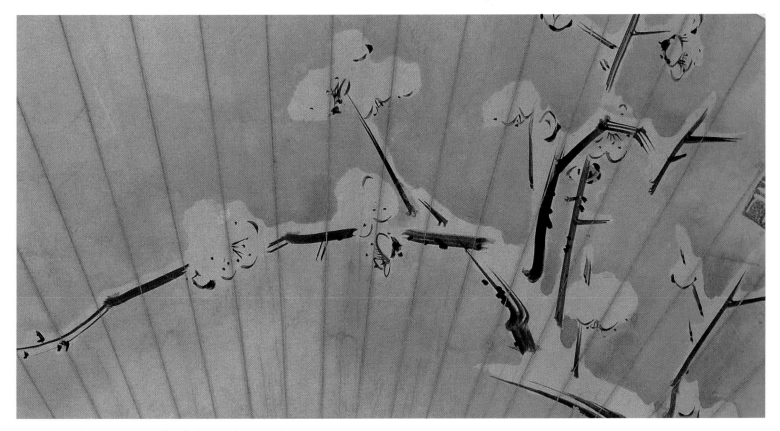

IMEI, *Plum Blossoms in Snow*, detail of cat. 3 (1966.110).

farmers alike who were attracted to the Chinese manner of 'idealist painting'[1] initially as a method of personal cultivation. In addition, many artists lived by travelling extensively and selling their paintings. The term *bunjinga* or literati painting, sometimes used as a synonym for Nanga, describes therefore the style and not the social background of its practitioners.

At first, the Japanese painters were at a loss to fit the diversity of styles they were receiving into their larger context as understood in China. The flow of information into Japan came in three main varieties: Chinese printed books of painting and poetry, original paintings and copies, and Chinese artists themselves, who settled for a time in Nagasaki.

The two most influential illustrated texts were the *Hasshū gafu (Book of Eight Kinds of Painting)*, first published in 1672 and the *Kaishien gaden (Mustard Seed Garden Manual of Painting)* Japanese edition of 1748. The former was made up of illustrations to poems, but the latter was a proper painting manual that described the various ancient masters' styles. Increasingly, actual Chinese paintings were available to be copied and studied. Chinese paintings had of course been seen in Japan much before the Edo period. Beginning in earnest with the Ashikaga shoguns in the late fourteenth century, paintings of the Song, Yuan and Ming dynasties, as well as bronzes, porcelain and textiles used for display or use in the tea ceremony, were enthusiastically imported. The constant flow of Chan (J: Zen) Buddhist monks from the mainland to the main Gozan monasteries of Kyoto also fed a general vogue for things Chinese. The curators (*dōbōshū*) of the Ashikaga shogunal art collection divided the Chinese artists into the main categories of upper, middle and lower, codifying the use of certain models for years to come. New paintings arriving from the mainland in the Edo period looked very different, therefore, from the so-called Chinese school in Japan, namely the Kano painting academy. More than the paintings, the greatest impact on the Nanga movement came from Chinese artists themselves who lived as part of Nagasaki's well-established Chinese community. I Fukyū (Ch: Yi Fujiu) who visited repeatedly from 1726 to 1744, brought his interpretation of Yuan dynasty masters such as Ni Zan. Though Fukyū's works were a catalyst for the Japanese to understand certain Chinese painting traditions, he is not credited with establishing a school per se. In this regard, Shen Nanpin (fl. mid eighteenth century), who stayed in Nagasaki from 1731–3, had the most lasting influence on native artists.

The Ashmolean's collection of Nanga works comprises paintings by late eighteenth- and nineteenth-century artists. The earliest piece in the section is a pair of handscrolls by Kō Fuyō (Cat. 1). It was no doubt based on a lost Chinese

or Chinese-inspired model, and expresses the Nanga painter's affinity for the landscape of the continent, even if he could only travel there in his own mind.

Like Fuyō, the next generation of Nanga artists continued to flourish in Kyoto, the cultural centre of Japan. The *Heian jinbutsushi (Who's Who of Kyoto)*, printed in several editions between 1768 and 1867, lists the many Nanga artists working in the capital. Native Kyoto artists such as Chikudō Kinei (Cat. 2) were great in number, but the city was of course a mecca for artists from other areas: Yamamoto Baiitsu (Cat. 5, 6) and Nakabayashi Chikutō (Cat. 4) came from Nagoya, and Tanaka Kaibi (Cat. 8) was originally from Osaka. In the capital of Edo, the movement began to take shape with Tani Bunchō, yet a rare work by Bairi Sanjin (Cat. 9) in the Ashmolean's collection gives us insight into Edo Nanga prior to Bunchō's revolution. Bunchō's extreme talent and diversity transformed the Edo art world. Two fan compositions, *Landscape* (Cat. 10) and *Butterflies* (Cat. 11), owe their inspiration to vastly different sources which Bunchō then executed as his own. His plethora of students, including Takaku Aigai (Cat. 12) ensured that his legacy would be felt in the capital for some time to come. Important regional centres for the arts sprung up as well, notably in Bitchū province, where artists such as Ono Unpō (Cat. 18) were active in cultural circles as patrons and painters.

The Nanpin school can be considered a branch of Nanga in that these artists were also influenced by Chinese paintings, or rather a mixture of Western and Chinese styles practised by artists in the port city of Nagasaki. Their work, mostly of flower and bird subjects, derives from a blend of realism with a brightly coloured decorative manner. Beginning with Shen Nanpin's only Japanese student, Kumashiro Yūhi (Cat. 13), artists such as Sō Shiseki (Cat. 14), Hirowatari Ganhi (Cat. 15), Masuyama Sessai (Cat. 16), and Kinoshita Itsuun (Cat. 17) took the Nanpin school beyond its origins in Nagasaki and beyond its basis in bird and flower subjects. Of course, many Nanga artists from Kyoto and Edo who did not affiliate themselves with the Nanpin school nevertheless incorporated its methods into their paintings, seen for example in Yamamoto Baiitsu's *Flowers of Summer and Autumn* (Cat. 6).

1 Joan Stanley-Baker uses this term in *The Transmission of Chinese Idealist Painting to Japan: Notes on the Early Phase (1661–1799)* (Ann Arbor: Center for Japanese Studies, University of Michigan, 1992).

I

Kō Fuyō 高芙蓉
1722–1784

Nine bends of a river in the Wuyi mountains, 1772

Part travel record and part legendary landscape, this riparian scene can be read on multiple levels. Two handscrolls carry the viewer through nine bends of a river that runs through the Wuyi mountains in Fujian province, China. Improbable rock formations follow one upon another, making the journey's rhythm intense and virtually without pause. Light washes of ink in black, grey, brown and blue help to make visual sense out of the profusion of cliffs, boulders and islets. The undulating landscape is accented by labelled landmarks, such as a tall thin rock aptly named 'The Peak of the Jade Lady (Yunu Feng)', and a majestic, top-heavy rock called 'Peak of the Great King (Dawang Feng)'. These are all actual locations in Fujian province, though their exaggerated shapes are no doubt partly the result of fantasy. A constant feature among all this complexity is the rolling mist that wafts among the rocks, though it is mostly confined to thin bands so as not to detract from the striking clarity with which the landscape can be seen. In addition, several blossoming trees with reddish flowers appear throughout the landscape from time to time.

The first scroll opens with a concentrated scene of natural and human activity: a waterfall roars in the middle distance while a figure crosses a bridge, and two boats set out on the river. Though the landscape seems inhospitable, several figures continue to dot it. Wherever one looks, a literatus is crossing a bridge or a fisherman is steering a boat. Figures commune with nature or go about their industrious activity comfortably at home in their paradise. Two small figures greet each other at one of the only areas of rest, a small oasis among the towering rocks. Others find time to enjoy a cup of tea or wine on a platform in the middle of the river labelled 'Platform of the Three Cups (Sanbei Tai)'.

An introductory poem naming the location as the Wuyi mountains is followed by nine poems for each of the nine bends of river that they describe. They are written by the artist and bear his seals. In the last poem, the story of the Peach Blossom Shangri-la is mentioned. This tale was written by the Chinese poet and scholar Tao Yuanming (J: Tōenmei) (c. 365–427), and relates the travels of a fisherman who follows a stream until he comes to a grove of peach trees. He continues, curious to see how far it extends, and comes to an entrance into a

PAIR OF HANDSCROLLS

INK AND COLOUR ON PAPER

SIGNATURE: *Fuyō ken sha* (PAINTED BY FUYŌ KEN) *Minamoto Mōhyō*

SEALS: *Koseki no in; Kyōchū Itsumin; Mōhyō; Juhi*

22.9 × 577.4 CM; 22.9 × 468.9 CM

1966.124, 1966.125

Purchased with the aid of grants from the Higher Studies Fund and the Victoria and Albert Museum Fund, also with donations from the friends of P. C. Swann

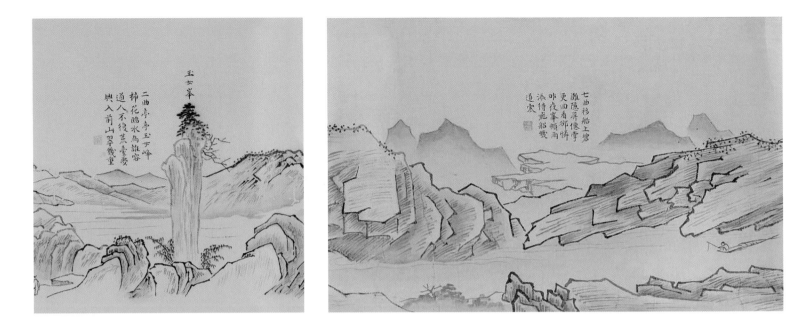

mountain. Leaving his boat behind, he ventures further and finds himself in a bountiful paradise where people are happily going about their daily routines. The fisherman learns that their ancestors had come here to escape the reigning war during the Qin dynasty (221–206 BC), and that they know nothing of events since that time. He tells them of all that had happened in recent years, and when he sets off to leave, they beg him not to mention their presence to the outside world. Carefully leaving markers so that he could retrace his steps, the fisherman returns home. He informs a town official who orders him to go back and investigate, but he never finds the markers nor the grove again.[1]

Bearing in mind this story, the blossoming trees in the Ashmolean's handscrolls may well be peach trees. The many fishermen's boats that one sees on the river could be interpreted as one fisherman at different points in time during his journey. Fuyō's work oscillates, therefore, between the fantastic story of the fisherman, and the actual landscape of the Wuyi mountain region.

Kō Fuyō was born in Kai province, and became a Confucian scholar active in Kyoto. Here, he befriended Ike Taiga (1723–1776), the gifted painter who was among the first to assert a particularly Japanese style of Nanga, when Taiga was only nineteen years old. The friends travelled together on a famous trip to the three peaks, Hakusan, Tateyama and Mount Fuji. They kept a very detailed journal of their expedition, which must have been a memorable experience that fuelled Fuyō's love of travel, a sentiment expressed in the Ashmolean's handscroll painted twelve years later. Stylistically, Fuyō was like his friend in that he copied many Yuan and Ming dynasty Chinese paintings, and could paint in several different modes.[2]

This pair of handscrolls is done in the so-called Ma-Xia style derived from works by the painters Ma Yuan (active c. 1190–1225) and Xia Gui (active c. 1200–1240) of the Southern Song dynasty in China. The heavy axe-cut texture strokes on the rock faces are characteristic of this manner. In addition, the large cliff that faces the river is a feature found in many Ma-Xia style landscapes, particularly handscrolls, from the Southern Song to the Ming dynasties.[3] Another element often confronted in panoramic handscrolls of this type is the jagged platform-shaped rock that juts out into the distance. The Ma-Xia mode had been known in Japan at least from the time of Shūbun (active 1418–1458), who incorporated many aspects of compositions into his attributed *shigajiku* (poem and picture hanging scrolls). He was probably looking at works of the Ming period Zhe school court painters done in this manner for the most part. After Shūbun, it was Sesshū (1420–1506) who was most prolific in his transformation of Zhe school models. His handscrolls condense the rhythm of earlier works into a frenetic pace by fragmenting the rock forms and increasing the human activity. In addition, Sesshū also produced Chinese river landscapes in which famous landmarks are labelled.[4]

In the Ashmolean's handscrolls, it is evident that Fuyō's model was a Ming period painting or was based on one. The profusion of detail, incessant rhythm, level ground-line and consistent perspective are characteristics of Ming period works done in the Ma-Xia manner, as opposed to earlier variations of this theme of a river journey.[5]

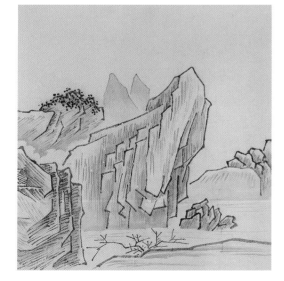

1 A translation of this story is published in Tan Shilin, *The Complete Works of Tao Yuanming* (Hong Kong: Joint Publishing Co. Ltd, 1992), 96–98.

2 For other works by Fuyō, see two landscape fans in Yoshizawa Chū, *Nihon no Nanga, Suiboku bijutsu taikei*, vol. 16 (Tokyo: Kōronsha, 1976) 94; a hanging scroll in *Kokka* 505 (October 1933), and an album of landscapes reproduced in *Kokka* 905 (August 1967), most of which are done in the style of Tang Yin (1470–1524).

3 Xia Gui's *Streams and Mountains, Pure and Remote* in the National Palace Museum, Taipei, and an anonymous Ming period handscroll of c. 1411 known as *Landscape: View of High Mountains with Tall Pine Trees along a River* in the Freer Gallery of Art, both have this feature. They are published in Tokyo National Museum and Kyoto National Museum, *Sesshū: Botsugo gohyakunen tokubetsuten* (*Sesshū, Master of Ink and Brush: 500th Anniversary Exhibition*) (Tokyo: Mainichi shinbunsha, 2002), 298–9.

4 Sesshū's handscroll of *Landscape in the Four Seasons* (*Long landscape scroll*) in the Mori collection is his most famous essay in the Ma-Xia manner, reproduced in ibid., 115. Sesshū may have based the landscapes with labelled landmarks on contemporary Chinese models. See his *Scenic Views of China* handscroll, ibid., 72–3.

5 In addition to the Freer handscroll, other Ming versions include Dai Jin's (1388–1462) *Pure and Remote Views of Streams and Mountains* in Guangzhou City Art Museum and *River Landscape*, an anonymous work of the sixteenth century in the Metropolitan Museum of Art.

2

Kinei Chikudō 紀寧竹堂

D. 1825

Viewing a Waterfall

Works by this artist are rare, and among them, his paintings are virtually unknown. Kinei Chikudō (not to be confused with Kishi Chikudō) is best known for his album of prints in the British Museum entitled *Chikudō gafu*, published in Kyoto in 1800 and 1815, one of the greatest achievements of the illustrated printed book form in Japan.[1] The image in the Ashmolean's collection is of a subject that was Chikudō's speciality, figures in a landscape done in the literati style. He was from Kyoto, and is listed in contemporary artist compendiums such as the *Gajōyōryaku* (1831) as a pupil of Murakami Tōshū (fl. c. 1800).[2]

In the painting, a scholar sits on a rocky plateau leaning on his arm extended behind him as he gazes up at a waterfall in the crevice between two towering mountains. Below him, two figures seen only from the shoulders up stand behind a cart. The season is early autumn as the trees display their full foliage, some of which is beginning to turn red. The artist has clearly taken his inspiration for the image from the famous Tang Chinese verse entitled 'A Mountain Excursion', by Du Mu (803–852), which is inscribed in part above by Tōjō Itsudō (1778–1857), a scholar from Kazusa:

停車坐愛楓林晚　　I stop the carriage and sit [awhile]
霜葉紅於二月花　　to enjoy the maple wood at dusk,
　　　　　　　　　The frost-touched leaves are more brightly red
　　　　　　　　　than the second month's flowers.[3]

Viewing a Waterfall and the *Chikudō gafu* are consistent in style, though one is a painting and the other prints. Mountain forms are rendered with broken, gently curving outlines. The ink washes which delineate the rocky crevices are in turn covered with few texture strokes. The figures have wide noses and dots for eyes, always with a quietly contented expression. Scholars, sages and labourers are all treated in the same manner. Chikudō's style of Nanga is soft and soothing with no angles or jarring colours; this evokes a sense of calm and tranquillity.

Hanging scroll
Ink and colour on silk
Signature: *Chikudō Kinei*
Seals: *Chikudō; Kinei*
97.79 × 32.38 cm
1966.123

Purchased with the aid of grants from the Higher Studies Fund and the Victoria and Albert Museum Fund, also with donations from the friends of P. C. Swann

1 See Jack Hillier, *The Art of the Japanese Book*, vol. 2 (London : Published for Sotheby's Publications by Philip Wilson Publishers, 1987), 621–2, 624–5.

2 Hori Chokkaku, *Fusō meigaden* (Tokyo: Tetsugaku shoin, 1899), 883.

3 This is translated in Wen–kai Kung, *Tu Mu (803–842) His Life and Poetry* (San Francisco: Chinese Materials Center Publications, 1990), 26–7.

3

Imei 維明
1730–1808

Plum Blossoms in Snow

FAN PAINTING

INK ON PAPER

SIGNATURE: *Imei*

SEAL: *Imei shujin*

18.2 × 52.1 CM

1966.110

Purchased with the aid of grants from the Higher Studies Fund and the Victoria and Albert Museum Fund, also with donations from the friends of P. C. Swann

Imei was a monk at the famous Shōkokuji temple (Kōgen'in subtemple) in Kyoto, known historically as a breeding ground for ink painters such as Shūbun and Sesshū prior to the Edo period. In the eighteenth century, the painter Itō Jakuchū was a lay Buddhist monk associated with the temple. He became one of the most gifted artists of his time who experimented with a variety of painting styles as well as printing techniques, and kept up his association with the temple throughout his career. Imei met Jakuchū at Shōkokuji and learned his method of painting plum blossoms.[1] The Ashmolean is fortunate to have a fan painting that so clearly expresses the artist's debt to his teacher.

Imei has painted a simple composition of a single branch of plum blossoms that occupies the right side of the fan and extends out to into the blank area on the left. The blossoms and the snow take on the colour of the paper. Imei has carved out their shapes by covering the background with a light ink wash and using lines of darker ink for the areas of the branch or flowers that peek out from underneath the snow. It is a simple yet effective device for picturing a complex image of white snow on a white flower. This manner of painting plum blossoms was made famous by the Chinese Ming dynasty painter Liu Shiru (1517–after 1601), known to artists in Japan.[2] The method of painting in which the colour of the paper is used like a pigment in the composition, while the background is filled with light ink wash was particularly taken up by Imei's teacher Jakuchū in paintings which date from 1790–92.[3]

1 Kimura Shigekazu, 'Gajō yōryaku, kinsei itsujin gashi', *Nihon kaigaron taisei*, vol. 10 (Tokyo: Perikansha, 1998), 58.

2 For Liu Shiru, see Osaka Municipal Art Museum, *Min shin no bijutsu, Chūgoku bijutsu* 5 (Tokyo: Heibonsha, 1982), 67. On the Japanese artist Yamamoto Baiitsu's familiarity with Liu Shiru, see Graham, 160.

3 A landscape painting in Saifukuji, Osaka, as well as a hanging scroll of a rooster and his family in a private collection make up a series of works done around the same time, while Jakuchū was living south of Kyoto, that are his most accomplished essays in this manner. See Kyoto kokuritsu hakubutsukan, ed. *Jakuchū!: Bunkazai hogohō 50-nen kinen jigyō tokubetsu tenrankai, botsugo 200-nen* (Kyoto: Kyoto kokuritsu hakubutsukan, 2000), 258–9, 356–7.

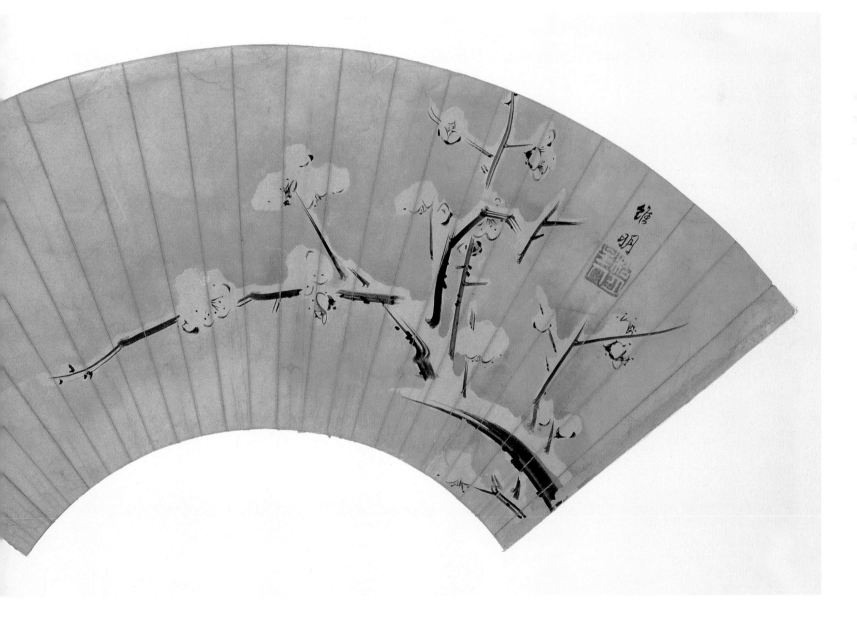

4

Nakabayashi Chikutō 中林竹洞
1776–1853

Riverside Landscape, 1814

Chikutō's signature style of painting rocky cliffs as if they were made up of several cube-like protrusions is unmistakable. The overhanging cliff dominates the entire right side of the small composition, while on the left we are afforded a contrasting view into deep space of a calm river leading up to a distant mountain. This architectonic landscape, while meticulously constructed and somewhat repetitive in its forms, is anything but monotonous. Chikutō uses his characteristic formula to create a highly effective rhythmic composition. The colouring of the landscape is equally beautiful, made up of grey ink used in a variety of values, with black and brown accents.

Born in Nagoya, the son of a doctor, Chikutō came under the patronage of wealthy merchant Kamiya Tenyū (1721–1801), a collector of Chinese paintings. Throughout his life, Chikutō maintained that copying the Chinese masters was the most effective way to learn the art of painting, and because the works of Tang and Song dynasty masters were not available, studying them through the veneration of later artists or through printed illustrations would have to suffice. He was particularly influenced by the work of Yuan dynasty master Huang Gongwang (1269–1354)[1] via the late Ming artist Lan Ying (1585–c. 1664).[2] Lan Ying's squarish rock structures form the basis of the Chikutō's style in many of his most beloved landscapes. From Mi Fu (1051–1107), Chikutō takes the idea of ink dots, though Chikutō's repetitive use of lateral dots in his work is his own interpretation.

In addition to painting, Chikutō was a great theorist and authored the *Chikutō garon*, among other writings. He studied the categorisation of the Northern and Southern schools of painting, as well as placing Japanese artists into three groups based on their merit in his estimation.

MATTED PAINTING

INK AND COLOUR ON PAPER

SIGNATURE: *Kinoe inu haru (no) hajime (ni) utsusu Nakabayashi Nariaki*
(DONE EARLY SPRING 1814, NAKABAYASHI NARIAKI)

SEAL: *Chikutō*

28.5 × 20.32 CM

1966.98

Purchased with the aid of grants from the Higher Studies Fund and the Victoria and Albert Museum Fund, also with donations from the friends of P. C. Swann

1 In particular, Huang Gongwang's handscroll in the Osaka City Art Museum is very similar in feeling to Chikutō's small composition in the Ashmolean. This is published in Suzuki Kei, *Chūgoku kaiga sōgō zuroku* vol. 3 (Tokyo: Tokyo daigaku shuppankai, 1983), 121.

2 For representative works by Lan Ying, see James Cahill *The Distant Mountains, Chinese Painting of the Late Ming Dynasty, 1570–1655* (New York, Tokyo: Weatherhill, 1982), figs 101, 102.

5

Yamamoto Baiitsu 山本梅逸
1783–1856

Ancient Masters (Shiko), with title by Ōkubo Shibutsu (1767–1837) and colophon by Kashiwagi Jotei (1763–1819)

A remarkable early work by Yamamoto Baiitsu, this album combines the artist's two strengths of landscape and flower painting. It dates to 1815–19, a period that coincides with Baiitsu's first stay in Edo, that would prove an extraordinary boost to his career. The inclusion of a title page and colophon written by the two best-known poets in the capital at the time, Ōkubo Shibutsu and Kashiwagi Jotei respectively, reveals that Baiitsu had already gained quite a reputation for himself. The album's early date among Baiitsu's known works, along with the use of a rare but documented seal on every page, makes it an important work. This album is discussed in detail in an essay at the beginning of this volume. Here, however, I would like to focus on two images not described in the essay, which highlight Baiitsu's unrivalled use of colour.

The album is made up of nine paintings based on common themes seen in Chinese literati painting:

Peony
Orchid and rock
Chrysanthemums and rock
Lilies
Grapes
Monkshood and rock
Landscape with hut
Boat returning to shore
Lotus root, lotus pod, watercress, water caltrop and arrowroot.

Two of the images in the album are monochrome, executed with various shades of black ink. The orchids and rock, as well as the landscape with hut done in the manner of Ni Zan (1301–1374), show that Baiitsu was adept at controlling the tones of ink as demanded in such ink painting subjects that are true tests of an artist's skill. However, it is in the images with colour that Baiitsu's talent and

ACCORDION-FOLDED VOLUME MADE UP OF NINE DOUBLE-PAGE PAINTINGS AND TWO DOUBLE PAGES OF CALLIGRAPHY

INK AND COLOUR ON PAPER

SIGNATURE: *Baiitsu sha* (PAINTED BY BAIITSU) (ON ONE PAGE)

SEAL: *Baiitsu* (ON EACH PAGE)

21.2 × 30.3 CM EACH

1964.89

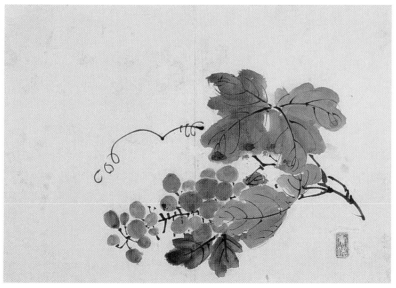

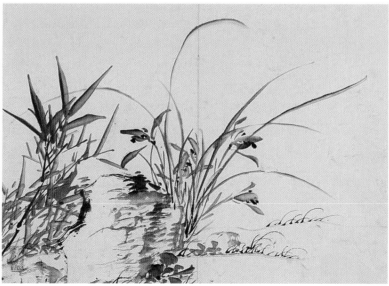

unorthodox methods become clear. For example, in the painting of grapes, each leaf contains several blended pigments ranging from reddish brown to green. This is not the *tarashikomi* technique wherein wet pigments bleed together on the painting surface, but a softer, more graduated blending in which the artist manipulates and mixes the pigments with his brush once they are on the paper, akin to painting with acrylics or oils. The exact same palette of colours is used for the grapes, except they appear just slightly more purplish than the leaves. In the last image containing a lotus root and pods, the colours are a bit more distinguishable from one another, but mixed in unusual combinations. The arrowroot are coloured with indigo pigment with brown highlights while the water caltrops are actually pink and blue. Overall, the combination of several pigments together to describe each form is more successful in this image than in that of the grapes. The album, therefore, is valuable in that we can see the artist has not yet worked out his technique of applying colours that would become the hallmark of his later, brightly coloured decorative bird and flower paintings.

As with the peony and landscape scenes discussed in the essay, the two images mentioned above reappear in Baiitsu's later works. His *Grapes and Praying Mantis* of 1851 in the Ichinomiya City Museum takes a similar model to the painting of grapes in the Ashmolean album, evident in the way the jointed stems are painted as well as a similar configuration of the fruit on the stems. Lotus root, lotus pods, arrowroot and watercress appear again in a hanging scroll of *Fish and Water Plants* of 1847 in the Nagoya City Art Museum.[1]

Baiitsu was born in Nagoya where early on he had access to Chinese paintings and manuals through his association with Kamiya Tenyū, a collector of mostly Ming dynasty works. The Nanga movement based on Chinese literati themes and ideals was in its decline by Baiitsu's time, yet his knowledge of Chinese paintings was far superior to those of previous generations. His study was exhaustive and far-reaching, and he copied works by well-known and rare masters alike, especially during his travels in Kyoto in 1802. The variety of styles exhibited in this album attests to Baiitsu's comprehensive knowledge of Chinese themes and techniques, even at this early stage in his career.

1 Both *Grapes and Praying Mantis* and *Fish and Water Plants* are published in Nagoya City Museum, *Nangaka Yamamoto Baiitsu: karei naru kachō sansui no fūga: tokubetsuten* (Nagoya: Nagoya City Museum, 1998), 19, 46.

6

Yamamoto Baiitsu 山本梅逸
1783–1856

Flowers of Summer and Autumn, 1839

This pair of hanging scrolls shows a side of Baiitsu not seen in the previous entry. *Flowers of Summer and Autumn* is done in Baiitsu's highly complex, decorative style. On the right is an arrangement of flowers of summer including irises, dandelions, lilies, a rose, lotuses and peonies. On the left are many autumn and winter flowers such as pampas grass, monkshood, bush clover, narcissus, hibiscus, chrysanthemums, pinks and morning glories.[1] Such a combination of plants, sometimes more than one variety of each flower, is done for obvious decorative effect and would never be found in nature. Baiitsu renders some of the forms in the *mokkotsu* or boneless method of painting without outlines, while other elements have a thick outline done in grey ink, especially many of the blossoms. The leaves in particular reveal Baiitsu's signature style of painting them twisting in space before coming to a point at the end. Yoshida Toshihide notes that Baiitsu's bird and flower compositions have the strength of line of the Kano school, the *mokkotsu* technique of the Shijō school, and the *tarashikomi* of the Rimpa school, seen here slightly in the brownish leaves of the composition on the left.[2]
 He combines traditional flowers that have been painted for centuries with more recent additions to the Japanese artists' painted garden. The rose, a relatively new subject in Japanese painting, seems to have entered Japan through Nagasaki where painters practised Chinese and Western-style painting. It was a subject particularly favoured by Baiitsu.[3]

Although decorative and no doubt done for a sale or by commission, *Flowers of Summer and Autumn* does retain elements of Baiitsu's more personal Chinese-inspired influences. The chrysanthemums and lilies in particular strongly resemble those in the previous entry, which Baiitsu was familiar with through printed manuals such as *The Mustard Seed Garden Manual* and from copying many actual Chinese paintings. The Ming painter Chen Shun's (1483–1544) works could have provided inspiration for Baiitsu's decorative manner, as they are very similar in composition as well as colouring.[4]

In addition, the previous album and this pair of hanging scrolls are alike in their inventive use of colour. In both, Baiitsu uses mostly vegetable pigments. These

Pair of hanging scrolls

Ink and colour on paper

Signature: right: *Baiitsu sha* (painted by Baiitsu),
left: *Tenpō tsuchinoto-i aki shichigatsu ni utsusu, Baiitsu Ryō* (painted in autumn, the seventh month of 1839, Baiitsu Ryō)

Seal: *Baiitsu*

173.3 × 66.0 cm

1966.115, 116

Purchased with the aid of grants from the Higher Studies Fund and the Victoria and Albert Museum Fund, also with donations from the friends of P. C. Swann

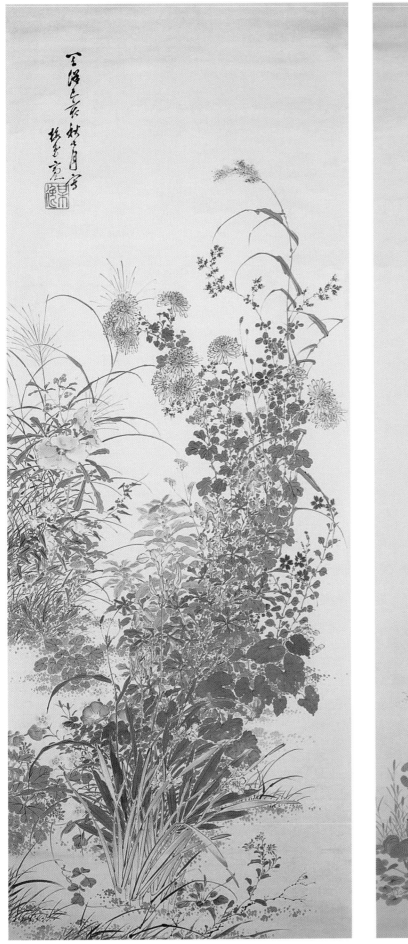
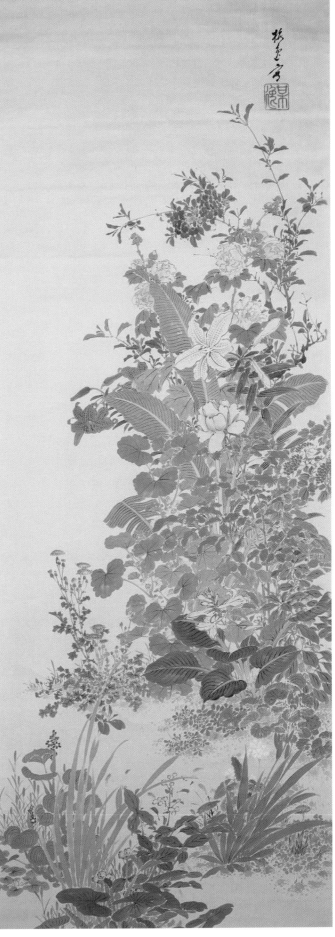

colours can be quite vibrant as in the case of the turquoise blue of the morning glories and the periwinkle blue of the irises. The result is a dazzling image made up of a wide-ranging palette of fresh colours.

In his early fifties, Baiitsu became known as a painter of birds and flowers and produced many similar works for sale or on commission, all of which are complex multi-coloured decorative images. This large-scale production continued until the artist was around seventy years old.[5] Baiitsu's flower and bird compositions are mostly hanging scrolls, though a few screens date to his latter years from 1840 on.[6] It is unclear whether the Ashmolean's pair of hanging scrolls were ever part of a screen. If so, it was not a continuous composition across many panels but an *oshi-e bari* screen wherein each panel has a separate composition pasted onto it.

These scrolls bear the date of 1839, when Baiitsu was living in Kyoto. At this time, he often accepted commissions for bird and flower paintings and would recommend his friend Chikutō instead for landscapes. The large seal reading Baiitsu is unrecorded, although recent discoveries are expanding the number of seals Baiitsu is known to have used throughout his career. It is, however, a larger version of a seal Baiitsu was known to have used at this time. The signature is a type used by the artist in his fifties and sixties, and while not unknown, is less common than his other signature forms.[7] More debate will have to take place before these works can be fitted firmly into Baiitsu's oeuvre.

1 A hanging scroll in the Kyoto National Museum bears the closest resemblance to the Ashmolean's compositions. The *santanka* (madder), tiger lilies and roses of the right-hand composition, and the narcissus and chrysanthemums of the left are here fused into one image. The rendering of the tallest branch of *santanka* in the two works is particularly close. The Kyoto National Museum painting is published in *Kokka* 737, 23, plate 7.

2 Yoshida, 22.

3 Other early examples of paintings with roses in Japan include Jakuchū's *Roses and Small Bird*, one of a set of ten hanging scrolls, Sō Shiseki's *Red Roses and Small Bird* and *Yellow Rose and Birds*, and Shiba Kōkan's *Rose and Cactus*, published in Tokyo National Museum, *Hana: tokubetsuten*, (Tokyo: Tokyo National Museum, 1995), 314–319, 323. Roses take centre stage in Baiitsu's *Roses in a Shower* of 1821 in the Kyoto National Museum, reproduced in *Kokka* 728 (November 1952), plates 1–2.

4 For example, see Chen Shun's *Summer Garden* (c. 1530) in Richard M. Barnhart, *Peach Blossom Spring: Gardens and Flowers in Chinese Paintings* (New York: Metropolitan Museum of Art, 1983), 70.

5 Yoshida, 20–22.

6 Baiitsu's screens of flowers include *Flowers and Birds of Spring and Autumn*, in the Kyoto National Museum and *Birds and Flowers* in the Idemitsu Museum of Art. See Yoshizawa Chū, 'Yamamoto Baiitsu hitsu shunshū kachōzu byōbu', *Kokka* 885 (December 1965), plates 6–7.

page 27 and Yoshizawa Chū, *Nanga sansui, Nihon byōbu-e shūsei* 3 (Tokyo: Kōronsha, 1979), plates 104,5, pages 112–113.

7 This is the so-called 'To' form of Baiitsu's signature, which Yoshida believes the artist used for a period after 1844. Yoshida, 23.

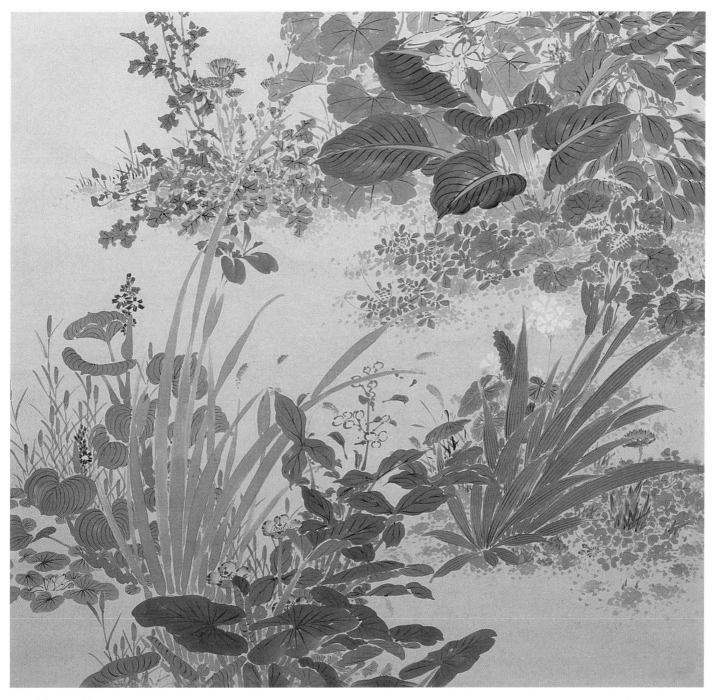

Detail from 1966.115

7

Oda Kaisen 小田海僊
1785–1863

Flowering Plants of the Four Seasons, 1842

HANDSCROLL

INK AND COLOUR ON PAPER

SIGNATURE: *Toki tenpō mizunoe-tora kagetsu Kaisen shirusu* (SUMMER 1842, WRITTEN BY KAISEN)

SEALS: *Nankyo shunsuikō; Ōei no in; Kyokai*

COLOPHON BY THE ARTIST

30.3 × 423.3 CM

1966.132

Purchased with the aid of grants from the Higher Studies Fund and the Victoria and Albert Museum Fund, also with donations from the friends of P. C. Swann

Flowers are sprinkled along the length of this handscroll, depicted either individually or in combination. The seasons progress from summer (pinks, lilies, sunflower) to autumn (hibiscus, chrysanthemum), then winter (peony, narcissus) and finally spring (camellia, plum). The flowers are mostly studies done in black ink, in the vein of literati flower painting, while colour is sparingly applied to the blossoms only in most cases. Each flower is rendered with sketchlike dark outlines in a very loose, free manner. Stems or leaves burst like fireworks, stretching out to fill the space dynamically. The drooping leaves of the narcissus reach out like fingers, and the chrysanthemum blossoms cascade to the left, rhythmically compelling us to unroll the scroll further.

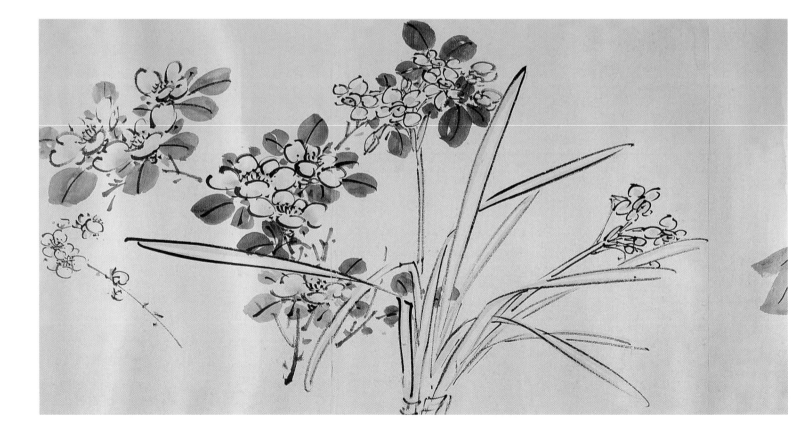

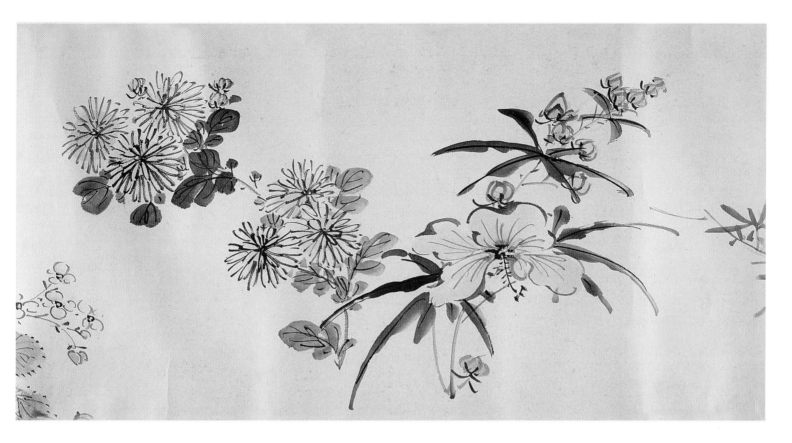

In his colophon to the handscroll, Kaisen mentions two famous painters of birds and flowers of the Five Dynasties period in China, Xu Xi (d. c. 975) and Huang Chuan (903–968). Both had reached legendary status in Japan where many works were wishfully attributed to them. Xu Xi and Huang Chuan were actually rivals who competed to surpass each other in their ability to paint flowers and birds as if they were infused with life. Huang Chuan is credited with innovating the technique of painting without outlines. Kaisen writes that, though he may try, he is unable to reach the level of the Five Dynasties painters in capturing the life-force of the flowers in his works.

Like many artists of his time, Kaisen was fluent in both the Nanga and the Shijō manners. He was from Yamaguchi, was then adopted by a family in Shimonseki, but like many of his time he moved to Kyoto to become a painter and benefit from the many cultural circles and artistic ideas circulating at the time. Kaisen became a student of Matsumura Goshun (1752–1811) and practiced the Shijō style of figure painting at first. Later in life he was heavily influenced by the scholar Rai Sanyō (1780–1832) and painted more in keeping with the Nanga manner, as in this handscroll dated to his later career. The friends travelled together to Nagasaki where, with Sanyō's encouragement, Kaisen studied the paintings of Chinese artists of the Yuan and Ming dynasties. He also became part of a group of artists that included Tanomura Chikuden and Uragami Gyokudō. In 1856, Kaisen participated in decorating the newly rebuilt Imperial Palace, a project that included no Nanga artists apart from himself, a testament to his versatility and high reputation.

8

Tanaka Kaibi 田中介眉
1814–?

Mountain Valley, 1859

FAN PAINTING

INK ON PAPER

SIGNATURE: *Tsuchinoto hitsuji shūgetsu kore wo utsusu, Kyūkyodō shujin kyōshi, Kaibi* (THIS WAS PAINTED IN AUTUMN 1859, FOR THE MASTER OF THE KYŪKYODŌ IN KYOTO, KAIBI)

SEALS: *Kai; Bi*

15.5 × 48.6 CM

1966.102

Purchased with the aid of grants from the Higher Studies Fund and the Victoria and Albert Museum Fund, also with donations from the friends of P. C. Swann

Kaibi has created a sinuous landscape within which a hermitage is ensconced. The busy setting is made up of wavy lines to create the impression that the hills and mountains are flowing in constant movement. This impression of agitation is reinforced by the short texture strokes used throughout. Several trees reach up underneath the peak of the mountain forming a dramatic focal point to the complex scene.

Mountain Valley is indebted to the painting style of I Fukyū, a Chinese artist who spent time in Nagasaki.[1] Kaibi was known to be a great collector of Ming and Qing period Chinese paintings, so he could have owned one of the Chinese painter's works or been versed in his style through one of his teachers.

Tanaka Kaibi was a sake merchant born in Osaka but is recorded as having studied under prominent Nanga artists in Kyoto such as Tanomura Chikuden (1777–1835) and Noro Kaiseki (1747–1828). There he became part of a circle of literati that included the proprietor of the Kyūkyodō stationery and art supply shop, as evidenced by this fan. According to the artist's signature, this image was painted for the head of Kyūkyodō in Kyoto, most likely Kumagai Naoyasu, in the year of his death.

1 *Mount Tiantai* of 1742 by Fukyū shows the same kind of dense, fantastic, ever-moving landscape. This is published in Stephen Addiss, ed., *Japanese Quest for a New Vision: The Impact of Visiting Chinese Painters, 1600–1900: Selections from the Hutchinson Collection at the Spencer Museum of Art* (Lawrence: Spencer Museum of Art, University of Kansas, 1986), 21.

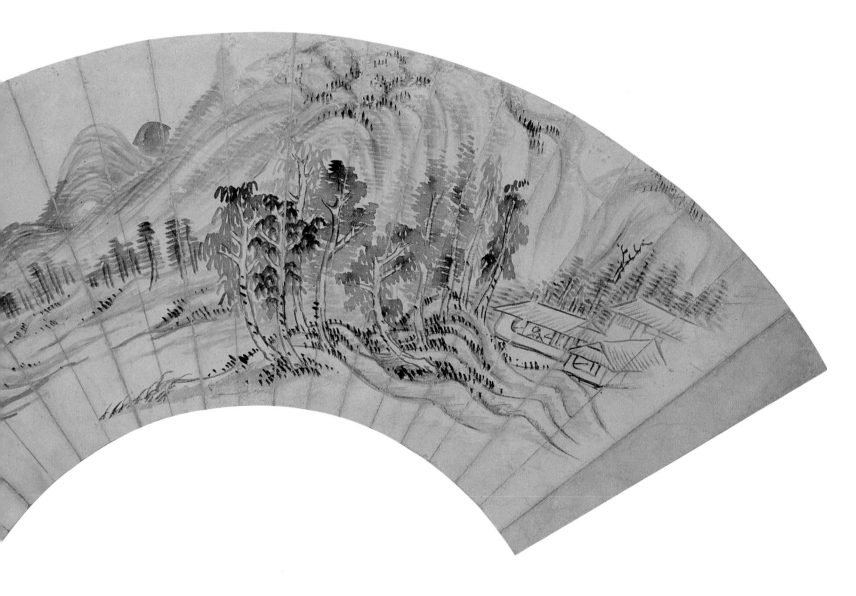

9

Bairi Sanjin 梅里山人

D. 1798

Mountain Landscape, 1791

Bairi Sanjin, whose family name was Terajima, is a little known artist today though he made quite a name for himself as a Nanga painter in his day in Edo. He is listed in both the *Kinsei itsujin gashi*[1] and the *Koga bikō*,[2] two nineteenth century compilations of artist's biographies.

He began a career in the tile business, and later in life increasingly devoted himself to painting. It is his later compositions that reveal the most creativity and masterful handling of the brush. The Ashmolean's painting is one of his few known extant works. It is dated to 1791, just seven years before the artist's death and demonstrates the technical knowledge and confidence he achieved at the high point of his career.

A majestic mountain done in subtle ink tones overpowers the scene in a truly monumental fashion. In the foreground, trees, rocks and river are all painted with a slightly wavy line, giving the sense that nature is indeed alive. Roots of the maple trees look as if they are about to break free from the ground, and the leaves about to blow away in the wind. The pair of trees intertwine, mimicking the closeness of the two friends who sit in conversation underneath. The men are seemingly unaware of the vitality of nature around them while an attendant fans the fire to heat up a pot of tea. However inviting it may be, the landscape is actually a static one that cannot be entered. The course of the water or dirt paths end or start abruptly, and the viewer is given no access to the landscape. Instead, our attention is drawn to the two friends enjoying a pleasant outing.

Bairi Sanjin was an artist working in an area of Edo known as Naka no gō. He was not one to be concerned with worldly affairs, leaving the running of the household and family business to his son and rarely accepting money for his paintings. His style was said to be free, easy and unconventional, though it is clear from the two figures in this work that he was familiar with models in the *Mustard Seed Garden Manual of Painting*. The artist has successfully used his knowledge of these models, however, to create a vibrant and magical landscape.[3]

1 Kimura, 294.

2 Asaoka Okisada, *Zōtei koga bikō* (Kyoto: Shinbunkaku, 1970).

3 Another painting by Bairi Sanjin of a mythical animal known as a *kirin* was in the collection of Umezawa Seiichi. It displays similar brushwork to the painting in the Ashmolean. See Umezawa Seiichi, *Nihon nanga shi* (Tokyo: Tōhō-shoin, 1929), 452.

HANGING SCROLL

INK AND LIGHT COLOUR ON PAPER

SIGNATURE: *Kanoto-i haru ni utsusu* (PAINTED IN THE SPRING OF 1791) *Sue Bairi, Bairi Sanjin*

SEALS: *Sue bō no in*; *Azana chūki*; *Setsu? ga ban*

129.8 × 55.9 CM

1966.117

Purchased with the aid of grants from the Higher Studies Fund and the Victoria and Albert Museum Fund, also with donations from the friends of P. C. Swann

10

Tani Bunchō 谷文晁
1763–1840

Landscape, 1808

Fan painting

Signature: *Tsuchino-e tatsu mōshū koko ni utsusu Shazanrō chū Bunchō* (painted early autumn 1808 by Bunchō in the Shazanrō studio)

Seal: *Shazan*

19.3 × 52.4 cm

x5431

Gift of Dr Michael Harari, from the collection of his father, Ralph Harari

A landscape coloured with soft blue, green and orange is dominated by a tall mountain just right of centre. On either side of the mountain, mist serves to soften the transition into the next vignette. To the right, a temple is nestled among the trees, and on the left a scholar is followed by a servant carrying a *qin* across a bridge that spans an expanse of water. A cluster of trees are rendered in the foreground in front of the mountain, some with lush foliage and others with bare branches, each one distinct. Using a limited palette of colours, as well as the colour of the paper for the mist, Bunchō here is able to describe a variety of textures and solid, three-dimensional forms. He has created an entire world on this one small fan, even the monumental mountain stays well within the bounds of the format.

Tani Bunchō was a cultural force in Edo period Japan as a painter, teacher, surveyor and connoisseur. He was a prolific artist, able to paint equally skilfully in several styles, and is hailed in Japan as the master of eight different methods of painting. He studied both Northern and Southern school Chinese paintings, as well as Tosa school methods and Western style painting, not to mention sketching true landscapes and creatures from life. Bunchō received greatest acclaim as a painter of landscapes, and is credited with bringing the Nanga style to Edo. While young, Bunchō studied with Katō Bunrei (1706–1782), a Kano school artist, before turning to Southern and Northern style Chinese painting with Nakayama Kōyō (1717–1780) and flower and bird painting in the Chinese manner under Watanabe Gentai (1749–1822), an artist from Nagasaki. But perhaps the person who had the greatest influence on Bunchō was Matsudaira Sadanobu (1758–1829),[1] the shogun's regent. In 1792, Bunchō came into his employ,[2] and was ordered to embark on making sketches of Chinese paintings and other antiquities throughout Japan, many of which were hidden from the public, resulting in the publication of *Shūko jusshū* (*Ten Varieties of Collected Antiquities*) in 1800.

The atelier Bunchō ran at the peak of his career was filled with students and admirers. He is said to have begun the vogue for calligraphy and painting meetings in Edo when he and his students met to discuss their work. Bunchō's careful teaching methods had distinct steps: he would begin by having a pupil copy works

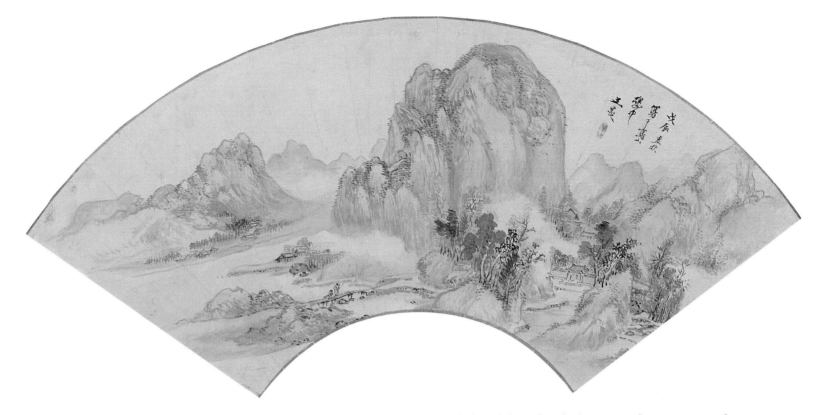

by Chinese masters, then have them sketch from life, and only then were they encouraged to develop their own style.[3]

It was with Watanabe Gentai that Bunchō began to be exposed to original Chinese paintings. Gentai owned twelve paintings by late Ming artist Lan Ying (1585–c. 1648), which Bunchō copied. During his lifetime, Bunchō produced many landscape paintings based on the composition of a foreground cluster of trees backed by a tall mountain, which is an interpretation of works by artists such as Lan Ying and Dai Jing'an, as seen here.[4] Many of his hanging scroll compositions have a dominant verticality that the format allows, but here Bunchō has adapted that to a fan composition. Compared to later works, this image is carefully and slowly rendered, less dynamic than the 'karasu' Bunchō style he would embark on shortly after this image, but beautifully fabricated. The soft colours here are characteristic of those favoured by Bunchō at this point in his career.[5]

1 On Sadanobu's activities, see Timon Screech, *The Shogun's Painted Culture: Fear and Creativity in the Japanese States 1760–1829* (London: Reaktion, 2000).

2 This relationship may have developed because Sadanobu was a member of the Tayasu family for whom Bunchō's father was a retainer.

3 See Kōno Motoaki, 'Kyōikusha to shite no Bunchō', in Tochigi Prefectural Museum of Fine Art, *Shazanrō Tani Bunchō* (Tochigi: Tochigi Prefectural Museum of Fine Art, 1979)and Frank Chance 'In the Studio of Painting Study: The Transmission Practices of Tani Bunchō', in Brenda G. Jordan and Victoria Weston (eds), *Copying the Master and Stealing his Secrets* (Honolulu: University of Hawai'i Press, 2003), 60–85.

4 On the influence of Lan Ying on Bunchō, see Kōno Motoaki, 'Bunchō and Lan Ying', *Yamato Bunka* 105 (May 2001), 1–10. For Dai Jing'an see Khan Trinh, 'In Pursuit of Ancient Styles: Tani Bunchō's Viewing the Waterfall, After Dai Jing'an', *Orientations* (Oct. 2000), 90–95.

5 For another example of a painting from this period with this colouring, see Kōno Motoaki, *Tani Bunchō, Nihon no bijutsu* no. 257 (Tokyo: Shibundō, 1987), plate 15.

11

Tani Bunchō 谷文晁
1763–1840

Butterflies

FAN PAINTING

INK, COLOUR, GOLD AND SILVER
ON PAPER

SIGNATURE: *Bunchō*

SEALS: *Tani uji Bunchō; Tani uji Bunchō*

20.9 × 53.0 CM

X5387

Gift of Dr Michael Harari, from the collection of his father, Ralph Harari

The Ashmolean's two Bunchō fans could not be more different in terms of style. The previous one is the artist's transformation of Chinese landscape models, while this fan of butterflies takes its cue from sketches of insects. Though based on nature, the butterflies are not painted as scientific specimens. Each seems to have its own personality in the way its wings or antennae bend. Bunchō has painted a host of characters, from the most delicate and small light pink butterfly to the most intimidating green-striped one. There is a bit of the artist's own fantasy added here, evident in the architectonic markings on the butterflies wings, some in colours that do not occur in nature. Less natural still is the shining gold and silver background against which the insects with their matted colours stand out. Great care has been taken in the butterflies' markings and colourings by painting several layers of pigment to get just the right effect. The lines of the feet and bodies are done with delicate calligraphic grace, the same touch as the artist's signature.

Many artists of the period, beginning with Maruyama Ōkyo (1733–1795)[1] produced studies of butterflies, such as Masuyama Sessai (1754–1819)[2] and Shibata Zeshin (1807–1891).[3] The general atmosphere of objective, scientific study of the natural world that grew out of Neo-Confucian philosophy was spearheaded by those daimyo with access to Western and Chinese books on botany and herbal medicine. Bunchō himself produced sketches of fish, cats and birds,[4] and the printed book *Shazanrō gahon* has illustrations of insects.[5] Bunchō began to experiment with Maruyama and Shijō school techniques when fellow-artist Watanabe Nangaku (1767–1813) came to Edo for three years in about 1808, and possibly entered Bunchō's studio.[6] Bunchō's signature on *Butterflies* most closely resembles those on works done between 1808 and 1812.

Our image of Bunchō is probably very different from how he was viewed by his contemporaries since we must rely on his extant works. *Butterflies* gives us insight into a type of painting Bunchō was known to have done, but with few remaining examples.

1 These are in the Tokyo National Museum and published in Yamakawa Takeshi, *Nanga to shaseiga, Genshoku nihon no bijutsu* vol. 18 (Tokyo: Shōgakkan, 1969), fig. 114.

2 Also in the Tokyo National Museum and published in Hosono Masanobu, *Kindai kaiga no reimei: Bunchō Kazan to Yōfūga, Nihon bijutsu zenshū* vol. 25 (Tokyo: Gakushū kenkyūsha, 1979), plates 103–4 and Yoshiaki Shimizu, ed., *Japan : the Shaping of Daimyo Culture 1185–1868* (London: Thames and Hudson, 1989), fig. 138 and page 219.

3 This is in the collection of Tokyo National University of Fine Art and Music, published in Itabashi Art Museum, *Shibata Zeshin ten: bakumatsu meiji no seika kaiga to shikkō no sekai* (Tokyo: Itabashi Art Museum, 1980), fig. 39.

4 Bunchō's sketchbook *Gagaku saikaganzukō* is published in Hosono, 220.

5 A copy of this book is in the British Museum.

6 Hosono, 144.

12

Takaku (Takahisa) Aigai 高久靄崖
1796–1843

Summary Mountains, c. 1830–43

MATTED PAINTING

INK AND COLOUR ON PAPER

SIGNATURE: *Kazan koko ni utsusu, Sorin Gaishi Chō* (SUMMER MOUNTAINS ARE PAINTED HERE, SORIN GAISHI CHŌ)

SEAL: *Aigai*

23.8 × 40.7 CM

1966.112

Aigai produced this loosely rendered landscape by holding the brush horizontally and overlaying the ink 'dots' in progressively darker tonalities. This technique was known as 'Mi dots' after the Song period Chinese artist and calligrapher Mi Fu (1052–1107), and became a standard way of depicting a summer mountain scene in nineteenth-century Japan. Here the artist has rendered two distant mountain peaks, as well as a cluster of trees in the foreground behind which appears a pair of modest huts.

Takaku Aigai was originally from Shimotsuke province (Tochigi), however he went to Edo to practice his trade where he came to the attention of Tani Bunchō. His skill was such that among all of Bunchō's disciples, whose numbers were considerable, Aigai was considered one of the two the most talented (the other was Watanabe Kazan). Before reaching that stage, however, Aigai was unsuccessful at gaining any notoriety and spent much time travelling and sketching landscapes. On his travels, he copied many paintings in temples and shrines to expand his large repertoire of techniques.

Another painting of summer mountains by Aigai done in the Mi style is hailed as one of the pre-eminent Japanese works in this manner.[1] It is signed *Sorin gaishi*, as is the Ashmolean image, and dated 1836. The two compositions have much in common such as the same lush trees in the foreground, and the use of empty space throughout to indicate mist. As opposed to his teacher Bunchō's many paintings of summer mountains in the Mi Fu manner,[2] Aigai uses just enough wash to produce a soft effect while keeping each brushstroke distinct.

1 *Kokka* 583 (June 1939), plate 5 and page 187.

2 Three are reproduced in Kōno, *Tani Bunchō*, 57–60.

Purchased with the aid of grants from the Higher Studies Fund and the Victoria and Albert Museum Fund, also with donations from the friends of P. C. Swann

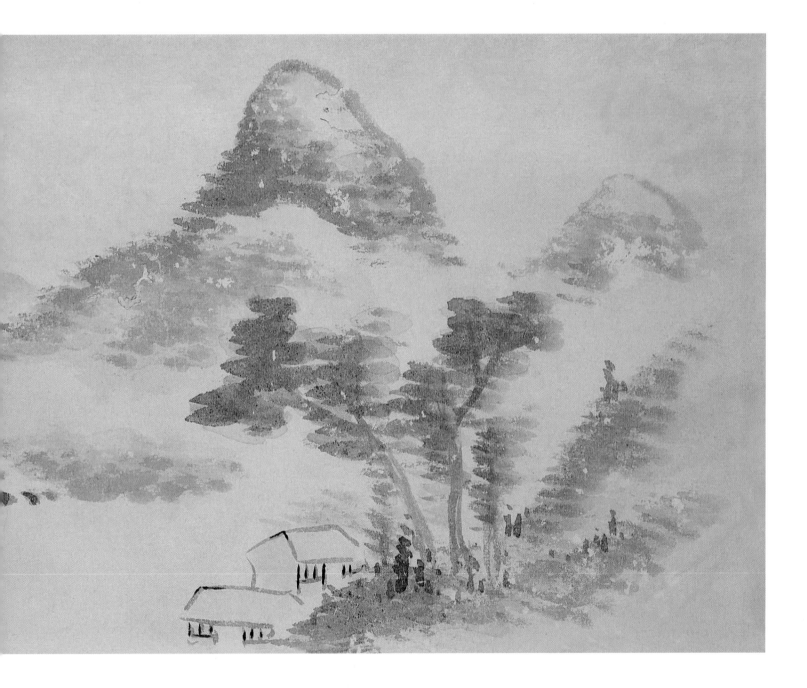

13

Kumashiro Yūhi 熊代熊斐
1713–1772

Mynah Birds on a Willow Tree

In this dynamic composition, Yūhi proves that he is the master of this subject matter that he has painted time and again. Two groups of mynah birds (*hahachō*), many with their mouths open in a cry, appear to be fighting over something. In the lower right, one bird even has the beak of another in its claw. Leaves fall off the tree as the birds thrash about.

The accomplishment of a painter like Yūhi is especially evident in the way the movement of the birds is expressed. Our eye moves from the quarrel in the upper left to the birds in the lower right. We see them from all possible angles; one seen from underneath is the most dramatic, but the heads and bodies of all of the birds twist and turn easily in space. For the feathers, a grey wash has been put down first, with a darker black painted on top of it. The branch of the willow tree has been done with a dry brush in grey tones, the darkest tone of ink being reserved for the birds.

The subject of mynah birds is also taken up by Yūhi as one panel of a pair of six-fold screens that the artist painted for the eighth head of the Owari domain, Tokugawa Munekatsu (1705–1761), in 1753 or 1754.[1] Another painting of mynah birds on a plum tree with the same seals as the Ashmolean's painting also shows one bird with its beak held by the claw of another.[2] This seems to have been a favourite pose of the artist.

Yūhi was a native of Nagasaki and was born into a family of Chinese language translators. Thus, when the painter Shen Nanpin sojourned in Nagasaki for two years beginning in 1731, it was natural that Yūhi met him, and became his only known Japanese pupil. It is through Yūhi that the Shen Nanpin style of realistic flower and bird painting spread, a style that claimed a great number of adherents in eighteenth- and nineteenth-century Japan including Sō Shiseki, Masuyama Sessai and others.

Hanging scroll

Ink on paper

Signature: *Shūkō Yūhi sha* (painted by Shūkō Yūhi)

Seals: *Shūkō; Yūhi no in*

130.5 × 28.0 cm

1966.4

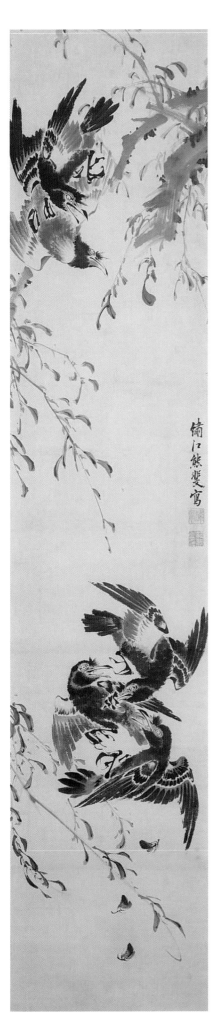

1 This is published in Chiba City Art Museum, *Edo no ikoku shumi: nanpinfū dairyūkō: shinseiki, shisei shikō 80-shūnen kinen* (Chiba: Chiba City Art Museum, 2001), 52–3, 174–5.

2 See Narasaki Muneshige, 'Kumashiro Yūhi hitsu getsubai hakka zu', *Kokka* 708 (March 1951), plate 5 and pages 126–31. For the same subject painted by Shen Nanpin see Tottori Prefectural Museum, *Tokubetsuten-Tottori gadan no genryū o saguru: Shiseki, Ōkyo to Hijikata Tōreiten* (Tottori: Tottori Prefectural Museum, 1997), 45.

14

Sō Shiseki 宋紫石
1715–1786

Crab and Tree Branch

莫咲蹣跚難獨行
溪河也足養斯生

Don't laugh at me walking alone with a
limping gait,
the river water is enough to sustain my life.[1]

All elements in the inscription above by Kyoto monk Daiten are reflected in Shiseki's painting. In this very sparse composition, a solitary crab ambles towards a tree branch. The crab is painted in the centre of an otherwise blank area, emphasising its isolation. Its legs look twisted, as if it is struggling to get a foothold on the shore.

The inscriber Daiten was one of the best-known scholars of Chinese studies of his time. He had studied Chinese poetry and literature from early on and continued as abbot of a subtemple of the Shōkokuji monastery. This Zen monastery, one of the five most important in Kyoto, known as the Gozan (Five Mountains), was a centre for cultural leaders in literature and the arts. In 1779, Daiten became chief abbot of the monastery. He was therefore well placed in the Kyoto cultural scene and associated with prominent scholars, tea aesthetes, and painters of his day, most notably the talented independent painter Itō Jakuchū on whose paintings many of Daiten's inscriptions can be found.[2]

Shiseki was an enormously influential artist who is credited with bringing the Shen Nanpin style to Edo. He was from the capital and traveled to Nagasaki to study the polychrome method of bird and flower painting practised by many Chinese artists resident there. This style became known as the Shen Nanpin school, after the Chinese artist who spent two years in Nagasaki, leaving behind his pupil Kumashiro Yūhi. Yūhi is recorded as one of Shiseki's teachers, along with Sō Shigan (Ch: Song Ziyan). However, debate continues as to whether Shiseki ever actually studied with Shigan, whose surname he took for his own, or simply adopted the name to add to his prestige and trump his rivals.[3]

On his way back to Edo, it is believed that Shiseki sojourned in Kyoto and taught a few pupils. Though it is possible that Shiseki visited Daiten at Shōkokuji at this time, resulting in *Crab and Tree Branch*, it is more likely that the painting can be

Hanging scroll

Ink on paper

Signature: *Sō Shiseki*

Seals: *Sō Shiseki; Katei; Nanrei sairyūhō*

Inscription: Daiten Baisō Kenjō (1720–1801)

110.8 × 34.6 cm

1966.147

Purchased with the aid of grants from the Higher Studies Fund and the Victoria and Albert Museum Fund, also with donations from the friends of P. C. Swann

dated to a few years later as it has the same seals and general signature style as those on a painting dated to 1764.[4] Perhaps Daiten visited Shiseki in Edo or was sent the painting to inscribe.

Shiseki's ink paintings are less common than his bird and flower compositions, but they do exist. He is known as a painter of ink bamboo, and a hanging scroll of a toad done in ink in the British Museum uses a very rough, abbreviated style close to that of the Ashmolean painting.[5] Though a monochrome ink painting, *Crab and Tree Branch* does bear the same compositional treatment found in many of Shiseki's bird and flower paintings, such as the generous use of blank areas and the flow of the composition from lower right to upper left.[6]

The Ashmolean's painting is important as it stands as evidence of Shiseki's links with the Kyoto cultural elite, and is an example of his loose ink-play style.

1 I am indebted to Dr Cary Liu of The Art Museum, Princeton University for this translation.

2 A famous collaboration by Daiten and Jakuchū is the handscroll *On A Riverboat Journey* that documents a boat trip the pair took together on the Yodo River. For a detailed commentary on this scroll, see Itō Jakuchū, *On a Riverboat Journey: A Handscroll by Itō Jakuchū with Poems by Daiten; Introductory Essay and Translation of the Poems by Hiroshi Onishi* (New York: G. Brazillier, 1989).

3 Yasumura Toshinobu, 'Sō Shiseki during the Hōreki Era (1751–64)', *Kokka* 1122 (1989), 40, 43.

4 *Parakeet on a White Plum Branch*, reproduced in Tsuruda Takeyoshi, *Sō Shiseki to Nanpinha, Nihon no bijutsu* vol. 326 (Tokyo: Shibundō, 1993), fig. 16. Incidentally, 1764 is the same year that Jakuchū painted an ink composition of a crab, prompting one to think that there is a link to a specific Chinese painting model or occasion. For Jakuchū's crab painting, see Kyoto kokuritsu hakabutsukan *Jakuchu!*, 219, 348.

5 Many of Shiseki's other ink painting compositions are illustrated in the printed *Sō Shiseki gafu*, a copy of which is in the British Museum.

6 Yasumura, 44.

15

Hirowatari Gi 広渡儀 (Ganhi 巖斐)

D. 1784

Frogfish (ankō) and Spring Onion

FAN PAINTING

INK AND COLOUR ON PAPER

SIGNATURE: *Kō Ganhi*

SEAL: *Gi*

19.3 × 51.1 CM

1973.66

Purchased with the aid of the Friends of the Ashmolean and Mr and Mrs J. Hillier

Little is known of the artist Ganhi (Hirowatari Gi or Koshū). In the *Koga bikō* he is mentioned as a pupil of Kumashiro Yūhi from whom he takes the character 'hi' in his name.[1] Thus he was part of the Chinese artist Shen Nanpin's legacy which thrived in Nagasaki in the eighteenth century. Beginning with Hirowatari Ikko (1644–1702) who was to gain the most prominence among them, a few generations of artists in Nagasaki carried the surname Hirowatari. According to records in the Chōshōji temple, Ganhi and his ancestors held the local post of Chinese paintings connoisseur (*kara-e mekiki*).[2]

This delightful fan painting rendered in sparse colours focuses on the satirical appearance of this rather odd subject matter. The *ankō*, also known as the frogfish for obvious reasons, totters clumsily, bulbous stomach-side up, awaiting his fate. This unusual-looking fish is actually a delicacy in Japan. Here it is paired with a spring onion, no doubt both are soon to be ingredients in a special, celebratory dish.

The Nagasaki school's founder, Shen Nanpin, stayed in Japan for only two years, though his impact on Edo period painting throughout Japan was profound. He excelled in realistic images of birds, animals and flowers, though the compositions were often highly decorative. The abbreviated description of the fish and infusion of the comic into this painting are not characteristic of the stylistic legacy Ganhi inherited.

1 Asaoka, *Zotei koga bikō*, 2177.

2 *Chōshōji kakochō*, included in Kyoto National Museum, *Nagasaki-ha Shasei Nanshū meiga sen* (Kyoto: Benridō, 1939), 116–7.

16

Masuyama Sessai 増山雪斎
1755–1820

A Scholar's Retreat, 1808

Fan painting

Ink and colour on paper

Signature: *Tsuchinoe tatsu shuka, Tenten-ō Sessai sha* (beginning of summer 1808, Tenten-ō Sessai)

Seals: *Masu uji; Sessai; Gojin*

19.8 × 51.1 cm

x5436

Gift of Dr Michael Harari, from the collection of his father, Ralph Harari

Alone figure of a scholar carrying a long staff is dwarfed by the large red gate through which he enters. The retreat is set on an outcropping of rock, and is truly isolated amidst an impossible landscape. Two high craggy peaks, ominous and unstable, tower either side of a waterfall that exists in a seemingly unlikely location. In contrast to the unsettling shapes, soothing pastel tones have been lightly applied to colour the scene.

Sessai was daimyo of Nagashima domain, part of present-day Mie prefecture. He became a member of the literati circles as an artist and a poet, especially knowledgeable about Chinese paintings of the Ming and Qing dynasties and Chinese culture in general. He was a particularly close associate of Kimura Kenkadō (1736–1802), the Osaka patron, as well as the painters Sō Shiseki and Watanabe Gentai. Sessai is primarily regarded as a painter of the Shen Nanpin or Nagasaki school due to his many images of semi-formal flower and bird paintings.[1] He seems to have had a dual personality when it came to painting, however, sometimes following this brightly coloured style of flower and bird painting, while at the same time creating serene images that show a subtle handling of colour, as in this fan. In addition, the Ashmolean fan stands out among known works by Sessai in that it is an idealised, fantastic landscape, whose purpose is not the same striving for realism that we see in his more common compositions of fish, birds, flowers or insects, which are based on the careful observation of nature.

1 For example, *Peacock* in the Nagoya City Art Museum.

17

Kinoshita Itsuun 木下逸雲
1799–1866

Trees and Rocks, 1862

FAN PAINTING

INK ON MICA-COATED PAPER

SIGNATURE: *Mizunoe tatsu chūshun Shin Sekiten no gahō ni narau Itsuun* (MID-SPRING 1862, COPYING THE STYLE OF CHEN ZHOU, ITSUUN)

SEAL: *Itsuun*

17.6 × 54.0 CM

1966.101

Purchased with the aid of grants from the Higher Studies Fund and the Victoria and Albert Museum Fund, also with donations from the friends of P. C. Swann

As a native of Nagasaki, Itsuun had contact with the long-established community of Chinese painters in the area. Beginning with early arrivals such as Shen Nanpin, Chinese artists exerted a strong influence on the Japanese painters who studied with them. We know that Itsuun studied Shen Nanpin's method of bird and flower painting with Ishizaki Yūshi (1768–1846), a painter in the Western and Chinese manners, and Jiang Jiapu (1744–after 1839),[1] a native of China who visited Japan often on business. In addition to his teachers, Itsuun followed the style of many artists by copying their paintings and making their methods his own. He reached such fame that he was known as one of the three great masters of Nagasaki (along with Hidaka Tetsuō and Miura Gomon). Painting was only one of Itsuun's many talents, however, which included Chinese and Japanese poetry, music and seal carving. He died tragically in a boat accident on his way back to Nagasaki from Edo. Of the copious number of paintings by him known to have existed, very few remain extant.

Here Itsuun has painted rocks and brambles, where the foliage is done with short strokes and the rocks are articulated with longer, wavy lines. The lean of the rock at the left is mimicked by the central tree's branches, both of which take one's eye across to Itsuun's signature.

Trees and Rocks dates to Itsuun's last years. The Ashmolean fan was painted the same year and month as a landscape in a private collection,[2] and both are done in the manner of the Ming dynasty painter Chen Zhou (1427–1509), according to the artist's inscription. From the earlier artist, Itsuun has taken the method of depicting foliage on top of high peaks with dot-like strokes and the bare branches of a tree that has lost most of its leaves, both of which are similar in Itsuun's two compositions.[3] Even at this late stage in his career, the similarity to his teacher Jian Jiapu's style is easily recognisable.[4]

1 *Landscape in the style of Huang Gongwang* in *Kokka* 939 (1971).

2 *Kokka* 502 (Sept. 1932), plate 7 and page 264.

3 For example, see *Landscape for Liu Jue*, in Cahill, *Parting at the Shore*, fig. 31.

4 For works by Jiang Jiapu, see Addiss, 73 and *Kokka* 939 (1971), plate 7.

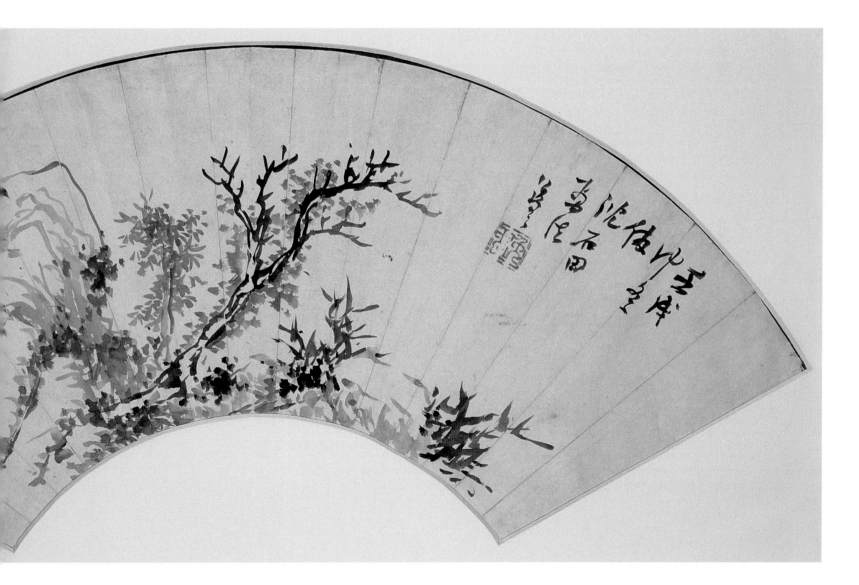

18

Ono Unpō 小野雲鵬
1796–1856

Mountain Landscape

Asolitary figure sits on the railing of a bridge gazing at the mountainside. He appears to be an ordinary Japanese man (not a Chinese literatus with attendants) who went to the scene quite deliberately. Neither is he a traveller, for he has no bags, walking stick nor hat with him and does not seem to be on his way to gather wood, or to the market. This leaves one to speculate whether the painting is a self-portrait, or a portrait of a friend done by the artist to commemorate a specific place.

In contrast to the peaceful gaze of the figure is the landscape, which appears to encroach upon him. Broken and quivering brushstrokes are used throughout the image, whether for rock faces or tree branches. The mountains in the middle-ground lean in towards the centre and huddle around the figure. What is more, the mountains in the distance have just as much detail in parts as those in the fore-ground, resulting in a rather complex, flattened landscape.

The artist, Ono Unpō, was a follower of Shibata Gitō (1780–1819), and a native of Nagao in Bitchū province (present-day Okayama). He used the name of Shōun in Kyoto,[1] but signed his works 'Unpo' after returning to his hometown. He was no doubt part of the same family as Ono Senzō, a farmer and student of Confucianism and Chinese poetry, and a patron of the the famous scholar and poet Rai Sanyō (1780–1832).[2] Unpō often used the seal reading 'ki 機', and should not be confused with Kameda Unpō (1857–?) or Ōoka Unpō (1764–1848).

HANGING SCROLL

INK AND LIGHT COLOUR ON PAPER

SIGNATURE: *Unpō Ono ga* (PAINTING BY UNPŌ ONO)

SEAL: *Unpō*

125.7 × 53.3 CM

1966.149

Purchased with the aid of grants from the Higher Studies Fund and the Victoria and Albert Museum Fund, also with donations from the friends of P.C. Swann

1 A work by this artist done during his time in Kyoto is published in the Museum of Kyoto, *Miyako no eshi wa hyakka ryoran, Heian jinbutsu shi ni miru Edo jidai no Kyoto gadan* (*The Blooming of Hundreds of Flowers: Painters of Edo Period Kyoto in the Heian-jimbutsu-shi*) (Kyoto: The Museum of Kyoto, 1998) 141.

2 For the Ono family of farmer-patrons, see Yoko Woodson, 'Traveling Bunjin Painters and Their Patrons: Economic Life, Style and Art of Rai Sanyō and Tanomura Chikuden' (Ph.D. thesis, University of California, Berkeley, 1983), 31–2, 110–22.

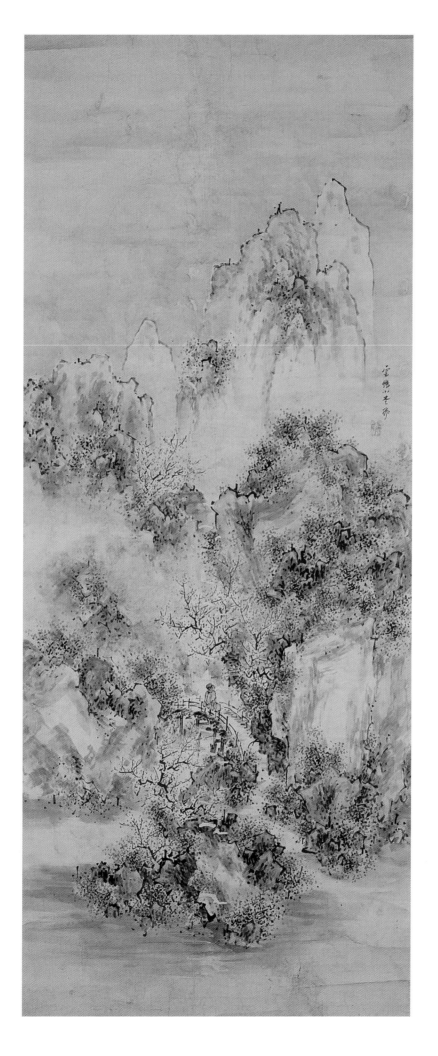

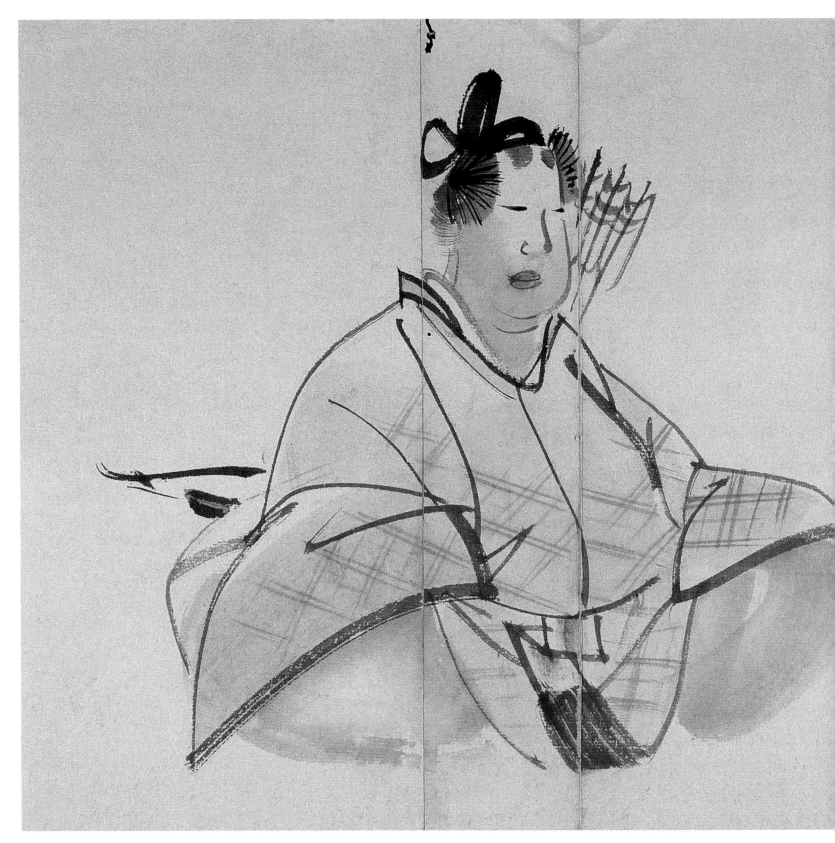

Suzuki Nanrei, *Ariwara no Narihira*, c. 1830, page from Cat. 34 (1973.116).

The Maruyama-Shijō and the *shasei* Schools

The nineteenth century has been termed 'the age of true depiction',[1] or the age of the *shasei* (sketch). *Shasei* based on the direct observation of life, became the basic element in conceiving compositions, and for the first time were used to compose large-scale works such as hanging scrolls, screens and sliding doors. Though not by any means the first to draw actual nature, Maruyama Ōkyo (1733–1795) was a pioneer who used his knowledge of Western perspective and visual realism to construct his paintings. As the founder of the Maruyama school, Ōkyo can effectively be called the father of all four *shasei* schools included in this section: the Maruyama, Mori, Shijō and Kishi schools.

Ōkyo became an apprentice to a Kano workshop in Kyoto at least by his teens. There he learned the school's fusion of Chinese-inspired ink painting and more native *Yamato-e* traditions of the Tosa school. Early works by the artist include *megane-e*, pictures made to be viewed through lenses to give a panoramic view of a certain scene. For many of these works, Ōkyo used a heavily shaded, Western-inspired construct that he saw in Chinese prints from the Suzhou area. These were perhaps his first introductions to depicting Western-style perspective and volumetric realism. The availability of scientific texts on botany and medicine fuelled a trend for objective observation and recording of flora and fauna. Against this background, Ōkyo set about making careful drawings of insects and birds, as in his notebook *Shasei zatsurokujō* (*Album of Various Sketches*)(c. 1771). Included are sketches of creatures he observed in nature, as well as notes on paintings, illustrations or interesting designs he came across. His most well-known book of sketches is the *Konchū shaseichō* (*Album of Sketches of Insects*) (1776). It should be noted that his sketches were not summary depictions of a view or the landscape around him, but detailed studies of various creatures.

No works by Maruyama Ōkyo are featured in this catalogue. However, the second generation of artists of the Maruyama school, made up of the most talented of Ōkyo's pupils, is well represented. After Ōkyo's death, his son Ōzui (Cat. 19) assumed the headship of the family. Maruyama Ōshin (Cat. 21) and Kunii Ōbun (Cat. 22) held the title in turn, and kept the large group of followers in contact and the school's treasure trove of *shasei* intact. Of Ōkyo's direct pupils,

Nagasawa Rosetsu, Oku Bunmei (Cat. 25), Yamaguchi Soken (Cat. 27), and Mori Tetsuzan (Cat. 28) continued to work primarily in Kyoto. Rosetsu, however, left the studio to develop into one of the most individual painters in Japanese art. Rosetsu's *Yama-uba* (Cat. 23) fan painting in the Ashmolean reflects his penchant for the more bizarre figures of Japanese legend. Another of Ōkyo's pupils, Watanabe Nangaku, ventured to Edo where he became a personal ambassador for the new style. His *Beauty and Skull* (Cat. 26) is one of the artist's masterpieces, published here for the first time since 1932. The history of the Mori school of artists is intertwined with that of the Maruyama school. Mori Tetsuzan's uncle, Sosen (1747–1821), its founder, was active in Osaka and famous for his lifelike depictions of monkeys. Though Tetsuzan went to Kyoto to join Ōkyo's studio, many Mori school painters, including Tetsuzan's father Shūhō, were active in Ōsaka and appear in the Ashmolean's *Calligraphy and Painting Album* of 1799–1805 (Cat. 29), a veritable who's who of artists in that city.

The Maruyama school's patrons were the wealthy merchant class in Kyoto as well as the imperial family, and were involved in many of the largest-scale commissions of the day. For example, from 1787 to 1795, Ōkyo and his pupils set about executing a decorative program for Daijōji temple in Hyōgo. Ōkyo, Soken, Rosetsu, and Tetsuzan were all involved in painting sliding doors with legendary subjects as well as birds and animals.[2] Many of the artists involved in that project are represented in the Ashmolean's collection.

Matsumura Goshun, founder of the Shijō school of artists, was a native of Kyoto born into a wealthy family. His father was an official in the mint, and he worked there for a time before leaving to pursue painting. He became the main pupil of Yosa Buson (1716–1783), famed for his *haiga* (*haiku* paintings), with whom he studied Nanga painting and poetry. After a series of family losses in 1781, Buson recommended that Goshun travel to Ikeda in Osaka. This would prove a turning point in his career. Sometime during his time in Ikeda, Goshun began to experiment with the Maruyama manner, and in 1789 he moved to Kyoto, perhaps on the advice of Ōkyo. Though he worked on commissions with Ōkyo, at Daijōji, for example, he continued to be viewed mainly as an independent artist. Among his later works, the Ashmolean's painting of the elderly couple Jo and Uba (Cat. 30) shows Goshun's affinity and sensitivity to poetry. Goshun's style was softer, more lyrical than that of Ōkyo. His new manner spread throughout Kyoto, and beyond, and was known as the Shijō school, after the location of his studio. Subsequent generations of the school remained clustered around Shijō (Fourth avenue): Shibata Gitō (Cat. 31), Yokoyama Seiki (Cat. 32) and Hishida Nittō (Cat. 33). Watanabe Nangaku's pupils, Suzuki Nanrei (Cat. 34)

and Onishi Chinnen (Cat. 35, 36), practised the Shijō manner in Edo. Able to capture the personality of a figure or the character of a flower with an economy of ink and a breathtaking colour sense, they represent the height of the Edo Shijō style.

Hirada Gyokuon, the only female painter featured in this catalogue, received the scholarly training typical of the Nanga school, but her paintings, such as *Obon Festival* (Cat. 37), have more in common with the Maruyama-Shijō school, taking subjects from the world around her.

The last school of the four is the Kishi school founded by Kishi Ganku, the famous painter of tigers from Echizen. Kishi Ganryō was his adopted son, and takes up his father's method of using agitated brushstrokes in his portrait of *Renshōbō* (Cat. 38). Shibata Zeshin (Cat. 39, 40, 41), who combined his knowledge of painting and lacquer both figuratively and literally, and Nakajima Yūsho (Cat. 42) brought the Shijō school into the Meiji period.

Nanga painters such as those featured in the previous section did not, in general, look kindly upon the new style that was flourishing in Kyoto. They believed that although Ōkyo and Goshun's skill at representing realistic elements was truly magnificent, 'their painting is not worth being emulated, or even appreciated'.[3] This was probably a reaction to the style's widespread appeal, for it did not require the study of Chinese theoretical texts or ancient masters, nor the cultivation that they engendered.

1 Sasaki Jōhei uses the term *shinsha no jidai* in the introduction to Minamoto Toyomune and Sasaki Jōhei, eds, *Kyoto gadan no jūkyūseiki*, vol. 2 *Bunka Bunseiki* (Kyoto: Shibunkaku shuppan, 1994), 8.

2 *Kokka* 945 (1972), 'The special number for the studies of the pictures of several painters of the Maruyama-Shijō School that remain at the Daijō-ji Temple'. *Kokka* 945 (1972) and Jōhei Sasaki, 'Maruyama Ōkyo to Daijōji, shinsutsu bunsho o te gakari to shite (Maruyama Ōkyo and the Daijōji, a study based on newly discovered documents'. *Kokka* 1205 (1996), 3–18.

3 Tanomura Chikuden, translated in Wylie, 274 (C: XXIII).

19

Maruyama Ōzui 円山応瑞
1766–1829

Ayu in a Stream and Pinks on the Shore

HANGING SCROLL

INK AND COLOUR ON SILK

SIGNATURE: *Ōzui*

SEAL: *Ōzui*

37.0 × 57.5 CM

1973.156

This image of a school of *ayu* (sweetfish) swimming in the shallow water shows Ōzui's reliance on Maruyama school sketches from life, or *shasei*.[1] Five *ayu* swim under waves painted with a light wash of blue pigment. The pinks in the foreground, by contrast, are done with bright white and pink pigment, and a few flowers are articulated with a very sharp dark outline.

The Ashmolean's painting is very similar in style to Ōzui's pair of six-fold screens of *Birds and Flowers of the Four Seasons* in Daishōji temple, in which a school of *ayu* is seen swimming in a stream beyond the flowers. The addition of small fish to the composition, not a traditional element, shows Ōzui's creativity in incorporating his father's sketches into finished works. In addition, both works share the same controlled brushwork and carefully detailed depictions of flowers.[2]

Maruyama Ōzui was the eldest son of Ōkyo and became head of the school after his father died in 1795. He is known primarily for faithfully continuing the style of his father, and for keeping the school's circle of artists and compositional models assembled. Around the same time as his father's death, other prominent artists of the Maruyama school passed away, such as Komai Genki (1747–1797) and Nagasawa Rosetsu (1754–1799) (who had been expelled from the studio some years before). In this turbulent period in the school's existence, Maruyama school artists would meet once a month at Ōzui's house to show their paintings and discuss them.[3]

1 The pinks of this painting are very similar to an album leaf by Kinoshita Ōju that has been separated from its album in the Yamato Bunkakan entitled *Album of a Gathering held at Daiichirō, Higashiyama* published in Kobayashi Tadashi and Kōno Motoaki, *Ōkyo, Rosetsu, Jakuchū: Maruyama-Shijō ha (Ōkyo, Rosetsu, Jakuchū : Maruyama-Shijō school), Edo meisaku gachō zenshū (Masterpieces of painted albums from the Edo period)*, vol. 7 (Tokyo, Osaka: Shinshindō, 1996), 151. This points to a shared model being used among Ōkyo's followers.

2 Published in Minamoto Toyomune and Sasaki Jōhei, eds, *Kyoto gadan no jūkyūseiki*, vol. 2 *Bunka Bunseiki* (Kyoto: Shibunkaku shuppan, 1994) 22–23.

3 Kimura Shigekazu, *Maruyama-ha nidaime: Ozui*, in ibid., 147.

*Purchased with the aid of the Friends of
the Ashmolean and Mr and Mrs J. Hillier*

20

Kinoshita Ōju 円山応受
1777–1815

Carp

Ōju was Maruyama Ōkyo's second son. He was never to head the Maruyama school himself, that role fell to his older brother Ōshin, so he took the name of Kinoshita and began a branch family.

Ōju's father painted several images of carp, the best known perhaps being a pair of hanging scrolls in Daijōji temple, Hyōgo of 1789 showing a carp ascending a waterfall and one swimming in calmer waters.[1] Several of Ōkyo's drawings of carp remained for his students to use when composing their own paintings. Like his other illustrations of fish, Ōkyo no doubt based these drawings on studies from life. In this image, Ōju has painted a single carp which swims just below the surface in the transparent water. With an economy of brushwork, Ōju succeeds in conveying the palpable volume of the fish in his own essay of one of his school's specialities. Notably, in contrast to many paintings of carp by other artists of the Maruyama school active at this time, Ōju has chosen not to fully describe the fish in crisp detail, but instead has painted a more spontaneous and playful image.

1 This is published in Hyōgo Prefectural Museum of History, *Maruyama Ōkyo ten: botsugo nihyakunen kinen* (Hyōgo: Hyōgo Prefectural Museum of History, 1994), 115.

HANGING SCROLL

INK AND LIGHT COLOUR ON PAPER

SIGNATURE: *Ōju*

SEAL: *Ōju no in*

43.1 × 57.5 CM

1973.144

Purchased with the aid of the Friends of the Ashmolean and Mr and Mrs J. Hillier

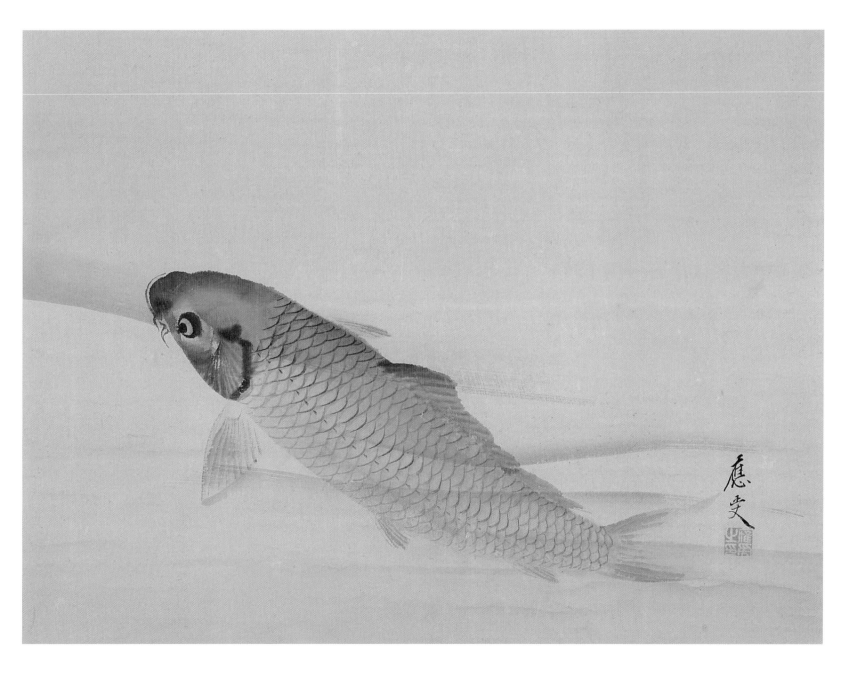

21

Maruyama Ōshin 円山応震
1790–1838

Nabe kaburi shōnin (The pot-wearing saint)

FAN PAINTING

INK AND COLOUR ON PAPER

SIGNATURE: *Ōshin*

SEALS: *Ō*; *Shin*

18.4 × 48.3 CM

1973.92

Purchased with the aid of the Friends of the Ashmolean and Mr and Mrs J. Hillier

Maruyama Ōshin, Ōju's son, became the third generation head of the Maruyama school in Kyoto. Little is known of his biography, but from a handful of works that exist, it is clear that Ōshin continued the Maruyama school style in figures and *kachōga* (bird and flower painting) faithfully. This is most notable on sliding doors painted with *Farming in the Four Seasons* of c. 1830,[1] part of the decorative programme of the main room of the *shoin* (study) of Hōkyōji temple. The figures are rendered with gently sloping lines done with a light touch, appropriate to this composition of cheerfully industrious peasants working the land during times of peace. This same figural style is also used for the tortured saint in the Ashmolean's fan.

In this minimal fan composition, a figure sits trying to remove a kettle from his head. The man is Nisshin (1407–1488), a religious follower of Nichiren (1222–1282). Nichiren founded a sect of Buddhism based on the teachings in the Lotus Sutra alone and began a popular religious movement in which the practitioner need not be trained in the rituals of esoteric Buddhism to achieve salvation. Nisshin's impassioned chanting of *namu-myōhō-renge-kyō* (devotion to the glorious true law of the lotus scriptures) was a challenge to Shogun Ashikaga Yoshinori (1394–1441) to accept the true faith. The shogun imprisoned the religious man and among other torments, had a pot placed over the saint's head in an effort to silence him.

Though Ōshin's religious beliefs are unknown, many artists and their patrons in Kyoto were Nichiren sect adherents, a sect marginalised throughout its history for its opposition to the shogunal authorities.

1 See Minamoto and Sasaki, 26–7, 182.

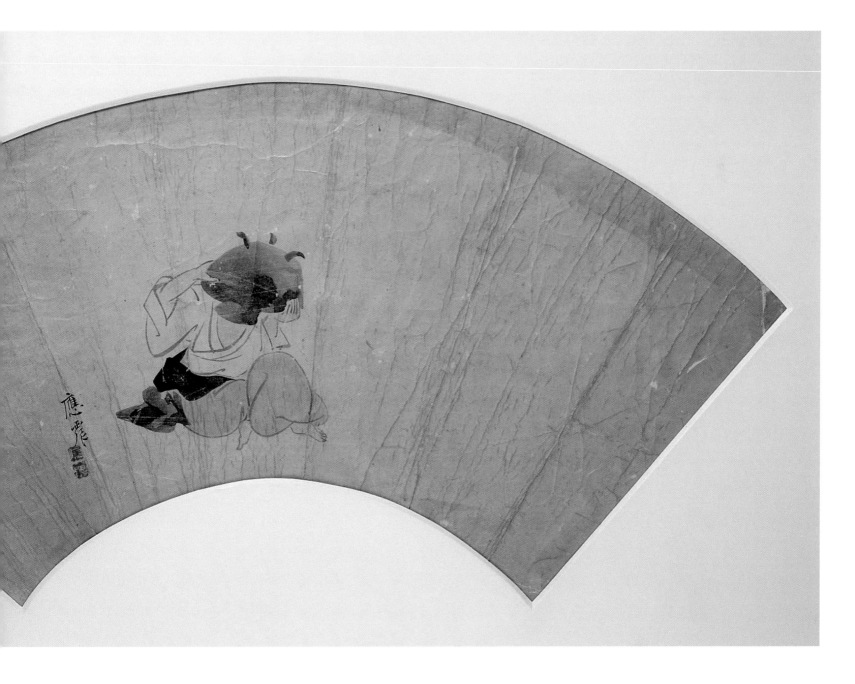

22

Kunii Ōbun 国井応文
1833–1887

Kōshohei (Ch: Huang Zhuping) and Sparrow on an Akebi plant, 1855

FAN PAINTINGS

INK AND COLOUR ON PAPER

SIGNATURE: *Ōbun sha*
(PAINTED BY ŌBUN)

SEALS: *Ō; Bun*

20.3 × 53.3 CM EACH

1973.90, 91

*Purchased with the aid of the Friends of
the Ashmolean and Mr and Mrs J. Hillier*

The story of the Daoist figure Kōshohei was a popular painting subject for the Maruyama and Shijō schools in the Edo period. According to legend, a young Kōshohei led his herd of sheep into the mountains and remained there for forty years to meditate. His brother managed to find him, and when he asked about the missing herd, Kōshohei transformed several white rocks into actual living sheep with a touch of his staff. Ōbun has painted a young-looking shepherd whose sleeve is caught up in a divine wind as he points his staff at the rock. The ears and eye of a sheep can be made out as it begins its transformation. The second painting of a sparrow on a stem of an *akebi* plant has the same characteristically taut and controlled brushstrokes as that of the shepherd.

Both paintings have two seals on the right edge done with *tan* pigment (a mixture of lead, saltpetre and sulphur that was originally red). The word *goyō* (in service) can be made out in the upper seal on the painting of the bird, however the lower seal is unreadable. The seals therefore indicate that this pair of painted fans were done by imperial order during the same year Ōbun participated in the decoration of the Imperial Palace, which had burned the year before. Though now they are mounted separately, the paintings probably made up two sides of one fan originally.

Ōbun, the fifth-generation head of the Maruyama school, was born in Edo. He moved to Kyoto to study painting, and apart from his work on the Imperial Palace mentioned above, he was active later in his life as a judge in the world of Meiji period exhibitions of the new style Nihonga paintings.

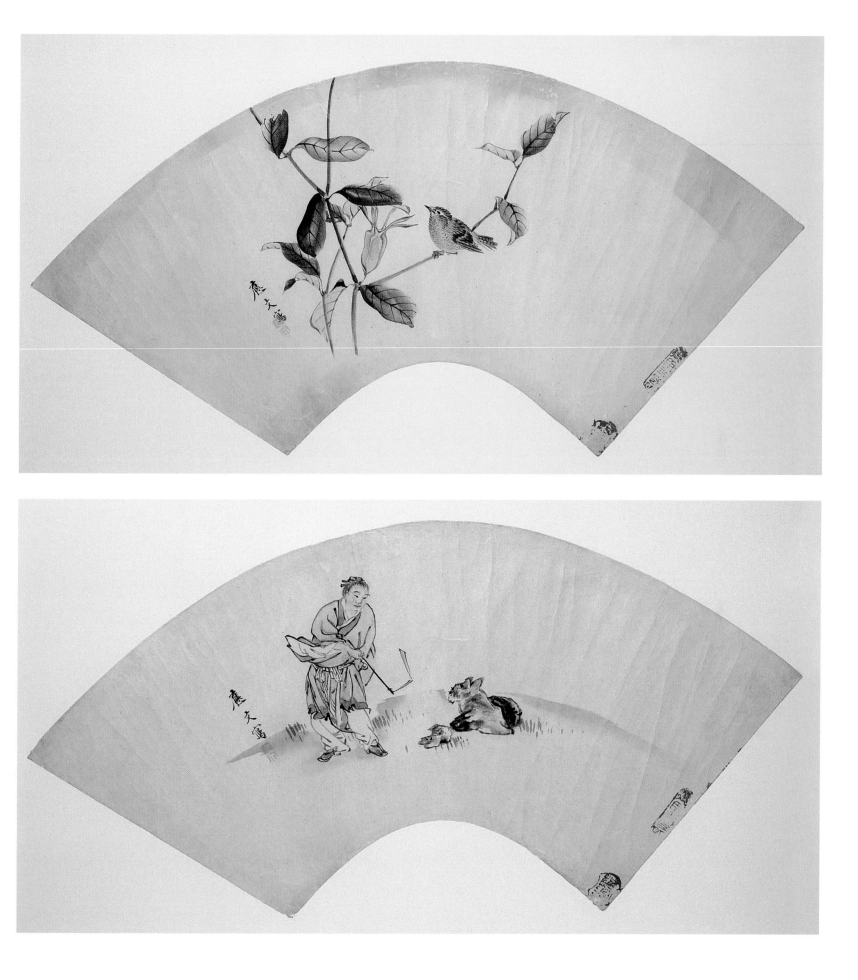

23

Nagasawa Rosetsu 長沢蘆雪
1754–1799

Yama-uba and Kintarō

FAN PAINTING

INK AND COLOR ON PAPER

SIGNATURE: *Heian Rosetsu sha*
(PAINTED BY HEIAN ROSETSU)

SEAL: *Gyo*

19.5 × 47.1 CM

1973.96

*Purchased with the aid of the Friends of
the Ashmolean and Mr and Mrs J. Hillier*

Kintarō, the mythological child-hero possessing enormous strength, was lost in the mountains as an infant and taken care of by Yama-uba (the mountain nurse or witch). The infant here is cradled close to Yama-uba's chest in her tattered robes. The hag with her thinning hair, enormous jaw and oversized hands and feet is a truly gruesome figure. Her expression as she stares straight at the viewer is one of confidence and perhaps mild annoyance as well. Kintarō's axe lays on the ground in front.

Rosetsu was drawn to the odder figures in folklore such as Yama-uba, Chinese eccentrics and ghosts.[1] He also took up the subject of the mountain witch in a large-scale votive plaque in Itsukushima shrine in 1797, which shows her dressed as a courtesan while Kintarō pulls at her robes. Again, she stares straight at us, while her oversized hands and feet spill out of her shredding clothing. Yet another image of Yama-uba by Rosetsu in the Price collection shows her as a somewhat awkward, but otherwise pleasant figure.[2]

Rosetsu was born into a low-ranking samurai family. He entered Maruyama Ōkyo's studio and became arguably the most talented of the master's pupils. It is unclear, but it seems Rosetsu was forced out of the studio due to his idiosyncratic manner. After becoming independent, Rosetsu's own painting style continued to develop, and he is hailed as one of the true free spirits of the Edo period, whose dynamic way of painting crosses divisions of school and media. The paintings of this much-beloved eccentric continue to gain great attention. The fan in the Ashmolean can be assigned to Rosetsu's later career in which his individual style apart from that of his teacher is fully expressed. In addition, the signature is in keeping with those on works done when Rosetsu was around forty years old.

1 For example, there is *Hanshan and Feng Kan*, a two-panel screen in the Tokyo National Museum, a hanging scroll painting of *Hanshan and Shide* in Kōzanji, Wakayama, and *Ghost and Sea God and Sea Turtle* in the Joe Price collection.

2 This is reproduced in *Puraisu korekushon kaiga, Catalogue of Japanese Art in Foreign Collections* (Tokyo: kobunkazai kagaku kenkyūkai, 1994), vol. 4, plate 122.

24

Gessen 月僊
1721–1809

Kanzan and Jittoku

FAN PAINTING

INK AND SLIGHT COLOUR ON PAPER

SIGNATURE: *Gessen*

SEALS: *unreadable*

INSCRIPTION: *Ichikawa Kansai*
(1749–1820)

17.8 × 49.0 CM

1966.99

*Purchased with the aid of grants from the
Higher Studies Fund and the Victoria and
Albert Museum, also with donations from
the friends of P. C. Swann*

The two sages Kanzan (Ch: Hanshan) and Jittoku (ch: Shide) grin widely at one another. Gessen has painted them as stooping figures with wild hair, appropriate for the legendary eccentrics. Kanzan is thought to be from the Tiantai mountains in China where he lived in seclusion. Jittoku was a monk who worked in the kitchen of a monastery, hence his attribute is always an old broom, seen here with its tip peaking out from behind him. It is said that from time to time, Kanzan would visit Jittoku and ask for food. They were an often-painted pair in China in Chan (Zen) circles, and became known in Japan when that pictorial tradition flourished in the Zen monasteries of the Muromachi period.

Gessen inherited this tradition as a painter-priest himself, however of the Jōdo sect of Buddhism. He was born in Nagoya and first studied painting in Edo at the Zōjōji temple before staying in Kyoto for a time at the Chion-in. As a mecca for artists, Kyoto afforded Gessen an opportunity to explore a variety of painting styles. He became a student of Maruyama Ōkyo for three years, after which he studied the works of Yosa Buson (1618–1683) and Ike Taiga. In addition, Gessen copied works from China of the Ming and Qing dynasties as well as past Japanese masters of ink painting such as Sesshū. As head priest of Jakushōji temple in Ise, Gessen would sell his paintings to pay for temple repairs. He is known for his often satirical figure paintings that have elements of both the Nanga and Maruyama school styles.

Usually, Kanzan points up to the sky, but in this fan, it seems as if he is gesturing towards the inscription to the left, a Chinese poem made up of four lines of five characters each which reads:

秋色天台詠　In autumn colours at the heavenly terrace chanting poems,
活仏携手時　the living buddhas go hand in hand,
禿帚休掃盡　Do not let the worn broom sweep them all away,
葉々有題詩　the leaves are inscribed with poems.[1]

The inscription is by Ichikawa Kansai, a well-known Chinese scholar and calligrapher from Gunma, and is signed 'Seinei', one of his literary names. He became the head of the official Confucian academy in Edo, the *Shōheikō*. He also served as a Confucian scholar in Toyama, and excelled in poetry to such a degree that he authored several texts on poetry.

1 My thanks go to Dr Cary Liu for providing this translation.

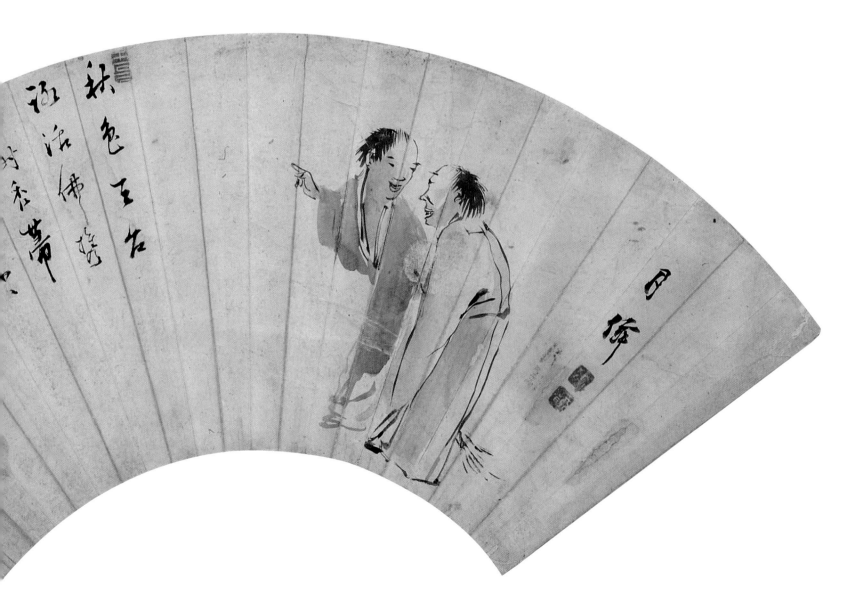

25

Oku Bunmei 奥文鳴

D. 1813

Gourd Plant

Fan painting

Ink and slight colour on paper

Signature: *Bunmei*

Seals: *Bun; Mei*

18.5 × 49.7 cm

1973.18

Purchased with the aid of the Friends of the Ashmolean and Mr and Mrs J. Hillier

Bunmei has painted a flowering gourd plant in ink, with just a touch of yellow in the centre of the open blossom. The thin stems of the flowers grow out of a base of broad leaves, and a small gourd is seen forming on the right. Spirals of delicate calligraphic lines form the plant's tendrils. Bunmei is obviously a master of controlling the ink through painting techniques, however here he combines this with an obviously careful study of nature.

Although one of Maruyama Ōkyo's ten best pupils, details of Bunmei's life are scarce and extant paintings by him are extremely few. He is especially well known as the writer of the biography of Maruyama Ōkyo, the *Sensai Maruyama sensei den*. In 1790, Bunmei was part of Ōkyo's workshop that produced wall paintings for the Imperial Palace, and he also executed paintings for Daijōji temple of which a painting of wisteria and birds, an Important Cultural Property, is extant.[1] That composition displays the same controlled handling of the brush without making the composition look contrived as in the Ashmolean's fan painting. Bunmei is able to show the real complexity of organic forms as they grow and twist, while managing to produce neat and pleasing pictorial compositions.

1 Published in Minamoto and Sasaki, 50, 191.

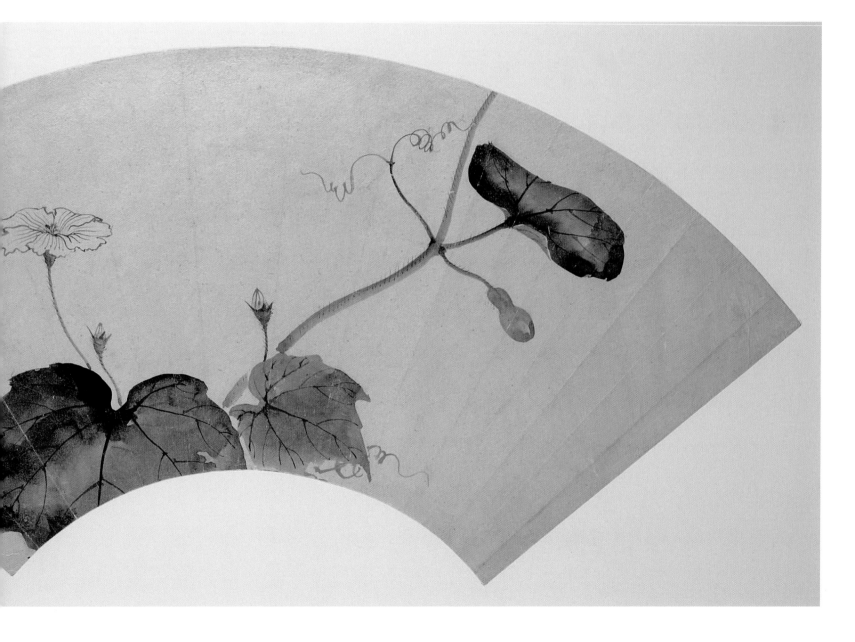

26

Watanabe Nangaku 渡辺南岳
1767–1813

Beauty and Skull

Hanging scroll

Ink and colour on silk

Signature: *Nangaku sha* (painted by Nangaku)

Seals: *Iwao (no) in; Iseki uji*

139.5 × 41.5 cm

1973.187

Purchased with the aid of the Friends of the Ashmolean and Mr and Mrs J. Hillier

This beautifully rendered image of a courtesan with a skull is one of Watanabe Nangaku's masterpieces. It has been published only twice before: in 1908 in *Maruyama-ha gashū*[1] as belonging to the collection of Shimizu Hanbeii of Kyoto, and again in *Nihonga Taisei* in 1932.[2] It is unclear exactly how it came into the possession of Jack Hillier, from whom the Ashmolean purchased the painting.

Nangaku's technical virtuosity is breathtaking, particularly in the rendering of the barefoot courtesan's several layers of kimono. There is a subtle gradation of colour in the outer kimono from blue-grey to green at the hem, where a pattern of ivy is painted delicately in gold and white *gofun*. The next layer of kimono bears a design of butterflies, the next of scattered cherry blossoms, and the innermost layer is of a tie-dyed fabric with pink colouring. Tie-dyed strips of fabric used in the mounting of the painting pick up the pattern of the inner kimono. The beauty's bright red *obi* has flying dragons painted in gold with silver details. Animal glue has been applied over the strands of her hair to make them shine when hit by the light. All of this meticulous detail contrasts sharply to the bold ink strokes used to define the folds in the garments. The artist obviously revels in reminding us that this is a painted two-dimensional image: the patterns on the kimono are painted flat where the robes fold.

The beauty bows her head and calmly looks at the skull, eerily painted with some of its teeth missing. The inscription above reads:

あさゆふの	No longer does she
かゞみもいまは	hold a mirror in her hands
てにとらで	morning to night,
これぞまことの	since now she has
すがたみにして	a true reflection of herself.[3]

Watanabe Nangaku was a distinguished pupil of Maruyama Ōkyo. He has been known for his images of beauties and of carp, however, in reality his subject range

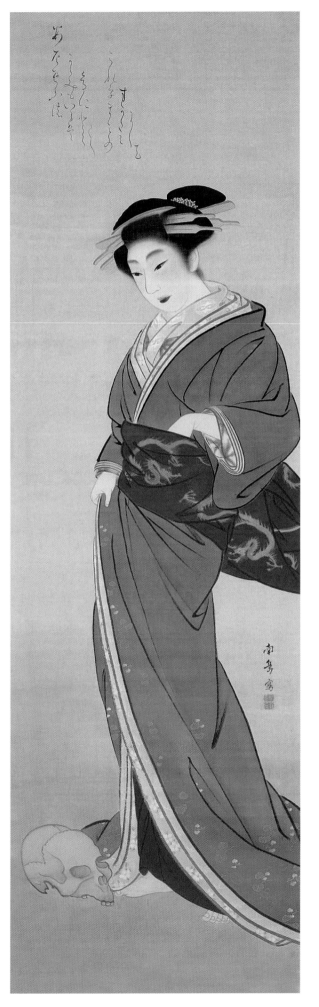

is quite broad, including comic paintings of animals as well.[4] Nangaku's stylistic influences are equally extensive, as he also spent three years in Edo where he was acquainted with Tani Bunchō and Bun'ichi (1787–1818), Sakai Hōitsu (1761–1828), and Ukiyo-e artists. In addition, he was known to have studied the paintings of Rimpa school artist and master of design Ōgata Kōrin (1658–1716). In turn, he is credited with bringing the Maruyama school style to the capital. His presence can be felt in the Maruyama-inspired fan of butterflies by Tani Bunchō earlier in this catalogue, as well as in the work of his Edo pupils Suzuki Nanrei (1775–1844) and Onishi Chinnen (1792–1851) to follow.

The underside of the lid of the box of *Beauty and Skull* bears an authentication by Kunii Ōyō (1868–1923) (Kunii Ōbun's son), a later Maruyama school artist in Kyoto who possessed and copied several sketches of Maruyama school images of beauties.

1 Tajima Shi'ichi, *Maruyama-ha gashū*, vol. 2 (Tokyo, Shinbi shoin, 1908).

2 Tōhō shoin, *Maruyama- ha 2*, *Nihonga taisei* vol. 13 (Tokyo, Tōhō shoin, 1932), fig. 90.

3 I am indebted to John Carpenter for providing the translation here.

4 For example, the *Frog-lord's Procession* in the Yamato Bunkakan is published in Minamoto and Sasaki, 47.

27

Yamaguchi Soken 山口素絢
1759–1818

Bush Clover

FAN PAINTING

INK AND COLOUR ON PAPER

SIGNATURE: *Soken*

SEAL: *Soken*

18.7 × 51.1 CM

X5366

Gift of Dr Michael Harari, from the collection of his father, Ralph Harari

Three gently sloping stems of bush clover painted just before the buds open are the subject of this simple fan composition. Bush clover or *hagi* is one of the seven plants of autumn and is a primary element in many compositions of the flowers of the four seasons in Edo period art, most notably in the work of Rimpa artists using the Inen seal in the seventeeth century. The white bush clover is most often featured in those works, however Soken clearly preferred the pink variety. The flowers appear in his large-scale flower paintings as well, such as a pair of screens of spring and autumn grasses and flowers painted on gold leaf ground in the Shizuoka Prefectural Museum of Art.[1] This fan painting is almost an exact quote of a section of that larger composition.

Though details of his personal life are few, Yamaguchi Soken was one of Maruyama Ōkyo's ten best pupils, known traditionally for his paintings of beauties. However, his talent was by no means limited to figure paintings, and he produced several printed books of his ink painting and flower and grasses compositions. His *Soken gafu kusabana no bu (Illustrations by Soken, Flowers and Grasses Part)* was published in 1806 and contains a full three volumes of illustrations.[2]

1 Minamoto and Sasaki, 41, 187.

2 A copy is in the British Museum. Unfortunately, it does not contain an image of bush clover.

28

Mori Tetsuzan 森徹山
1775–1841

Album of sketches by Tetsuzan (Tetsuzandō sōgachō)

THIRTY DOUBLE-PAGE PAINTINGS
IN AN ACCORDION-FOLDED ALBUM

INK ON PAPER

NO SIGNATURE

SEALS: *Tetsu, san or haku* (?);
hō (?)(ON EACH PAGE)

8.9 × 43.2 CM EACH

1962.209

van Houten gift

Tetsuzan has used a very wet brush to render a variety of subjects including vegetables and other plants as well as flowers, animals, everyday figures and immortals. Using either blue, black or grey ink for each image, the ink has soaked into the paper to produce a variety of effects: from the feathers of a bird, the fur of a mouse to the smoother hide of an ox. In other images, the ink wash outlines the contours of a white heron or white rabbit whose colour is that of the blank paper. The reclining deer and horse, by far the most powerful images in the album, use still another technique of rendering the outlines of the animal in dark ink and the fur (or mane in the case of the horse) in a lighter wash.

The mass of the deer as it leans sideways with its foot teetering in the air is clearly felt. Also, the bulk of the horse is wonderfully conveyed through the strength of the artist's lines. Paintings of horses in this manner have a long history in the Maruyama and Mori schools. For example, compositions by Maruyama Ōzui and Mori Shūhō were influenced by illustrated books such as Ōoka Shumboku's (1680–1763) *Soga benran*.[1] In fact, the buffalo in Tetsuzan's album is nearly identical to one painted by Shūhō on a two-fold screen.[2] The same subject is most famously taken up by Tetsuzan himself in his painting of two cattle done on silver leaf in the Tokyo National Museum.[3] Tetsuzan had two methods of painting animal fur, one was to meticulously construct the fine texture through delicate brushwork, while the other used forceful lines in a sketchlike manner which was common in Maruyama school circles. The images in this album are in the latter style.

Tetsuzan was born in Osaka as the son of Mori Shūhō, but was adopted by his uncle Sosen, the famous painter of monkeys. After studying painting with his uncle, Tetsuzan became one of Maruyama Ōkyo's pupils in Kyoto. In 1795 at the age of twenty-one, he joined the master and his most distinguished pupils in painting rooms at Daijōji temple. Tetsuzan became one of the premier painters of the Maruyama school, and even married into it: he and Maruyama Ōzui were married to sisters. He had a reputation for painting animals imbued with life and for realistically expressing the texture of animal's fur with ink. A few images in

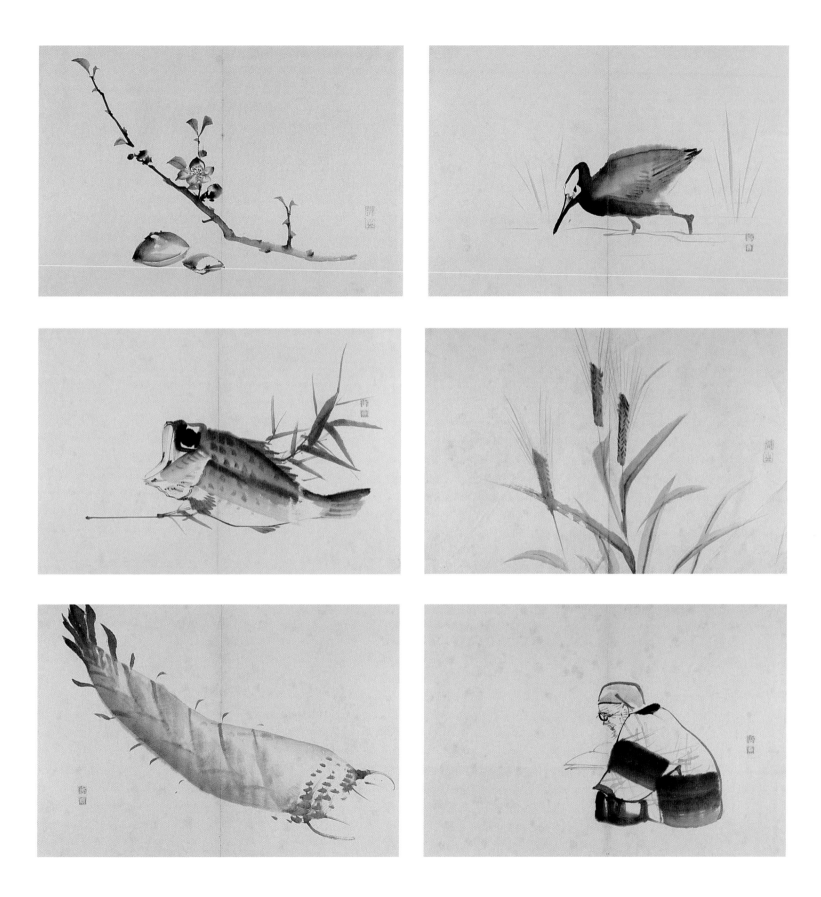

this album have seals that could read 'Hakuhō', perhaps indicating that the work of Mori Hakuhō is included here.

1 See *Kobijutsu* 49 (Sept. 1975) for Shūho's paintings of horses and for the *Soga benran*.

2 Ibid.

3 This is published in *Kokka* 628 (March 1943), plate 3 and page 82.

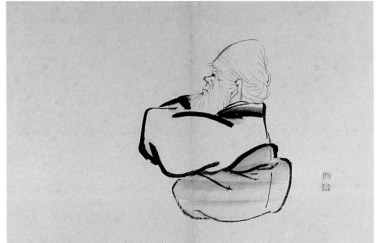

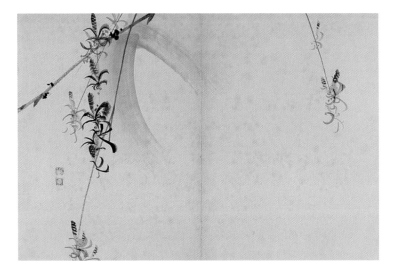

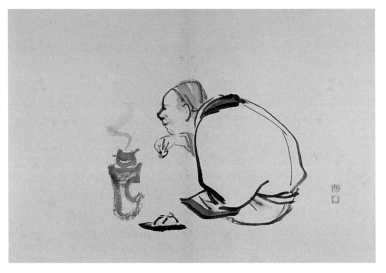

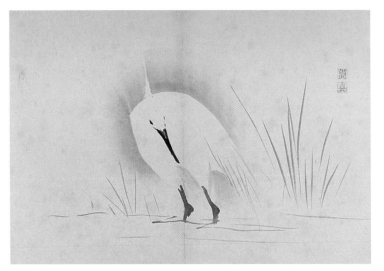

29

Various artists

Painting and Calligraphy Album, 1799–1805

The vogue for assembling painting and calligraphy by various artists was rampant in the early nineteeth century. The albums were made for several reasons including to celebrate someone's venerated old age, to wish a friend farewell, for an exhibition, or to commemorate a meeting or visit. Nakai Monju (1757–1808) was responsible for some of the most ambitious assembled albums (*yoriai* or *shūshū gajō*) of his time. The Ashmolean's album is one of these. It contains mostly works by artists in Osaka, particularly the Mori school and Fukuhara Gogaku's (1730–1799) students. Because of the prevalence of the Mori school, this album has been included in the current section, though it should be noted that many artists whose works are in the album actually considered themselves proponents of the Nanga school. Interestingly, the order in which the paintings and calligraphy appear seem to have been arranged to emphasise the album's diversity. Paintings alternate with calligraphy, and an effort has been made to alternate between different scripts among the calligraphy.

The album opens with the title *gachū yūshi*, which translates as 'Poetry within painting', written in bold grass script and signed Kanrin Shindō. Next, the two-page preface is by Komai Hansai (1727–1803) and sealed with his *gō* of 'Hōmei'. It is dated to 1801, when the calligrapher was seventy-five years old. In the preface, Hansai relates the circumstances surrounding the making of the album: Nakai Monju of Hino (Shiga prefecture) collected works by artists in Edo, Kyoto and Osaka and compiled them into three albums, of which this is one. He writes that the paintings included were not all done on one occasion at a gathering, like the Higashiyama albums of just a couple of years earlier to which he alludes.[1] The inclusion of a majority of Osaka artists is explained by a number of reasons made clear in the preface. Hansai claims that Osaka is the equal of Kyoto in calligraphy and painting in every way. He also comments that the collected paintings and calligraphy were loosely grouped according to similarity, which perhaps resulted in a preponderance of Osaka artists in this volume. Lastly, none other than Kimura Kenkadō (1736–1802) asked Hansai, in haste, to write the preface.

Kimura Kenkadō was a wealthy sake merchant in Osaka who acted as patron and advisor in many cultural projects of the time. He was an extremely cultivated

Two-page title, two-page preface, and 28 paintings alternating with 28 pages of calligraphy in an accordion-folded album

Ink and colour on silk

23.0 × 28.0 cm

1964.95

6 Mori Shūhō, *Black Bear Cub in Snow*, 1799.

man who studied philosophy, literature and Western learning. This he undertook not so much to learn each field in depth but more to be able to compare and explore their commonalities and differences.[2] From an early age, he studied painting with Ōoka Shunboku (1680–1763), a Kano school artist, as well as Nanpin school painting with the monk Kakutei (1722–1785). Poetry was another of his serious pursuits, and he was apprenticed to a botanist in Kyoto for a time as well. Hansai was a Confucian scholar and poet who had known Kenkadō from his early years as a student of poetry. Kenkadō, as a leading figure in the cultural circles of Osaka, would naturally have prompted the inclusion of many Osaka artists. Specifically, a large number of the names in this album are to be found in his *Kenkadō nikki* diary.

It seems Nakai Monju was the director of the project to compile the Ashmolean album, while Kenkadō was called in to provide the necessary cultural contacts when they were lacking and to bring the project to a fitting conclusion. In addition, Hansai's involvement may have prompted the inclusion of Mori school artists due to the fact that he was married into that family.

The first painting in the album is of a black bear cub in the snow by Mori Shūhō painted when the artist was sixty-two, that is, in 1799, and therefore the earliest painting or calligraphy included in the album. The small bear with blue eyes looks directly out at us as he sits uneasily on a ledge amid the snowflakes. His furry coat is painted with the skill befitting a Mori school artist. Shūhō was a member of the Mori school of painters who specialised in humanised depictions of animals. He was the elder brother of Sosen (1747–1821), the famous painter of monkeys. Though less well regarded than his brother, Shūhō was a respected and prolific artist in his hometown of Osaka. This painting is signed '*hokkyō* (Bridge of the Law) Shūhō', and was done before he attained the highest honorary rank of *hōin* (Seal of the Law). Shūhō often wrote his age after his signature, as done here, making it possible to chart his career quite closely.

Another artist who rose to the rank of *hokkyō* in Osaka was Okada Gyokuzan (1737–1812), a *Ukiyo-e* painter known primarily for his genre paintings, but who also painted landscapes as well as birds and flowers. Here, he has painted cherry blossoms as white and pink circles. The trunk of the cherry tree is a mixture of ink and gold pigment. As a prolific illustrator of books for mass consumption in Osaka, he was often looked down upon by the more literary set. His inclusion towards the beginning of the present album, a space usually reserved for the most respected artists, is therefore a matter of great interest. On the next page is a painting of three Chinese men around a tea brazier by Nakai Rankō (1766–1830), a painter, poet and illustrator of printed books in Osaka. It is painted in ink with thick,

2 Kanrin Shidō, *Title: yūshi.*

1 Kanrin Shidō, *Title: Gachū.*

4 Komai Hansai, *Preface,* 1801 (cont.).

3 Komai Hansai, *Preface,* 1801.

caricature-like outlines. Rankō's ink painting style, and especially his use of outline, came out of his study of Sesshū as well as of Chinese masters such as Mu Qi, though he often painted in the Shijō manner as well. Further on in the album, Hamada Kyōdō (1766–1814), a less well-known painter, has conceived a stunning image of a rose blossom and buds. Done only in various tones of grey ink, the brushstrokes of the blossom are invisible, resulting in a remarkably three-dimensional image. Kyōdō was also an Osaka painter and pupil of Fukuhara Gogaku like so many of the artists included in the album. He was a physician, but was better known for his painting and was said to have chosen his models among Chinese paintings of the Ming and Qing dynasty carefully.[3]

Not all of the painters are from Osaka, however. A handful of inclusions are by artists from various locations who painted the images while in Edo as indicated by their signatures. This is the case with Yamaoka Geppō (1760–1839), a student of Ike Taiga, and Tani Sukenaga, who both painted their contributions in 1800. Sakai Hōitsu's (1761–1828) contribution of a painting of morning glories is noteworthy, but unfortunately there is no indication of where or under what circumstances he was asked to participate.

Among the calligraphers involved, the names Shinozaki Ōdō (1737–1813) and Totoki Baigai (1749–1804) stand out in particular. The latter was a well-known calligrapher and poet of Chinese verse, who contributed to this volume soon after he retired to Osaka.

The pages in order as they appear in the album are:

1 Kanrin Shidō, Gachū (Title)

2 Yūshi (Title cont.)

3 Komai Hansai (1727–1803), Preface, 1801

4 Preface (cont.)

5 Anonymous, *Plum Branch*

6 Mori Shūhō (1738–1813), *Black Bear Cub in Snow*, 1799

7 Shinozaki Ōdō (1737–1813), Calligraphy, 1801

8 Sumie Buzen (1734–1806), *Entrance to a Mountain Retreat*

9 Okuda Genkei (1727–1807), Calligraphy

10 Okada Gyokuzan (1737–1812), *Cherry Blossoms*

11 Fujii Genshuku (dates unknown), Calligraphy, 1801

12 Kanseki Gakkō, Calligraphy, 1801

13 Nakai Rankō (1766–1830), *Three Chinese Men*

14 Enzan, Calligraphy

15 Hamada Kyōdō (1766–1814), *Rose*, 1801

16 ?Segi, Calligraphy

10 OKADA GYOKUZAN, *Cherry Blossoms.*

17 Kushiro Unsen (1759–1811), *Chinese Landscape*, 1800

18 Fuchigami Kyokkō (?–1833), *Drunken Li Po*

19 Tachihara Man, Calligraphy

20 Mori Shunkei (fl. 1800–1820), *Butterfly, Praying Mantis, Cricket and Rock*

21 Katei, Calligraphy, 1801

22 Sekisho, Calligraphy

23 Kanae Shungaku (1766–1811), *Mountain Landscape*, 1801

24 Ohashi Ritsujo (dates unknown), *Orchid and Rock*

25 Kichūdō Suichiku, Calligraphy

26 Shozan Kisho, Calligraphy, 1805

27 Sakai Hōitsu (1761–1828), *Morning Glory*

28 Oka Yūgaku (1762–1833), *Landscape*

29 Totoki Baigai (1749–1804), Calligraphy

30 Bankatsu Shōfu, Calligraphy

31 Yamaoka Geppō (1760–1839), *Landscape*, 1800

32 Minkaryū, Calligraphy

33 Oka Ennen (active c. 1789–1800), *River Landscape*

34 Sō Mitsuzō, Calligraphy

35 Kyokkō, *Bird on a Flowering Branch*

36 Gaizan, Calligraphy, 1801

37 Soryū Sanjin, *Butterfly*

38 Oke Genchō, Calligraphy

39 Tani Sukenaga, *Youth with a Biwa*, 1800

40 Mizouchi ?masa, Calligraphy

41 Kayō sanjin, *Landscape with Scholar*, 1801

42 Kyusaimo, Calligraphy

43 Fukuhara Tōgaku (dates unknown), *Scholar and Attendant*

44 Mashige Yūsai, Calligraphy

45 Dōgetsu Yoshimasa, *Boy Mounting an Ox*

46 Yagi Sonsho (1771–1836), Calligraphy

47 Yagi Sonsho (1771–1836), Calligraphy

48 Kinryū Sanjin, Calligraphy

49 Katei (Hagura Ryoshin?), *Pine and Rock*

50 Chiisai, Calligraphy

51 Ohara Tōno (Minsei) (active c. 1818–1829), *Scholar Viewing a Waterfall*

52 Kōkōkyō, Calligraphy

53 Morikawa Chikusō (1763–1830), *Bamboo*

54 Shintori Banka, Calligraphy, 1801

55 Terajima Hakuju (active c. 1804–1817), *Snowscape*, 1801

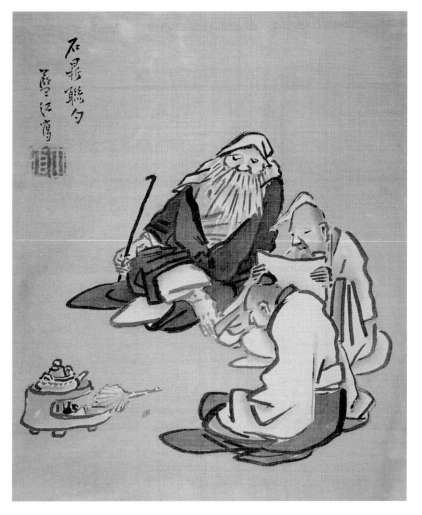

13 NAKAI RANKŌ, *Three Chinese Men.*

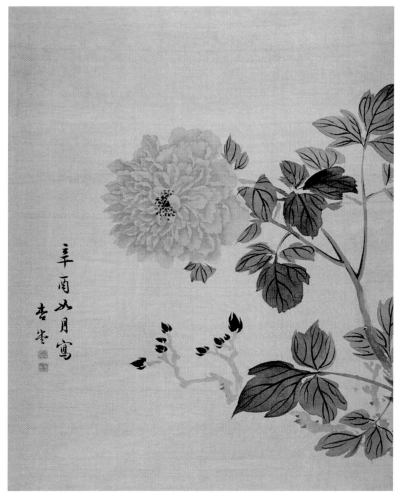

15 HAMADA KYŌDŌ, *Rose,* 1801.

56 Hobun, Calligraphy

57 Yanada Kunitaka, *Mountain Retreat*

58 Seizan Sanjin, Calligraphy

59 Yamanaka Kaiin, *Quail*

60 Sawai Seitai, Calligraphy[4]

A sixty-page album like that in the Ashmolean is not extraordinarily large by any means, but it is of a relatively early date. Album compilations of this sort began to appear with regularity from about 1789, but became increasingly more popular in the first decades of the nineteenth century. Kenkadō was an early proponent of these albums. He was probably also involved in putting together another album, the *Hoji Seigandō*, an album of fifty-eight paintings and fifty-eight pages of calligraphy in two volumes. The albums share ten artists and calligraphers with the Ashmolean's album,[5] and have been collated along similar lines.

1 These are the *Higashiyama daiichirō shogajō*, of which seven volumes are known. Bunjū also held similar gatherings in Sendai and Edo. Takeda Kōichi, 'Shoga ga atsumaru/shoga o atsumeru', in Kobayashi Tadashi and Kōno Motoaki, eds, *Bunjin shoga: yoriai shogajō, Edo meisaku gajō zenshū*, vol. 10 (Tokyo, Osaka shinshindō, 1997), 158.

2 'Kimura Kenkadō to sono kōyū', in Yamanouchi Chōzō, *Nihon Nangashi* (Tokyo: Ruri shobō, 1981), 173.

3 This is mentioned by Kanai Ujū and translated in Wylie, 158.

4 Many thanks are due to Professor Nakatani Nobuo of Kansai University for identifying many of the calligraphers and painters.

5 They are Hamada Kyōdō, Morikawa Chikusō, Kanae Shungaku, Mori Shūhō, Fuchigami Kyokkō, Totoki Baigai, Fukuhara Tōgaku, Nakai Rankō, Katei, and Okada Genkei. The album is treated in Kobayashi and Kōno, 106–19, 175–81.

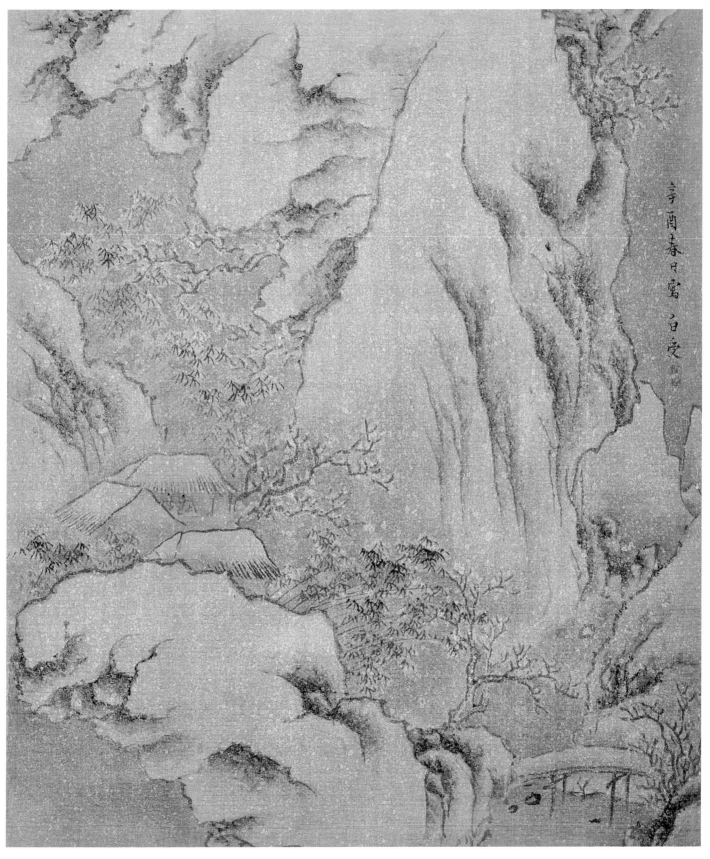

辛酉閏春日寫 白受

55 Terajima Hakuju, *Snowscape*, 1801.

30

Matsumura Goshun 松村呉春
1752–1811

Takasago

HANGING SCROLL

INK AND LIGHT COLOUR ON SILK

SIGNATURE: *Gekkei sho*
(WRITTEN BY GEKKEI)

SEALS: *Go*; *Shun*

INSCRIPTION BY THE ARTIST

32.0 × 48.8 CM

1973.162

*Purchased with the aid of the Friends of
the Ashmolean and Mr and Mrs J. Hillier*

In this subdued, understated composition from Goshun's later years, an elderly couple are placed just right of centre amid a vast blank space. Jo and Uba are painted quietly posing, she with a broom, and he a rake. The story of Jo and Uba is part of the Nō play Takasago. According to legend, the two fell in love when young and lived in happiness until a very old age. Their spirits are said to dwell in a pine tree in Takasago that has a divided trunk. The two are naturally symbols of love and longevity, and images of them are appropriate for wedding gifts and decorations. A *minogame*, or ancient tortoise, also a symbol of longevity, is seen in the brocade used for the mounting of this hanging scroll.

The inscription by Goshun to the right is a poem from the Takasago play which reads:

まさきのかつら長き式の
ためしなりけるときは木の
中にも名は高砂の相生の松そ
ひさしき

[Morning and night I rake beneath the tree
yet fallen needles never fail, for it is true,
pine needles fall not all at once;
their green only grows]
as grows the *masaki* vine,
the sign of an enduring reign;
and among all evergreens
the Takasago Pine,
in this latter age, signals blessings.[1]

Goshun often used the name Gekkei (Moon Valley) for his signature on his poetry-inspired paintings, as he has done here. The above inscription contains variants from the text of the play of the kind someone writing from memory would make.[2] As a native of Kyoto, he led a cultured life as the son of an official of the gold mint. He became a student of Yosa Buson in his twenties, with whom he studied *haiku* poetry and painting. Goshun's works from this period show an advanced knowledge of literati painting in the Nanga manner, such as *Road to Shu* and *Life in the Mountains* in the Michigan University Art Museum.[3] After a series of family losses, Buson encouraged his student to go to Ikeda, close to Osaka. From this time, Goshun's paintings take a decidedly Maruyama style turn. Though he later

returned to Kyoto and worked with Maruyama Ōkyo,[4] Goshun was still considered primarily Buson's student. Having mastered both Nanga and Maruyama school techniques, Goshun created his own style known henceforth as the Shijō school, after the location of his studio on 'fourth avenue' in Kyoto. In his new style he infused the Maruyama manner of sketching from life with a more subjective and emotional feel. Subsequently, his style spread to become the greatest influence on Japanese painting of the nineteenth century.

Goshun produced another larger painting of *Jo and Uba* in the Itsuo Art Museum in which the benign elderly couple are shown wrinkled to a comical extent.[5]

1 From *Takasago* translated in Royall Tyler, trans. and ed., *Japanese Nō Dramas* (London: Penguin Books, 1992) 286–7. The section in brackets is not inscribed on the painting but forms the first part of the poem as it appears in the play. I again thank John Carpenter for pointing me towards this reference.

2 I am grateful to John Carpenter for making this comment.

3 Published in Celeste Adams, *Heart Mountains and Human Ways, Japanese Landscape and Figure Painting: A Loan Exhibition from the University of Michigan Museum of Art* (Houston: Museum of Fine Arts, 1983), 56, 59.

4 Goshun helped to decorate Daijōji temple with other prominent Maruyama school artists from 1787 to 1795.

5 Suntory Art Museum, *Itsuō bijutsukan meihinten* (Suntory Art Museum, 1971), 30. The Ashmolean painting is the later of these two compositions.

31

Shibata Gitō 柴田義董
1780–1819

Tachibina dolls

During the Edo period, images like this were probably hung to adorn the home at the time of the Hinamatsuri, Doll or Girl's Day festival, on 3 March. This type of doll first appeared in the fifteenth century, and in the sixteenth century was a children's toy, as deduced from portraits.[1] Tachibina, or standing dolls made of either paper or clay, are always in pairs. The male doll's arms are outstretched and the female doll has a very simple cylindrical-shaped body wearing a kimono tied with a sash, or *obi*. Perhaps paintings were preferred to the actual dolls though, since the dolls could rarely stand up without support and were easily knocked over.

Pairs of these dolls are found as a design on lacquerware, porcelain and *netsuke* carvings, as well as painted hanging scrolls. Their kimono display a range of motifs including wisteria and irises, but the pine tree, as seen here, seems to be the most popular when this couple is painted. Here, the couple are the only image on an otherwise blank background. They are dressed like Heian period courtiers: he has on *hakama* trousers and a courtier's cap and they both have distinctive high-placed eyebrows that courtiers would apply with makeup. The artist delights in the simple geometric forms of the round heads and cylindrical bodies. Despite such clear contours, the image is not a stiff one. In fact, both figures are imbued with a very cheerful and relaxed human sense due to their smiling expressions.

Gitō was Goshun's pupil. He was born in Bizen (present-day Okayama prefecture) where his father was in the shipping business. After moving to Kyoto, he occupied a studio off Shijō, and came to be known as a painter who excelled in figural images, rarely copying his master's works or using models. He was proficient in many subjects, but is particularly known for his Chinese figures and *Ukiyo-e* beauties.[2]

HANGING SCROLL

INK AND SLIGHT COLOUR ON PAPER

SIGNATURE: *Gitō sha*
(PAINTED BY GITŌ)

SEALS: GITŌ; *Ichū*

120.0 × 28.0 CM

1973.171

Purchased with the aid of the Friends of the Ashmolean and Mr and Mrs J. Hillier

1 This type of doll can be seen in a portrait of Maeda Toshiie's daughter, Kikuhime, done in 1584. See Shigeki Kawakami, 'Ningyō: An historical approach', in *Ningyō: The Art of the Human Figurine: Traditional Japanese Display Dolls from the Ayervais Collection: With Additional Pieces from the Peabody Essex Museum, Salem, Massachusetts, the Newark Museum, and the Museum of the City of New York* (New York: Japan Society, 1995), 14.

2 For examples, see Minamoto and Sasaki, 95–100, 206–7.

32

Yokoyama Seiki 横山清暉
1792–1864

Three Old Men

Three old men with stubborn expressions on their faces sit facing one another. Above them, the *kyōka* verses relate their thoughts:

HANGING SCROLL

INK AND COLOUR ON PAPER

SIGNATURE: *Seiki*

SEALS: *Sei*; *Ki*

INSCRIPTION BY THE ARTIST

39.6 × 50.8 CM

1973.191

Purchased with the aid of the Friends of the Ashmolean and Mr and Mrs J. Hillier

往生は願ひはせねど
塵非もなし
八十八を過しての度

Although death should bring comfort, this is not assured, after one passes the age of eighty-eight.

冥土よりいまにも使
来るならば九十九までは
留守とこたへよ

If the messenger from the other world comes now, I'll answer that I'll be out until I'm ninety-nine.

るすといはゞまたもや
つかひ来るべし
いっそいやじゃと言きって
おれ

If you say you're out, the messenger will certainly return. Rather, I would just tell him to go away for good.

The verses, written in very colloquial, informal language speak of the messenger of the Buddha coming to take the men upon their death. Not convinced that a better place awaits them in the afterworld, they agree to defy death for as long as possible. Though they refute the Buddhist belief in salvation and rebirth, the trio sits in the form of a Buddhist triad. The figure in the middle takes the place of the Amida Buddha who ushers souls to the Pure Land after death. The two figures on either side mimic the Buddha's attendants. The direction in which the verses are read reinforces this allusion. The verse at the left reads right to left, the one on the right reads left to right, and the one in the middle is read beginning with the centre line first.

Yokoyama Seiki was a native of Kyoto and a pupil of Matsumura Keibun (1779–1843), himself a pupil of Goshun. He was a talented painter, and represented the Shijō school on important commissions such as decorating the Imperial Palace in 1855. It is tempting to see *Three Old Men* as a very telling composition, which gives us insight into Seiki's personality.

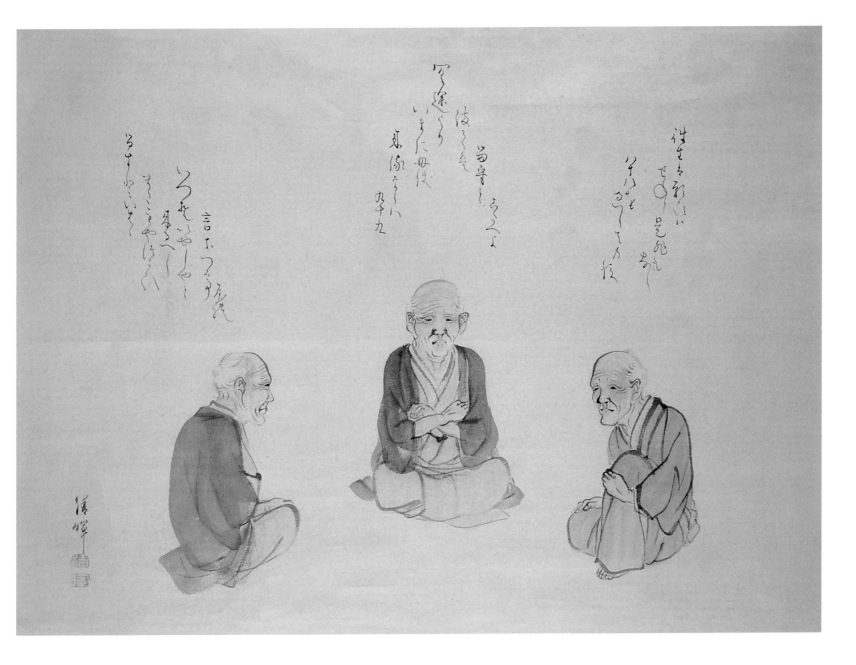

33

Hishida Nittō 菱田日東
1817–1873

Kōshohei (Ch: Huang Zhuping)

Nittō has chosen to illustrate the story of Kōshohei by depicting a very young shepherd boy. We see the moment of the Daoist legend when Kōshohei transforms white rocks in a field into sheep, as in the fan painting by Kunii Ōbun included earlier in this catalogue. Here the artist shows one rock beginning to take on certain features of a sheep such as eyes and legs. A fully formed sheep that has just sprung to life is also drawn, and perhaps the two are meant to depict sequential stages of the transformation of the same rock.

The shepherd boy is a sweet, plump figure who is gently directing the sheep towards the mountain. The image is painted with a very light touch and delicate lines which adds to the sense of sentimentality. It seems not only the sheep, but the boy who needs to be directed as well.

Hishida Nittō was a little-known artist of the Shijō school active in Kyoto. He studied with Nakajima Raishō (1796–1871) and Tanaka Nikka (d. 1845). From Nikka, Nittō took the first character of his name as well as the *gō* of Kyūhōdō, which is how he signs his name here. His painting style is also very much in keeping with the manner of his teacher Tanaka Nikka.

MATTED PAINTING

INK AND LIGHT COLOUR ON SILK

SIGNATURE: *Nittō Kyūhōdō*

SEAL: *Kyūhōdō*

29.3 × 17.9 CM

1973.89

Purchased with the aid of the Friends of the Ashmolean and Mr and Mrs J. Hillier

34

Suzuki Nanrei 鈴木南嶺
1775–1844

Album of paintings by Nanrei, volume 2 (Nanrei gachō nihen) c. 1830

Suzuki Nanrei's true talent in being able to characterise his subjects with a few abbreviated strokes is the highlight of this album of figures, plants, animals and landscapes. Nanrei's signature appears on the second page of the album in this volume; another album in the British Museum (volume 3) has no signature.[1] Paper seams in both volumes suggest that the drawings were once mounted as handscrolls. The albums are dated to the 1820s or 1830s, when Nanrei was at the peak of his career.[2]

In addition to being able to illustrate a subject with a minimal number of brushstrokes, Nanrei is also adept at showing the volume of forms and creating a solid three-dimensional presence for them. Lastly, his method of applying colour in swathes loosely contained within outlines shows the enormous control he had of the brush.

Nanrei uses his refined sense of abbreviation to capture the essence of his figural subjects. In the drawing of a monkey trainer and performer, the artist paints a comical scene overflowing with expression. Nanrei has painted the brightly clothed performer with small eyes but a very big mouth, and we can see that the performer is clearly trying to be as dramatic as possible. The monkey looks at him, transfixed, as do we. His stance is firm and the weight of the huge *hakama* trousers can be clearly felt. Flesh colour has been applied only over half the figure's face, and the grey of the *hakama* go beyond their outline. The poet Sojo Henjo, one of the Six Immortal Poets, is likewise drawn to feature the man's personality. He leans on his hand, staring demurely downward as if thinking of his next poem. The purple and red of his robes and yellowish-gold *kesa* form a beautiful colour trio. Among the other poets depicted, Ono no Komachi is a mass of colour and robes, and Ariwara no Narihira appears dignified despite his comical large lips.

The flowers in the album are done in a more restrained manner with less colour. The picture of dandelions in particular is magnificent as the thickly applied yellow colour makes the flowers pop out at the viewer. Nanrei characterises his animals as he does the figures, capturing the hulking mass of an ox or the quickness of a badger (*tanuki*) with great economy.

ACCORDION-FOLDED ALBUM CONTAINING TWENTY-SEVEN DOUBLE PAGE PAINTINGS

INK AND COLOUR ON PAPER

SIGNATURE: *Nanrei ga (?)* (PAINTING BY NANREI)

NO SEAL

27.4 × 39.3 EACH

1973.116

Purchased with the aid of the Friends of the Ashmolean and Mr and Mrs J. Hillier

Suzuki Nanrei was a Shijō school artist who studied with Watanabe Nangaku, the artist credited with bringing the school's method from Kyoto. Nanrei is also recorded as the pupil of Azuma Tōyō (1755–1839) and Okamoto Toyohiko (1773–1845). In his later career, he became the official painter for the daimyo of Tamba province. Along with sketches, Nanrei is most well known for his many *surimono* and designs for illustrated books.[3]

1 Volume three is published in part in Jack Hillier, *The Harari Collection of Japanese Paintings and Drawings*, vol. 3 (London: L. Humphries, 1970–73), fig. 271; Hillier, *The Harari Collection of Japanese Paintings and Drawings: An Exhibition Organized by the Arts Council at the Victoria and Albert Museum, 15 January–22 February 1970* (London: Arts Council of Great Britain, 1970), fig. 44; and Hillier, *The Uninhibited Brush: Japanese Art in the Shijō Style* (London: Hugh M. Moss Ltd., 1974), 311–313. Sections of the Ashmolean's album are also published in J. R. Hillier, *Great Drawings of the World: Japanese Drawings from the 17th to the end of the 19th Century*, (London: Studio Vista, 1965) 114–15, and *The Uninhibited Brush*, 307–10

2 These are dated by Jack Hillier in *The Uninhibited Brush*, 312.

3 Nanrei's works in these formats are discussed in Hillier, *The Uninhibited Brush*, 315, and Hillier, *The Art of the Japanese Book*, vol. 2, 772–9.

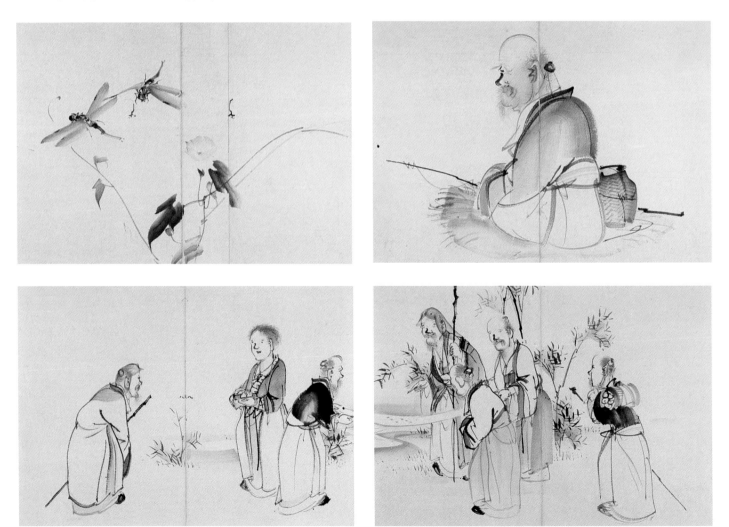

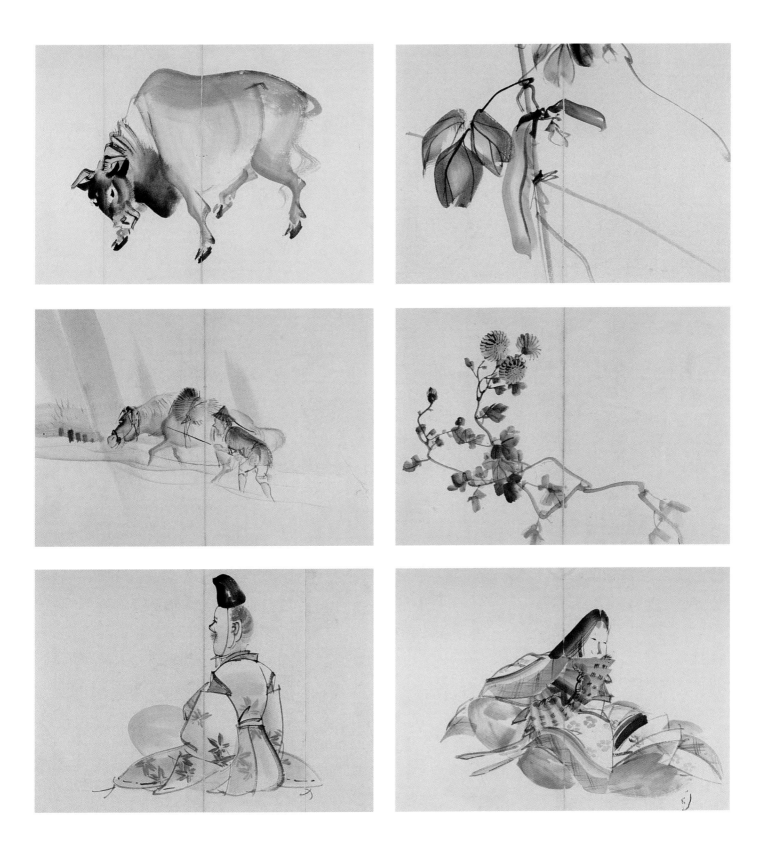

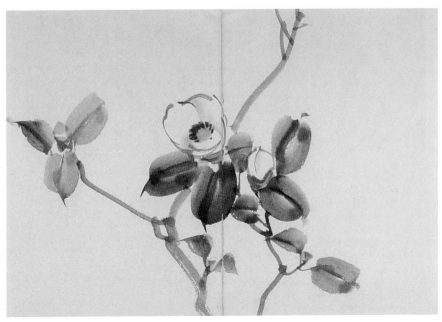

35

Onishi Chinnen 大西椿年
1792–1851

Miscellaneous subjects, 1838

Chinnen has painted sixteen scenes of flowers and grasses, insects, fruits and sea life. It is the first of a set of three handscrolls, the other two scrolls are in the British Museum[1] and the Chester Beatty Library in Dublin. The Ashmolean's handscroll is dated 1838 (2nd month, 21st day) at the end of the scroll. All of the subjects have been rendered with a very broad brush to apply washes of ink. In the image of a camellia (*tsubaki*), the side of the brush has been used for the leaves while its tip was used to make the flower's outline. The veins of the leaves done in black ink were applied while the green pigment was still wet so they have intentionally blurred. In another scene, the segments of the body of a lobster (*ebi*) are each drawn with one stroke of the brush. The effect is that the lobster's joints appear realistically soft and flexible.

Jack Hillier first published segments of this handscroll in *The Uninhibited Brush*,[2] in which he compares an image of turtles from the handscroll to a picture of the same subject in the artist's printed book of 1834, the *Sonan Gafu*,[3] which he hails as one of the highpoints of the print medium. The Ashmolean's handscroll is valuable in that it gives us an idea of what type of paintings the printed blocks were modelled on.

Chinnen was a native of Edo who first studied the Maruyama style under Watanabe Nangaku when he came to the capital, as did Suzuki Nanrei. Like Nanrei, the artist of the previous entry, Chinnen was an extraordinarily talented artist who was adept at conveying the essence of a form with an economy of brushwork.

1 The handscroll in the British Museum is dated 1837 and came from the Harari collection. It is published in Hillier, *The Harari Collection of Japanese Paintings and Drawings*, vol. 3, 504–6.

2 *The Uninhibited Brush*, 315–25.

3 A copy is in the British Museum.

HANDSCROLL

INK AND COLOUR ON PAPER

SIGNATURE: *Chinnen*

SEAL: *Taiju*

28.5 × 658.8 CM

1973.132

Purchased with the aid of the Friends of the Ashmolean and Mr and Mrs J. Hillier

36

Onishi Chinnen 大西椿年
1792–1851

Thirty-six Immortal Poets

FAN PAINTING

INK, COLOUR, GOLD DUST ON PAPER

NO SIGNATURE

SEAL: *Sonan*

20.6 × 54.4 CM

X5426

Gift of Dr Michael Harari, from the collection of his father, Ralph Harari

The ever-popular thirty-six immortal poets are traditionally painted individually, sitting ceremoniously with one of their poems inscribed above. However, here Chinnen shows the poets, who were not contemporary with one another, all huddled together in one place. Moreover, the scene is clearly an undiginified one, as each poet appears to be in various stages of discomfort. One poet wearily rests his head on his hand, another tugs at his collar, others stroke or scratch their faces, and the courtier in front of the curtain has even fallen asleep.

This kind of composition showing all of the poets together in one room was made popular by Sakai Hōitsu (1761–1828), an artist in the Rimpa lineage. The two most well known examples are a two-fold screen in the Freer Gallery of Art, as well as one in the Shin'enkan collection.[1] The humorous image was later copied by other artists of the Rimpa school as in Suzuki Kiitsu's (1796–1858) version, a hanging scroll in the British Museum.[2]

Chinnen was known in particular for his creative compositions in his illustrated books, most notably the *Sonan Gafu* of 1834 which has a playful rendition of the poet Murasaki Shikibu.[3] In the Ashmolean's fan, he has taken inspiration from the Rimpa style, and has even used an oversized seal reminiscent of artists of that school. However, Chinnen's rendering is more in keeping with the Shijō manner than those by later Rimpa artists. For example, the faces are much less caricatured, and the robes and other forms are painted without the exaggerated curves often seen in works of the Rimpa school.

1 The work in the Freer Gallery of Art is reproduced in Takeda Tsuneo, Yamane Yūzō, Yoshizawa Chū, eds, *Jinbutsu-e: Yamato-e kei jinbutsu, Nihon byōbu-e shūsei* vol. 5 (Tokyo: Kodansha, 1981), 64, and the Shin'enkan Screen is published in Osaka Municipal Museum of Art, *Shin'enkan korekushon: umi o watatta Nihon no bi* (Osaka: Osaka Municipal Museum of Art, 1985), 72.

2 Published in Hirayama Ikuo and Kobayashi Tadashi, *Daiei hakubutsukan, Hizō Nihon bijutsu taikan* vol. 3 (Tokyo Kodansha, 1982), plate 32.

3 See Owen E. Holloway, *Graphic Art of Japan: The Classical School* (London: Alec Tiranti, 1957), plate 84.

37

Hirada Gyokuon 平田玉蘊
1787–1855

Obon Festival Scene

The female painter Hirada Gyokuon is little known today, though she gained quite a reputation for herself during her lifetime. In recent years, interest in this artist has increased, especially in her hometown of Onomichi in Hiroshima which was host to an exhibition of her work in 1998.[1] Many details of her life have been reassessed and the scope of Gyokuon's oeuvre is beginning to be pieced together. *Obon Festival Scene* is the most energetic composition of her rare genre scenes, introduced here for the first time.

A crowd of over one hundred people are shown involved in various activities during the *obon* festival. This Buddhist event is traditionally celebrated in August (the 13th–15th of the 7th month on the lunar calendar) in order to give the souls of the departed some relief from the pains of the hereafter. It is anything but a sombre event and, although there are regional differences, today the occasion is usually marked by people in brightly coloured summer kimono with decorated fans dancing in groups after dark. In addition to this, in the Edo period the celebration included several other elements depicted in this image. In the foreground is a scene particular to the Southern part of Honshū where the artist was born: oversized umbrellas are raised above a crowd of merrymakers carrying drums, playing the *shamisen*, wearing masks and dancing.[2] In the middle distance a large banner is hoisted with a figure of the strongboy Kintarō riding a wild boar which reads 'Kubo', the name of a town which is part of Onomichi. The lanterns that a few figures are holding are an important element of the *obon* period as they are said to light the way for the souls. In the distance, a small group dances the characteristic folk dance with their arms raised.

Gyokuon was a revolutionary figure in Edo period Japan. She never married, but instead devoted herself to her career and ran her own studio where she taught pupils. Her father Goho was also a painter who had studied with Fukuhara Gogaku (1730–1799), a Nanga painter from whom she also received instruction. Her main teacher, though, is acknowledged to be Hatta Kōshū (1760–1822), a Maruyama school painter in Kyoto whom she would travel to meet. Early in her career, her work caught the attention of the well known scholar and cultural leader Rai Sanyō

HANGING SCROLL

INK AND COLOUR ON SILK

SIGNATURE: *Gyokuon*

SEALS: *Hirada uji no in tomo*; *Gyokuon*

121.5 × 57.0 CM

1973.136

Purchased with the aid of the Friends of the Ashmolean and Mr and Mrs J. Hillier

(1780–1832) from Kyoto, probably because she had been studying Chinese poetry with Rai Shunsui (1746–1816), Sanyō's father, who inscribed Gyokuon's painting on at least one occasion.[3] Soon her paintings were in demand and her career flourished, however after what was probably a failed love affair with Sanyō, she was shunned by many. Gyokuon also decorated sliding doors in temples, very rare for a female artist.[4]

At the beginning of her career, her painting subjects were mostly Chinese figures, however later her attention turned to genre scenes and bird and flower subjects as well as landscapes. Her works vary from formal compositions to more sentimental scenes of daily life to sketches of wildlife made from observation.[5]

1 Onomichi Municipal Museum of Art, *Hirada Gyokuon ten: saikō no gaka* (Onomichi: Onomichi Municipal Museum of Art, 1998)

2 Nishitsunoi Masayoshi, *Nenjū gyōji jiten* (Tokyo: Tokyodō shuppan, 1958), 750.

3 This is a picture of Shi Ro, a Chinese scholar, published in Onomichi Municipal Museum of Art, 20.

4 For example, *Paulownia and Phoenix* in the Jikanji temple in ibid., 51.

5 For the latter, see *Birds of the Four Seasons*, ibid., 56.

38

Kishi Ganryō 岸岸良
1798–1852

Renshōbō (Kumagai Naozane 1141–1208)

HANGING SCROLL

INK AND COLOUR ON SILK

SIGNATURE: *Garaku no suke Ganryō*

SEALS: *Ganryō; Ganryō*

INSCRIPTION: *Gyokuju*
(ACTIVE C. 1830–1843),
SEALED 'HERMIT OF THE BAMBOO
GROVE'

119.0 × 41.5 CM

1973.165

*Purchased with the aid of the Friends of
the Ashmolean and Mr and Mrs J. Hillier*

A priest, identifiable from the rosary beads clutched in his hand, sits backwards on a horse. This is a picture of Renshōbō (Kumagai Naozane), a famous warrior who fought valiantly in many of the decisive battles of the Heiji wars of the twelfth century on the side of the Minamoto clan. He is usually shown in one of two guises: as a determined warrior in full armour astride a charging horse and waving a war fan, or like this, after his conversion to Pure Land Buddhism. Legend has it that Nobuzane chose to enter religious life when he was called upon to kill the son of his enemy, a boy who looked very much like his own son and shared the same birthday.[1] Other accounts say that it was after he heard the words of the saint Hōnen, whose disciple he became. Wanting to face the Western Paradise, Renshōbō sat on a horse backwards as he came along the Tōkaidō road.

The inscription is by Gyokuju, a chief priest of the Daikoin subtemple of Kyoto's Bukkōji temple. Gyokuju himself was known to paint landscapes and figural subjects.[2] He took the words of Nikkei Hōrin (1693–1741), a scholar of the Jodo shinshū faith and fourth head teacher at Nishihonganji temple in Kyoto.[3] The painting was probably done on the anniversary of Hōrin's death, the Western Paradise being a reference to death and rebirth. The inscription is read unusually from left to right, the same direction that the priest faces:

可嘆本願大磁石	It is a pity that my wilful nature is as stubborn as a large lodestone,
今此族機向西方	Today, this hidden nature [is to be found by] facing the Western Paradise
日渓法霖師讃	Eulogy by Master Nikkei Hōrin
七十五叟玉樹書	written by Gyokuju at age seventy-five.[4]

Ganryō was the adopted son of Kishi Ganku, the founder of the Kishi school of painting. The Kishi school can be regarded as an offshoot of the Maruyama/Shijō manner with more energetic brushwork. Ganryō came into the service of Prince

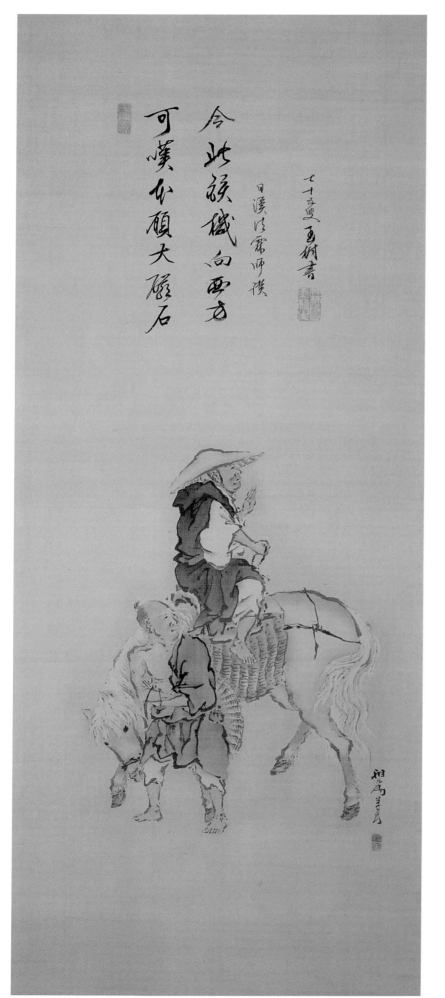

Arisugawa and the Imperial Court, positions he inherited from Ganku. Ganryō continued Ganku's use of agitated, short strokes to great effect. Among his known paintings are *Cranes in the Sun* and *Carp among Rapids*, a pair of two-fold screens in the Musée National des Arts Asiatiques-Guimet in Paris.[5]

1 Hiroshi Kitagawa and Bruce T. Tsuchida, transl., *The Tale of the Heike* (Tokyo: University of Tokyo Press, 1977), 561–3.

2 Araki, Tadashi, ed., *Dai Nihon shoga meika taikan*, vol. 1 (Tokyo: Daiichi Shobō, 1975), 423.

3 For Hōrin, see Kokushi daijiten henshū iinkai, ed., *Kokushi daijiten* vol. 12 (Tokyo: Yoshikawa Kōbunkan, 1984), 679.

4 My thanks again to Dr Cary Liu for the translation.

5 *Paintings of Musée National des Arts Asiatiques-Guimet, Paris, Japanese Art in Foreign Collections* vol. 6, 95.

39

Shibata Zeshin 柴田塵真
1807–1891

Melon (makuwa-uri)

MINIATURE MATTED PAINTING

INK AND COLOUR ON SILK

SIGNATURE: *Zeshin*

SEAL: *Shin*

8.6 × 7.0 CM

1973.111

Purchased with the aid of the Friends of the Ashmolean and Mr and Mrs J. Hillier

This tiny painting of a melon has been deftly executed on silk. Such a large fruit, with even larger, broad leaves is an interesting choice for a diminutive composition. The dark green pigment of the vegetable has been painted over a lighter shade of green. This colour combination is reversed in the lighter-coloured leaves that have darker-toned veins. The strong dominant shapes and sharp diagonal formed by the leaves and flower at the top is a compositional device mastered by Zeshin.

It is difficult to date this painting, as with all of Zeshin's works, although it is probably from the artist's later career. The same combination of signature and seal is seen in a lacquer painting (*urushi-e*) album in the Yamatane Art Museum with Zeshin's age, seventy-one, written before his name, making it a work of 1877.[1] At this later stage, Zeshin's interest in the miniature became pronounced as evidenced in particular by his many lacquer painting albums.[2] We can also see a move to the miniature in Zeshin's lacquer objects, such as several *inrō* dateable to his later life.[3]

Yet there are some inconsistencies with the chronology beginning to form of Zeshin's career. Seals with the singular character of 'Shin' as seen here are thought to have been used by Zeshin in 1832. The signature on *Melon*, however, most closely resembles a work of the mid 1840s or slightly later.[4] Nevertheless, *Melon* is a charming work by Zeshin, published here for the first time, which will add to our skeletal understanding of the artist's career.

1 See Itabashi Art Museum, *Shibata zeshin ten: bakumatsu meiji no seika kaiga to shikkō no sekai*, (Tokyo: Itabashi Art Museum, 1980), fig. 10.

2 For example, a painted album dateable to 1881 of paintings of the twelve months in the Honolulu Academy of Arts is 11.5 x 8.9 cm, an album of ten lacquer paintings also in Honolulu measuring 12.1 x 8.7 cm is dateable to the late 1870s, and an album of eighteen lacquer images from the Khalili collection of c. 1879–90 measures 11 x 8.5 cm. For the first two examples, see Howard Link's exhaustive study, *The Art of Shibata Zeshin: the Mr and Mrs James E. O'Brien Collection at the Honolulu Academy of Arts* (London: R. G. Sawers Pub., Honolulu: Honolulu Academy of Arts, 1979), 93–6, 90–92. For the last example, see Joe Earle, *Shibata Zeshin: Masterpieces of Japanese Lacquer from the Khalili Collection* (London: Kibo Foundation, 1997), 59–68.

3 Earle, 31–56 and Link, 144–5

4 See Link, 187–8, where the seal on the Ashmolean piece is the same as the one reproduced as number 22. The signature resembles that on *Symbols of the Weavers' Festival*, catalogue number 12, page 52.

40

Shibata Zeshin 柴田塵真
1807–1891

Tiger and Bamboo

An airborne tiger comes bounding towards us, claws outstretched, with a mischievous grin on its face. In the foreground, a few stalks of bamboo give way to seemingly giant tiger tracks. One would expect the tiger to be among the bamboo, as in other paintings of this well-loved subject, however, our surprise comes as we look up and see the tiger in the distance.

Zeshin has painted the elements very loosely in ink with just a touch of reddish wash on the tiger. The simplification of the composition down to two or three elements as well as leaving large blank areas is characteristically Zeshin. For example, in *Butterfly and Flowering Plant* in the Honolulu Academy of Arts, Zeshin paints one of a pair of handscrolls with only a small butterfly making its way down to the flowers on the other scroll.[1] The similarity to that painting in terms of the composition and the style of the signature makes it likely that *Tiger and Bamboo* dates to Zeshin's middle period (1832–40). The seal reading 'Koma', however, has heretofore been believed to have only been used on Zeshin's lacquer paintings, as the name comes from lacquer artist Koma Kansai II, Zeshin's teacher.[2] It is the author's wish that the publication of *Tiger and Bamboo* here will prompt further study to determine how this painting may fit into the chronology of Zeshin's career.

Paintings of tigers and bamboo, often paired with dragons and clouds, have been a common subject in ink painting since the Muromachi period, when Chinese ink paintings of this theme entered the collection of the Ashikaga shoguns. While the compositions vary to a great extent, Zeshin's painting with its footprints and flying tiger is uncommonly humorous.

HANGING SCROLL

INK AND SLIGHT COLOUR ON PAPER

SIGNATURE: *Zeshin*

SEAL: *Koma*

112.0 × 33.7 CM

1973.176

Purchased with the aid of the Friends of the Ashmolean and Mr and Mrs J. Hillier

1 Published in Link, *The Art of Shibata Zeshin*, 40–41.

2 Ibid., 62. The seal here most closely resembles that reproduced on page 191, no. 34, which is exactly the same size (3.0 x 1.8 cm) as the Ashmolean's painting. In addition, the silk has been examined and appears to be the type of tight weave used by Zeshin for his other paintings on silk. I would like to thank Ephraim Jose for his assessment of the painting's silk.

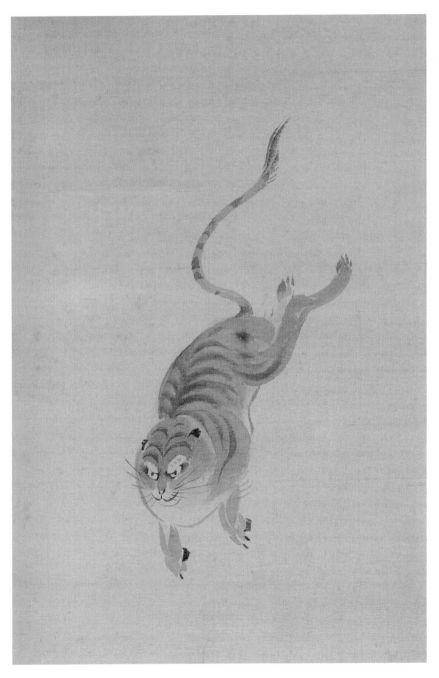

41

Attributed to Shibata Zeshin 柴田塵真
1807–1891

Chrysanthemums

MATTED LACQUER PAINTING (*urushi-e*)

SIGNATURE: *Zeshin*

SEAL: *Reisai*

LACQUER, COLOUR AND GOLD ON PAPER

19.6 × 15.5 CM

1966.161

Gift of Victor Rienecker

Zeshin was an extraordinarily innovative artist who rose to fame for his participation in the great expositions of the Meiji era. His earliest formal study beginning in 1817, was as a lacquerer apprenticed to Koma Kansai II (1766–1835). Shortly thereafter in 1822, Zeshin developed his skill as a painter under the tutelage of Suzuki Nanrei, whose comical paintings, such as that of an album reproduced in this catalogue, must have made a strong impression on Zeshin. Soon Zeshin was encouraged to move to Kyoto and began studying with Shijō artist Okamoto Toyohiko (1773–1845), before settling in Edo. In addition to his skills as a lacquerer and painter, Zeshin was adept at *haiku* poetry and a practitioner of the tea ceremony. Zeshin's long artistic career is marked by several striking innovations in lacquer technique and compositional layout. These two interests come together in the lacquer paintings, or *urushi-e,* of his later period. For these, he invented a method of mixing colour with a kind of lacquer that would not crack when applied to a flexible surface such as paper or silk.

Here, a single stem of chrysanthemums with three flowers in full bloom juts out diagonally across the image. Several features of this work are unlike the majority of Zeshin's other lacquer paintings. The graduated gold dust background is much less common than his well-known lacquer paintings that have a solid, overall gold background. The leaves of the chrysanthemum are more muddy and less skilfully done than those in many other lacquer paintings by the artist, and the composition lacks the type of dynamism seen in such works as an album in the Tokyo National Museum.[1]

However, these differences may be explained by the presence of the seal reading 'Reisai' of Zeshin's earlier years. Only one other lacquer painting can be attributed to this early period,[2] which pushes back the date of Zeshin's experimentation with lacquer on paper to the mid-1830s. The authenticity of *Chrysanthemums* will have to be determined with further study.

1 This album is published in Itabashi Art Museum, fig. 7.

2 *Wild Grass and Lotus*, published in Link, *The Art of Shibata Zeshin*, 46, 53.

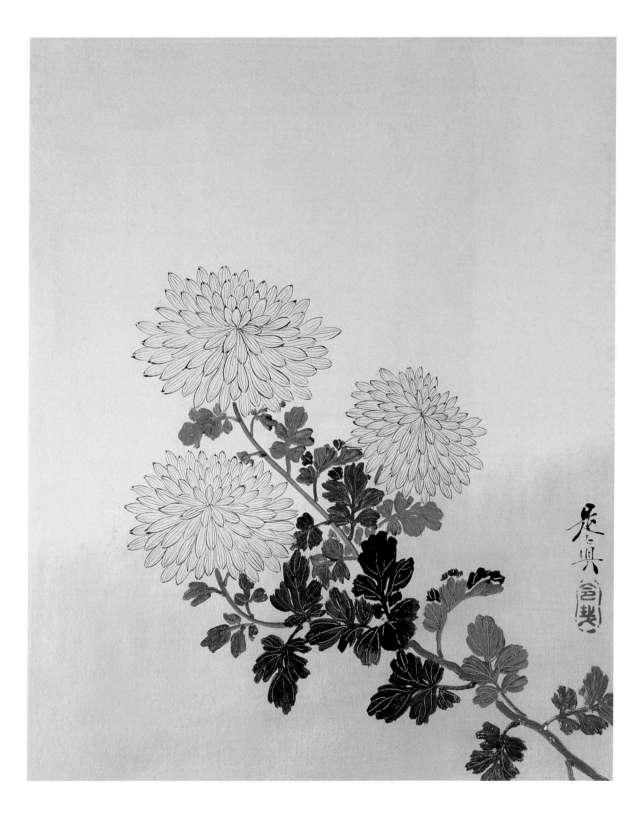

42

Nakajima Yūshō 中島有章
1837–1905

Shōka (Xiao Ho) following Kanshin (Han Xin) by Moonlight

Yūshō is much less well known than his teacher Nakajima Raishō as an artist of the Maruyama school of painting in Kyoto at the end of the nineteenth century. Like Raishō, he excelled in painting horses.

The story seen here is one of two Chinese heroes of the Han dynasty (206 BC–AD 220). Of his own accord, the local official Shōka has set out to bring back the warrior Kanshin. After not eating for three days during his pursuit, we see the moment when Shōka first catches sight of Kanshin. Upon their return, Shōka is scolded by Duke Liu Bang (J: Ryūhō) for leaving without permission, especially to go after such a useless man when Shōka himself is so vital. Shōka explains that Kanshin is an excellent warrior, and while others may run away and return, once Kanshin leaves he would be gone forever. Liu is then persuaded to make Kanshin a general of the highest level. With the help of Kanshin's ability in the battlefield, Liu becomes the emperor and founder of the Han dynasty.

The legend of Shōka and Kanshin can also be seen on Chinese porcelain,[1] and probably made its way to Japan on such objects or as the subject of woodblock printed illustrations. In the Edo period, the story was taken up by Japanese artists such as Yosa Buson in one side of a pair of six-fold screens.[2]

1 See Toyomasu Yasumasa, 'Chūgoku tōji ni miru moyō (12)- Jinbutsu (6)- Shōka to Kanshin', in *Tōsetsu* 560, 54–6.

2 Published in Toda Teisuke et al., *Kangakei jinbutsu, Nihon byōbu-e shūsei*, vol. 3, plates 62, 63, pages 68, 139–40.

HANGING SCROLL
INK AND COLOUR ON SILK
SIGNATURE: *Yūshō*
SEAL: *Yūshō*
124.0 × 57.5 CM
1973.184

Purchased with the aid of the Friends of the Ashmolean and Mr and Mrs J. Hillier

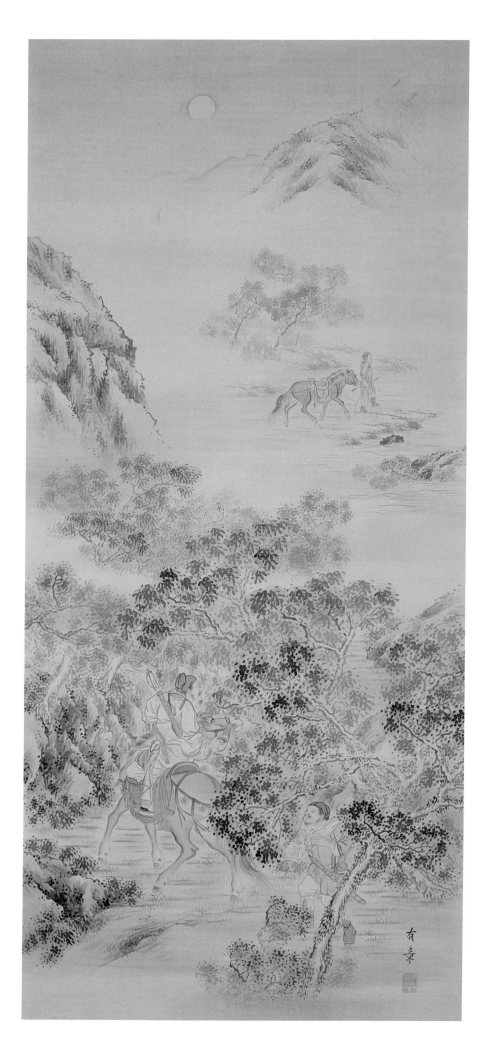

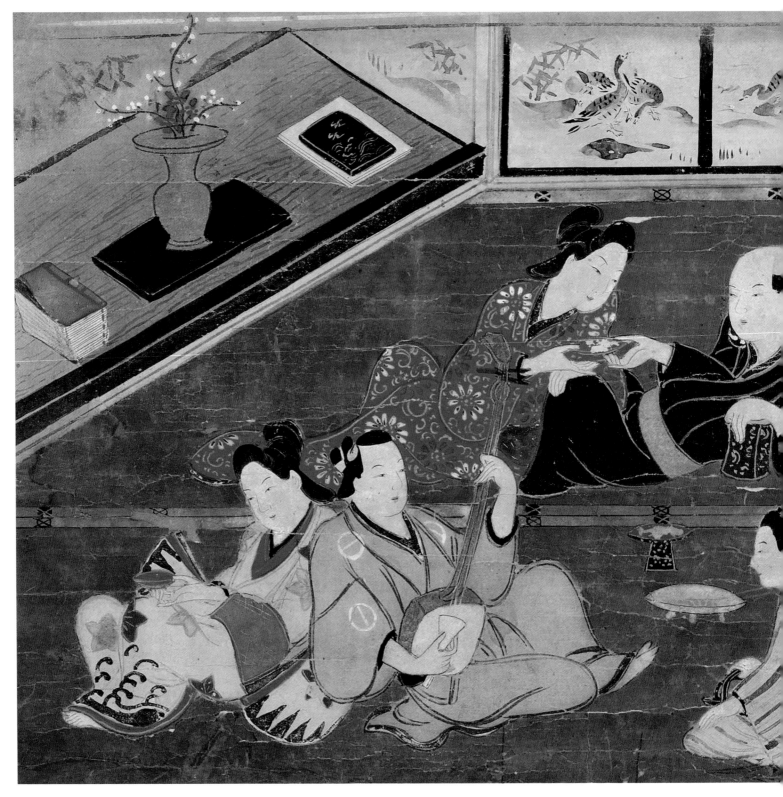

Anonymous, *Scene in the Pleasure Quarters, c. 1670–85* (detail from Cat. 52).

The 'Japanese' Schools: *Yamato-e*, its Revival, *Rimpa* and *Ukiyo-e*

Though the majority of Japanese paintings in the Ashmolean Museum are by artists of the Maruyama/Shijō and Nanga schools, as discussed in the previous sections, some of the most noteworthy paintings in the collection fall outside of these traditions. The artists treated in this section can be termed painters of the 'Japanese' schools, as their subject matter and painting style ultimately hark back to Japan's golden age of court painting, the Heian period. This time in Japanese history marks the development and promotion of native modes of calligraphy (*kana*), poetry (*waka*) and architecture (*shinden tsukuri*) that distinguished themselves from those inspired by predominantly Chinese examples. While the influence of China was still keenly felt, it was the first time that a distinctly Japanese means of expression was consciously developed in these arts. Works painted by court artists of the *Edoko-ro* (academy of painters) produced what is known as *Yamato-e* (lit. pictures of Yamato, or Japan). This painting style, popular among the Fujiwara nobles, featured the ceremonies of the court, the native scenery, the seasons, *waka* poetry or fictional court narratives. The National Treasure *Tale of Genji* handscroll dating from the first half of the twelfth century was created at this time. Its gem-like colours, carefully described gestures and dramatic architectural elements combine to give the images a strong emotional impact that still resonates with viewers today.

In the Edo period, several strains of *Yamato-e* were thriving simultaneously. It is difficult to lay out a clear explanation of the emergence and subsequent flourishing of each, as the proliferation of styles in the Edo period was not confined by school or geographical boundaries. For our purposes here, however, a brief mention of the historical circumstances of each school or group is in order.

The inheritors of the legacy of the earliest court painters were the Tosa school artists who painted for the imperial court in Kyoto from the fifteenth century. These artists specialised in small format works that utilised bright mineral pigments and a generous amount of gold. Their subjects were historical events, fictional court tales and poetry of the Heian and Kamakura periods. In the Edo period, such works appealed not only to the sequestered courtiers in Kyoto, but also

to wealthy Kyoto merchants and the shogunate in Edo, who were both interested in adopting the rich imperial cultural history for themselves as markers of status.

The *Tale of Genji* album (Cat. 44) in the Ashmolean's collection, dateable to the late eighteenth to early nineteenth centuries, appears to be the product of a Tosa school studio or a studio with access to Tosa school models. It was probably made for a wedding, and would have been included in the bride's trousseau. In the album, twelve miniature paintings illustrate scenes from the tale in splendid detail. The calligraphy pages are poems based on the five virtues of filial piety (*gojō*) by premier calligraphers of the age. The poems, meant to instruct, are a fitting accompaniment to the Genji scenes, as the tale was upheld as a moral guidebook for women in Edo period society. Also included in this section is a single scene from the Akashi chapter of the *Tale of Genji* (Cat. 43) painted on small *shikishi* format paper that may have been intended for inclusion in such an album or to be pasted on a screen.

An offshoot of the Tosa school was the Sumiyoshi school, official painters to the shogun in Edo from the seventeenth century. The fan paintings by Sumiyoshi Hiroyuki (Cat. 45) and Hironaga (Cat. 46) demonstrate the appeal courtly tales and styles had for the shogun. However, even the most conservative *Yamato-e* painters such as the Sumiyoshi were not immune to the influences of the Maruyama/Shijō schools. One traditional technique of *Yamato-e* painters is called *tsukuri-e* (lit: 'built-up' picture), referring to the application of thick mineral pigments in layers as seen in the *Tale of Genji* album mentioned above. The flowing lines and translucent colours of Hironaga's painting of Sei Shōnagon, however, shows that the *Yamato-e* style could not remain forever static.

The revolution in *Yamato-e* would be complete with the rise of the *Fukko Yamato-e* (Revived *Yamato-e*) painters such as Tanaka Totsugen. Totsugen himself studied with Tosa school artists Mitsusada and Mitsuzane, and was also trained in Kano school techniques and Chinese ink painting. He directly copied numerous works of the Heian and Kamakura period and revived the animated brushwork of these models. He and his fellow *Fukko Yamato-e* artists were loyal to the imperial cause which continued to gain adherents until the eventual overthrow of the shogun in 1867. The political leanings of this group of artists brought a new energy and urgency to the classical subjects of an imperial age gone by. The fan by Totsugen of the aristocrat Minamoto Yorimasa (1104–1180) (Cat. 47) in the Ashmolean is a work of the artist's later years, when he was beginning to lose his sight, but is painted with great economy and skill.

Another strain of *Yamato-e* active in the nineteenth century was the *Rimpa* school of artists bound together by stylistic grounds rather than political ideology.

The *Rimpa* school had its origins with the workshop of Tawaraya Sōtatsu in the seventeenth century, whose style was revived at different points and locations in subsequent centuries. Sōtatsu's compositions often took classic tales as their subject, incorporating individual characters from Kamakura period handscrolls. After Sōtatsu, the compositions of one of *Rimpa*'s most talented artists, Ogata Kōrin (1658–1716), were to impact the work of Sakai Hōitsu (Cat. 50) in Edo, and Nakamura Hōchū and Yoshimura Shūnan in Osaka. Hōitsu was the author of printed compendiums of Kōrin's known works (*Kōrin hyakuzu*), as well as a study into the seals of his stylistic predecessors (*Ogata ryū ryaku inpu*). Nakamura Hōchū similarly revered Kōrin and based his own bold works on Kōrin's compositions, an example of which, *Chrysanthemums* (Cat. 48), is included in this volume. In his fan painting of the poet Kiyohara Motosuke (Cat. 49), Yoshimura Shūnan, an artist with origins in the Kano school, imitated Kōrin's design, thereby demonstrating the cross-fertilisation of schools and styles in the nineteenth century.

Workshops of *machi-eshi* (town painters) easily found customers for paintings in the *Yamato-e* manner throughout the Edo period. With a growing client base, the town painter working in the *Yamato-e* style expanded his subject matter and became a chronicler of the world around him, for example by producing guidebooks and views in and around Kyoto. The six-volume *Record of Famous Sites of the Tōkaidō Road* (Cat. 51), included in this section, was probably the work of a town painter. Though the rendering of the figures is cursory, the pervasive use of gold and its lacquer container illustrate that this was not a work for popular consumption, like the printed travel guides, but was made for the enjoyment of a particular patron.

The last of the *Yamato-e* schools to be treated here is the *Ukiyo-e* (lit. pictures of the floating world) school. Following the town painters who were interested in depicting the world around them, *Ukiyo-e* was originally distinguished by its subject matter. Taking the vital new city of Edo's Yoshiwara pleasure quarters and Kabuki stages as their main sources of inspiration, the *Ukiyo-e* artists painted the famous courtesans and actors of the day. An unsigned image of the pleasure quarters (Cat. 52) dating to the latter part of the seventeenth century gives us a view of the street life of the pleasure quarters complete with parading courtesans, customers hiding their faces, and musical and other delights in the back rooms. Towards the end of the *Ukiyo-e* tradition, Katsushika Hokusai's *Pilgrims at Kasuga Taisha Shrine* (Cat. 53) relates the popular pastimes of the era outside of the Yoshiwara. In this case we get a humorous look at travellers of all walks of life on pilgrimage to a sacred site.

43

Anonymous

Scene from the Akashi chapter of the Tale of Genji, 17th century

SHIKISHI POEM SHEET

INK AND COLOUR ON GOLD-LEAFED
PAPER

NO SIGNATURE

NO SEAL

25.3 × 21.7 CM

1970.94

Gift of Prince Paul of Yugoslavia

In this scene from the Akashi chapter (chapter 13) of the *Tale of Genji*, the protagonist makes his visit to the daughter of a monk in the hills. Genji is full of apprehension, uncertain whether his presence will be at all welcome. On horseback, he travels with several attendants along a pine-covered shore with spring plants dotting their path. Barely perceptible are the shells at the water's edge.

The verse reads:

秋の夜の	Race on through the moonlit sky,
月げのこまよ	O roan-coloured horse,
はがこふる	And let me be briefly with her for whom I long.[1]
雲居いをかけれ	
時もまもみむ	

The once-silver moon has tarnished and is hardly noticeable against the darkened lapis lazuli sky. Other mineral pigments have faded, including the brown of the guide's trousers revealing a colour notation underneath that reads *koi enji* (deep red). In this small painting, details are rendered in such delicate miniature as to seem impossible, yet every finger, toe and strand of hair in a beard is clearly seen. The pattern of Genji's robe and the tassels of the horse's trappings are delicately and carefully done, leaving us in no doubt that this is the work of an artist well versed in painting in miniature, as was the Tosa school in the seventeenth century. The depiction of the scene is a rather standard one including all of the basic elements such as Genji on horseback, a page, a guide pointing the way, and the full moon. Missing here, though, is the roof of the temple for which they are headed.[2]

1 This is translated in Edward G. Seidensticker, *Murasaki Shikubu: The Tale of Genji* (London: Secker and Warburg, 1976), 262.

2 For another depiction of the same scene attributed to an early Edo period Tosa school artist in the Sakai City Museum, see Akiyama Ken and Taguchi Eiichi, eds, *Gōka 'Genji-e' no sekai, Genji monogatari* (Tokyo: Gakushū kenkyūsha, 1999), 74.

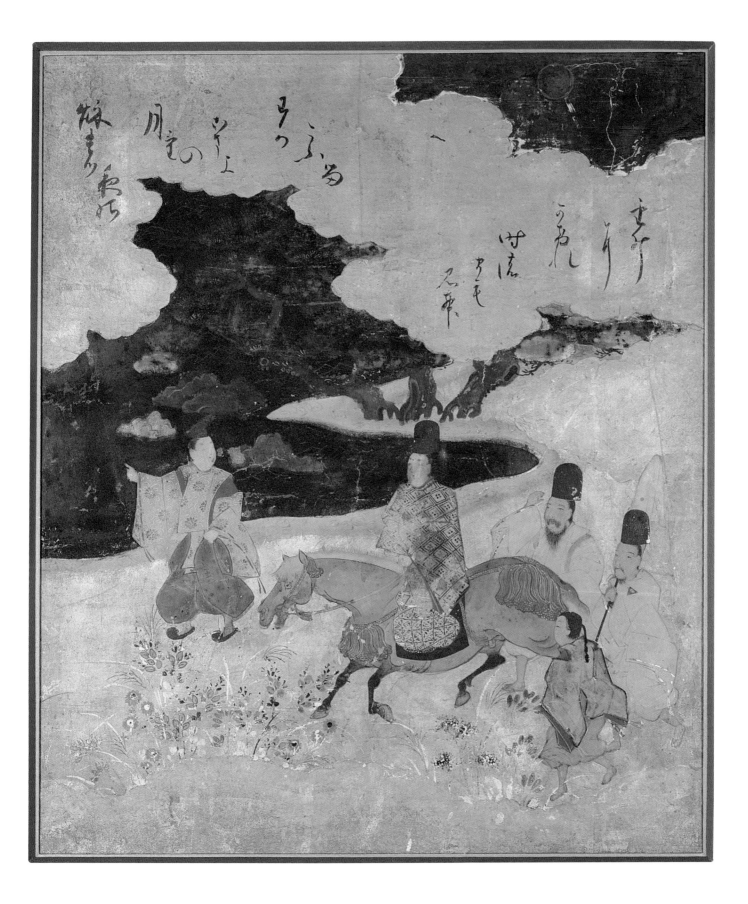

44

Anonymous

Tale of Genji *album, late 18th–early 19th century*

This exquisitely painted album includes a seemingly random selection of only twelve scenes from the fifty-four chapters of the *Tale of Genji*. The paintings are done in the traditional *Yamato-e* manner of the Tosa school, with a few important differences. As described in the essay at the front of this catalogue, some of the painted images deviate from the standard depiction of these scenes in albums of the same subject attributable to Tosa school artists. In addition, an immediately noticeable characteristic of all of the scenes of courtly life is the extreme elongation of the faces.

The scenes appear largely in chronological order from the earliest chapters of the tale and proceed through the story. The last few painted scenes, however, stray from this pattern and seem to depict earlier chapters. Due to the presence of earlier pre-modern repairs, it seems the leaves were salvaged from a more complete album or set of albums that were damaged significantly by water. In the order they appear in the album, the chapters illustrated can be identified as:

Chapter 2, Hahakigi (The Broom Tree)

Chapter 4, Yugao (Evening Faces)

Chapter 8, Hana no en (The Festival of the Cherry Blossoms)

Chapter 9, Aoi (Heartvine)

Chapter 15, Yomogiu (The Wormwood Patch)

Chapter 17, E-awase (A Picture Contest)

Chapter 23, Hatsune (The First Warbler)

Chapter 30, Fujibakama (Purple Trousers)

Chapter 45, Hashihime (The Lady at the Bridge)

Chapter 37, Yokobue (The Flute)

Chapter 51, Ukifune (A Boat Upon the Waters)

Chapter 40, Minori (The Rights)

In 'The Wormwood Patch' illustration, Genji and his men hack through an overgrown garden on their way to a dilapidated house. It is the residence of the Safflower Princess, Jijū, a past love of the prince's whom he has been neglecting. In the dark of night under the moonlight, Genji's man has an exchange with the

ACCORDION-FOLDED ALBUM, FOUR PAGES OF CALLIGRAPHY AND TWELVE PAINTINGS

PAINTINGS ARE GOLD, INK AND COLOUR ON PAPER, CALLIGRAPHY IS INK ON SILK DECORATED WITH COLOUR AND GOLD

27.0 × 22.5 CM

1965.69

Gift of R. Somervell

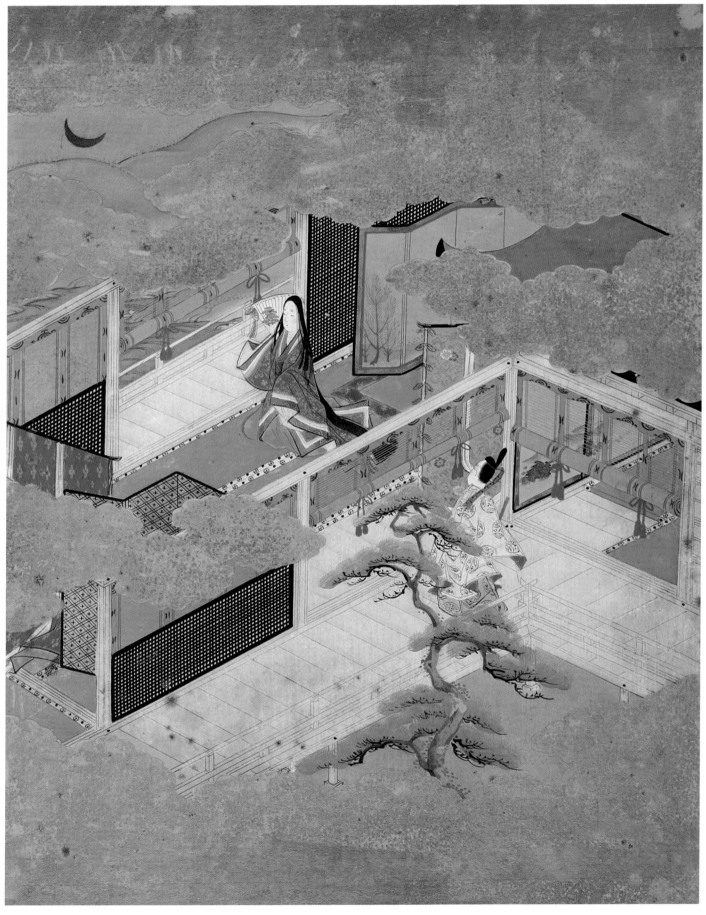

HANA NO EN, *The Festival of the Cherry Blossoms* (chapter from the *Tale of Genji*, late 18th–early 19th century).

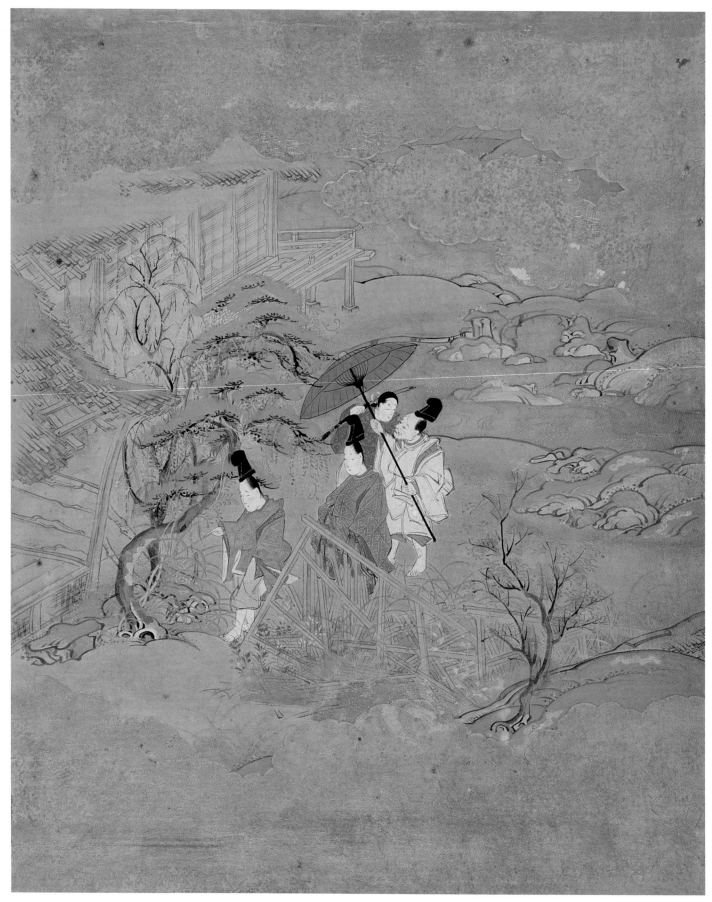

YOMOGIU, *The Wormwood Patch* (chapter from the *Tale of Genji*, late 18th–early 19th century).

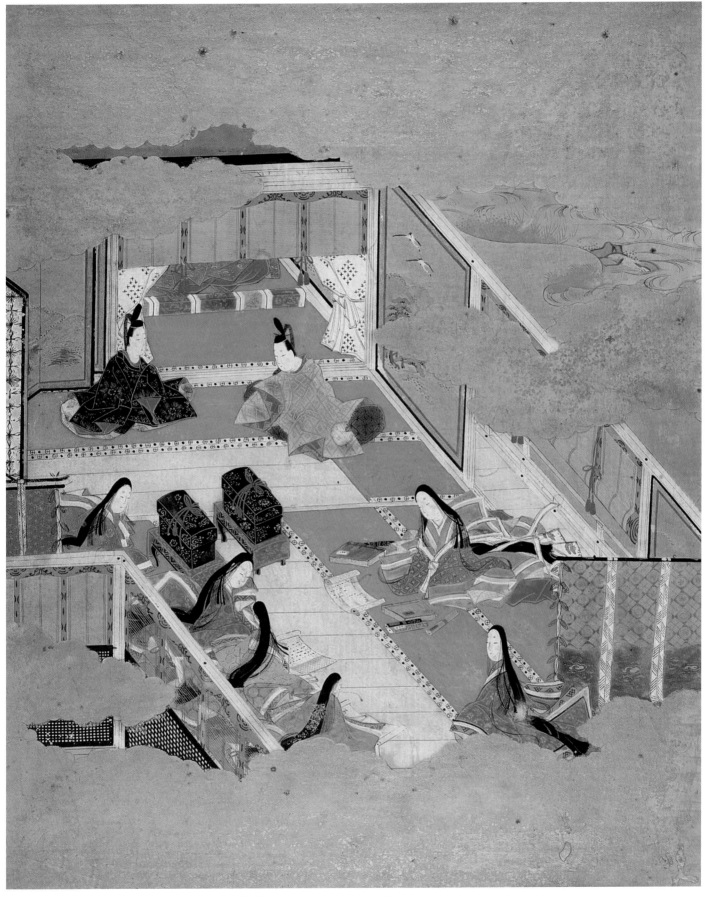

E-AWASE, *A Picture Contest* (chapter from the *Tale of Genji*, late 18th–early 19th century).

elderly maid of the house. Wet and unkempt, Genji finally makes it into the house. The distressed expression of the servant carrying the umbrella is in stark contrast to Genji's composure. It is one of the most evocative scenes in the novel where the description of the setting mimics the inner emotional life of the characters. It is a favourite scene of illustrators of the tale that can be seen in the earliest illustrated version of the early twelfth century.

In the illustration for 'A Picture Contest', two factions of ladies sit unrolling handscrolls. They discuss the various virtues of the paintings before them, trying to outdo one another. First they unroll several scenes from ancient tales, but for the finale in front of the emperor, the Kokiden faction brings out scrolls painted by Genji detailing his time in exile. The painting and the captions of the handscroll before them perfectly reflects Genji's melancholy during those years, and the Kokiden faction wins the contest. The artist of the Ashmolean album has chosen to depict scrolls with poetry rather than paintings, as was the standard for this scene. One of the most elaborate in the album, the scene includes several sumptuously clothed figures and decorated lacquer boxes with details painted in with gold. The artist has even gone so far as to paint gold decoration on the handscroll that the women are discussing.

Word and image come together in this album for a specific instructional purpose. The painted scenes are prefaced by poems based on four of the five Confucian virtues of filial piety (*gojō*) written on lavishly decorated silk. The calligrapher of the poem for *rei* (politeness) can be identified as Reizei no Tameyasu (1735–1816) from his idiosyncratic writing style. The *gojō* poems originally appeared in the fourteenth century text, the *Shūgyokushū*, but were quite popular in the eighteenth century as evidenced by their appearance in woodblock prints.[2] The poems were seen as didactic verses for young women as they negotiated family relationships. Likewise, the *Tale of Genji* itself was also read as a sort of behavioural manual for women to learn the refined manners of the courtly past.[3] The calligraphy and *Tale of Genji* scenes together would have made an appropriate gift for a bride from a wealthy merchant or daimyo family for inclusion in her wedding trousseau.

1 For example, a set of five prints by Suzuki Harunobu (1724–70) illustrate the *gojō* poems. For the set in the Art Institute of Chicago, see Gentles, *Clarence Buckingham Collection of Japanese Prints* vol. 2, 68–70.

2 This is evidenced in the writing of Kumazawa Banzan (1619–1691). See page 36, n20.

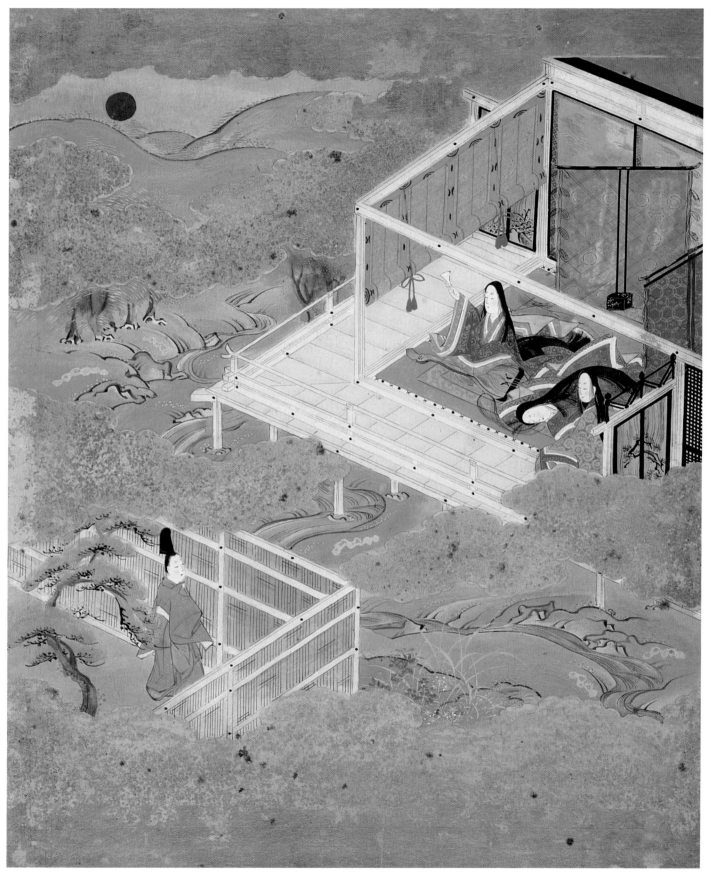

HASHIHIME, *The Lady at the Bridge* (chapter from the *Tale of Genji*, late 18th–early 19th century).

45

Sumiyoshi Hiroyuki 住吉廣行
1755–1811

Scene from the Usugumo chapter of the Tale of Genji

Genji and the Akashi lady sit overlooking a garden on a crisp autumn day in Oi. The shutters have been raised and the blinds have been rolled up to expose the many flowers and grasses of the season in the garden including the red maple leaves, bush clover and *susuki* (pampas) grass. In the distance, cormorant fishermen with their torches lit follow the birds who peer into the water and catch the fish up in their mouths. Though most of the painting is taken up by the activity on the lake and the garden, neither figure looks out at them. He looks at her, and her gaze is cast slightly downward. Though their expressions are minimal, the scene is obviously a melancholy one. Genji has recently taken the Akashi lady's young daughter to live with his wife Murasaki. When he visits the Akashi lady his thoughts are therefore often of a solemn and guilty nature. He remarks that while in China people revere the colours of spring most highly, in Japanese poetry it is the gloomy autumn that is preferred.[1] The Akashi lady recites the poem:

> The torches bobbing with the fisher boats,
> Upon those waves have followed me to Oi.

To which Genji replies:

> Only one who does not know deep waters,
> Can still be bobbing, dancing on those waves.[2]

The *Tale of Genji* is the novel by Murasaki Shikibu (c. 973–1014) about the amorous adventures of Prince Genji. The artist of this fan would have been adept at depicting many scenes from the novel, fluent in the application of the thick mineral pigments, the stiff figural style and the depiction of architectural elements known to him through family archives of models. Sumiyoshi Hiroyuki is a descendant of the line of artists who were official painters to the Tokugawa shoguns. The Sumiyoshi are a branch family of the Tosa artists whose members were the super-intendents of the Imperial Painting Office in the fifteenth and sixteenth centuries. Both schools were proficient in the Japanese mode of painting, *Yamato-e*, which took as its subject the literature and legends of the court's golden age during the

FAN PAINTING

INK, COLOUR AND GOLD ON PAPER

SIGNATURE: *Sumiyoshi naiki Hiroyuki hitsu* (BRUSH OF SUMIYOSHI NAIKI HIROYUKI)

SEAL: *Hiroyuki no in*

20.5 × 52.9 CM

X5400

Gift of Dr Michael Harari, from the collection of his father, Ralph Harari

Heian period. Often in paintings of the *Tale of Genji*, gold clouds serve to soften the boundaries between scenes and help the viewer to focus on the central elements of the painting. In this fan, however, the gold 'clouds' are more like two bands along the upper and lower edges of the composition. They cease to be useful in their original role, and serve only as a reminder of what Sumiyoshi school painting is expected to look like. By this stage, the Sumiyoshi school artists were still highly valued due to their pedigree, but the compositions were sorely in need of an infusion of life. It was this fact that led to the resurgence of *Yamato-e* with a strong new spirit, spearheaded by Tanaka Totsugen.

1 Seidensticker, *Tale of Genji*, 345.
2 Ibid., 347.

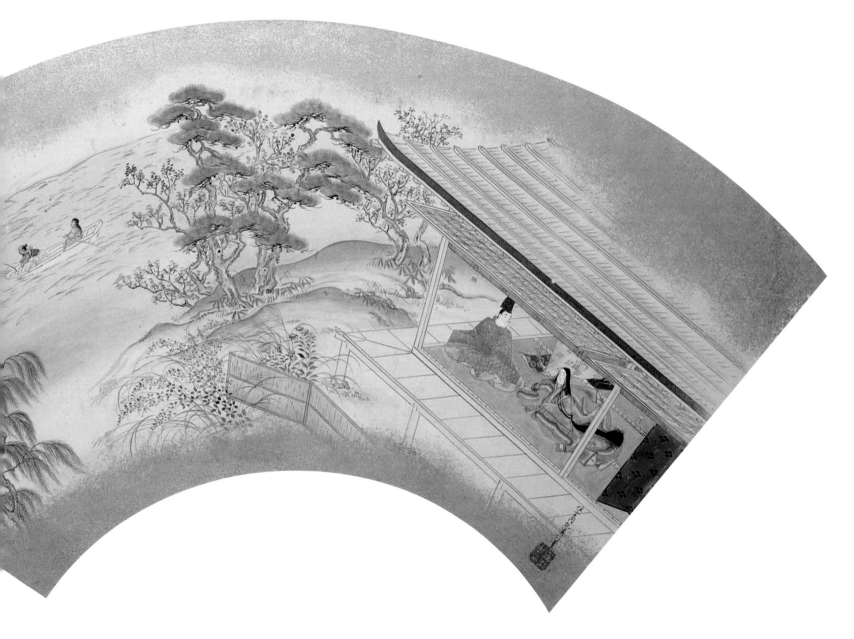

46

Itaya Hironaga 板谷広長 (Keii 桂意)
1760–1814

Sei Shōnagon

Sei Shōnagon gazes out onto a wintry landscape dressed in the many-layered kimono of a court lady. The shutters have been propped up, and she unrolls a *sudare* blind to expose the view across the veranda, out to the pine tree in the garden, and to the distant snow-covered peaks beyond.

This is a scene from the *Makura no sōshi* (*Pillow Book*), a diary written by lady-in-waiting Sei Shōnagon in the late tenth century describing her time at court. During a gathering of the empress and several of her ladies, the empress asks Shōnagon 'How is the snow on Xiang-lu peak', referring to a famous poem by the Chinese Tang period poet Bo Juyi.[1] Quick-witted Shōnagon cleverly understands the empress' meaning and has the shutter raised so that she may roll up the blind and look out, as the poem states was done by Bo Juyi.

Indeed, the artist has drawn Shōnagon with an expression of utter calm and confidence, appropriate considering her contemporaries thought her to be brilliant, yet quite smug.[2] Every element of the painting is delicately rendered from Shōnagon's face to her graceful hands that prop up the bowing *sudare* in the centre. The colours the artist uses are light and washy, especially the red of the under-kimono which is almost transparent. This contrasts with the thick mineral pigments of the courtly tradition popular in the preceding centuries. The architectural elements are rendered with the thinnest of brushes in straight, sure lines. The decorative pattern of her kimono is done in gold and white paint, and the thin lines of the *sudare* are painted right over her figure. A bit of snow piled up in the corners of the shutters as well as dots of white pigment mimicking snowflakes throughout the painting are subtle details. The right edge of the image where the fan would have been attached to the broadest stick is covered with silver foil, appropriate for a winter scene.

Itaya Hironaga was a follower (and brother) of Sumiyoshi Hiroyuki, official painter to the Tokugawa shoguns. The Sumiyoshi, an Edo branch of the Tosa school,[3] were painters of traditional courtly subjects often in intimate formats such as handscrolls and albums, who served the shogunate from the mid-seventeenth century on. Hironaga used the *gō* (artist's name) of Keii later in life, so this fan is thought to be from his later career.

Fan painting

Ink, colour and silver leaf on paper

Signature: *Keii Hironaga hitsu* (brush of Keii Hironaga)

Seal: *Hironaga*

24.2 × 52.5 cm

X5378

Gift of Dr Michael Harari, from the collection of his father, Ralph Harari

1 This is episode 278, 'One day, when the snow lay thick on the ground', translated in Ivan Morris, *The Pillow Book of Sei Shōnagon* (New York: Columbia University Press, 1967), 243.

2 Ibid., xiii.

3 For an explanation of how the Sumiyoshi derive from the Tosa school, see John M. Rosenfield, 'Japanese studio practice: The Tosa family and the Imperial Painting Office in the seventeenth century', in *The Artist's Workshop. Studies in the History of Art*, no. 38, ed. Peter Lukehart (Washington, DC: Center for Advanced Studies in the Visual Arts, National Gallery of Art, 1993), 79–102.

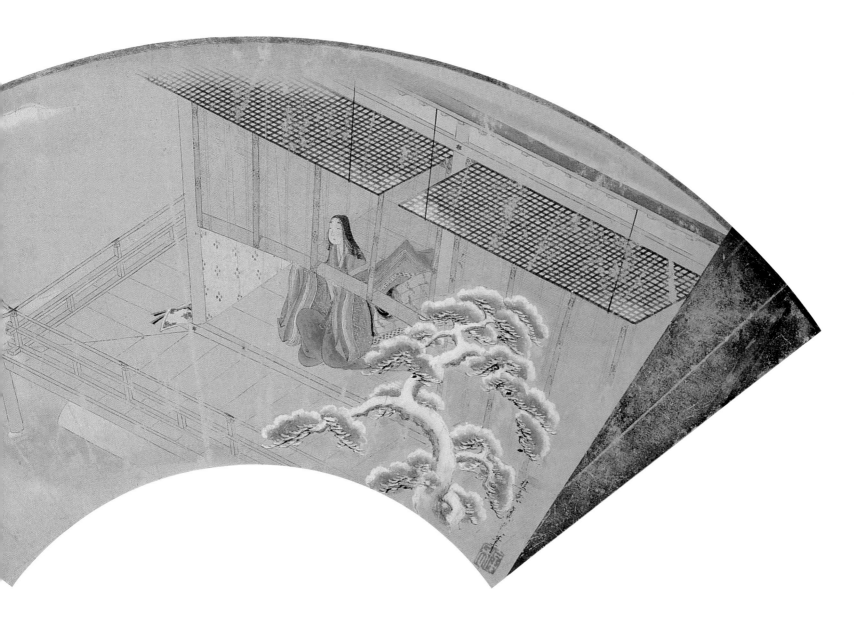

47

Tanaka Totsugen 田中訥言
1760–1823

Minamoto Yorimasa Gathering Nuts

Tanaka Totsugen began his painting career by studying with Ishida Yūtei (1721–1786), an artist of the Kano school. In addition to this, the young artist copied many styles on his own, including Chinese ink painting and Rimpa school works. After Yūtei's death, Totsugen switched to the Tosa school, specialising in subjects from Japanese historical tales and literature. He was a native of Nagoya who moved to Kyoto where he studied under Tosa Mitsusada (1738–1806) and then Tosa Mitsuzane (1780–1852). In 1788, at the young age of twenty-two, Totsugen was given the honorary title of *hokkyō* (Bridge of the Law), usually reserved for artists who have proven themselves through decades of work. By 1790 he had achieved such fame that he produced paintings for the newly built Imperial Palace.[1] He is credited with spearheading the *Fukko Yamato-e* movement, or *Yamato-e* revival, because he took his cues from Heian and Kamakura period artwork of that tradition. He would copy and therefore preserve scores of older works by a method called *hakuraku utsushi* whereby peeling pigments are taken off the original and incorporated into a new, exact copy. Totsugen's own individual style was based on the animated brushwork of these models, quite unlike contemporary Tosa or Sumiyoshi school artworks. In addition, he pioneered new compositions of historical figures and legends that emphasised different events in Japanese history than the usual *Yamato-e* repertoire.

A barefoot courtier bends down to brush the ground in front of him where some nuts lie. His brow is furrowed and he gingerly pulls aside his sleeve. Colour has been added to the figure along the outlines only in the palest of washes for the hands, foot and *hakama* trousers, and his garment is covered with mulberry leaves painted in gold.[2] The composition is extremely minimal: nothing of a setting is provided except for the round chestnuts which rest on an invisible ground.

The figure is that of Minamoto Yorimasa (1104–1180), a prominent military figure in several key battles in the twelfth century when a succession of emperors needed to assert their authority against rivals backed by the military house of the Taira. Yorimasa was himself of aristocratic birth, and was an accomplished poet. His verses are included in the poetic anthologies of the period such as the *Shin kokinshū* and *Senzai wakashū*. His most famous legendary battle was with the

FAN PAINTING

INK AND COLOUR ON PAPER

SIGNATURE: *Totsugen*

SEAL: *Kaison*

18.8 × 51.0 CM

X5425

Gift of Dr Michael Harari, from the collection of his father, Ralph Harari

166

grotesque animal known as a *nue* in the grounds of the Imperial Palace. He defeated the animal at night when it made itself known through its cry. Here, Totsugen illustrates a scene based on Yorimasa's famous poem:

One who lacks access
to a means of climbing
must be satisfied
simply to gather up nuts
under the sweet chestnut tree.[3]

The word for fourth rank, or *shii*, is a homonym for the word chestnut in Japanese. Therefore the poem is meant to express Yorimasa's frustration at remaining a noble of the fourth rank. He rose to the third rank shortly after reciting this poem.

The seal on this painting reads 'Kaison', which roughly translates to 'in the dark', a seal that Totsugen began to use in his forties when his sight was failing. As one can imagine, works from this period in the artist's life are rare compared to his earlier output.[4] Gradually his eyesight continued to worsen until he could no longer paint.

1 These were two cedar door paintings of birds and flowers. See Muramatsu Shōfū, *Honchō gajinden*, vol. 1 (Tokyo: Chūō kōronsha, 1985), 258.

2 Another painting of Yorimasa depicting a different episode was done by Totsugen in which the figure's face and clothing are identical to the Ashmolean fan. This is published in *Fukko yamato-e ha Totsugen Ikkei Tamechika gashū* (Kyoto: Taigadō, 1943), fig. 4.

3 This is translated in Helen Craig McCullough, *The Tale of the Heike* (Stanford: Stanford University Press, 1988), 162

4 Hosono, 161.

48

Nakamura Hōchū 中村芳中

FL. LATE 18th–C. 1813

Chrysanthemums

On this fan, Hōchū has painted pom-pom-like bunches of chrysanthemums coloured lightly with a pink pigment. The flowers' leaves are done with a mixture of malachite green and ink that blended together on the paper while the paint was still wet. This technique, known as *tarashikomi*, was one of Hōchū's great talents.[1] Aside from *tarashikomi*, Hōchū was also adept at *tamekomi*, a technique whereby a dry brush absorbs wet pigment after it has been applied to the paper or silk. This small composition further stands as testament to Hōchū's experimental painting techniques as it is a finger painting. It seems the outlines of the flowers' petals were done with the artist's fingernails and the pigment for the leaves and pink of the flowers was applied with his fingertips.

A record of 1794 states that Hōchū was particularly well known for his finger paintings.[2] Hōchū's knowledge of this technique may have been due to his association with Nanga artists through the patron Kimura Kenkadō in Osaka. Finger painting probably entered Japan from China where its best-known proponent was Gao Qipei (d. 1734). Chinese artists in Japan must have schooled others in the method, as it is a technique that cannot be learned by looking at finished paintings.[3] Ike Taiga,[4] Tani Bunchō and Nagasawa Rōsetsu were all known to have produced finger paintings. Though one scholar wrote that he knew of signatures on Hōchū's works stating that that they were finger paintings, none of those works have been published.[5] The Ashmolean's fan, therefore, is important visual evidence that backs up the references to Hōchū's finger paintings in historical records.

Nakamura Hōchū, who was born in Kyoto and lived most of his life in Osaka, is considered one of the premier artists of the *Rimpa* school. The English equivalent of the Japanese word *ha* or 'school', is used both to designate the primarily familial organisation of most painters as well as the *Rimpa* artists whose members can only be said to be based on blood ties in the short term. For its sustenance as a tradition through the centuries, the school owes more to the reverent attitudes of later artists to past masters, expressed most often in what have been called 'homage pictures'.[6] The term *Rimpa* is a modern designation that only became fixed with the 1972 exhibit in the Tokyo National Museum. The character *rin* is the second of the

FAN PAINTING

INK AND COLOUR ON PAPER

SIGNATURE: *Hōchū shitō sha* (PAINTED BY HŌCHŪ USING FINGERS)

SEAL: *unreadable*

17.8 × 49.6 CM

X5417

Gift of Dr Michael Harari, from the collection of his father, Ralph Harari

artist Ogata Kōrin's name, and it is Kōrin's style that had the most influence on Hōchū's development as a painter. In this fan, Hōchū closely follows compositions by Kōrin, such as a fan painting of chrysanthemums in the Feinberg Collection, Washington, DC.[7] That Hōchū would have been very familiar with Kōrin's works is demonstrated by the publication in 1802 of a printed book of his own compositions, based on Kōrin's designs, called the *Kōrin gafu*.

1 For more on Hōchū's use of *tarashikomi*, see 'Nakamura Hōchū no tarashikomi', in Kobayashi Tadashi, *Edo no gakatchi* (Tokyo: Perikansha, 1990), 54–7.

2 This is in the *Kyojitsu satonamari*. See Tsuji Nobuo, 'Nakamura Hōchū ni tsuite', in Yamane Yūzō, ed., *Rimpa kaiga zenshū, Kōrin II* (Tokyo: Nihon keizai shinbunsha, 1977), 45.

3 Joan Stanley-Baker identifies Shen Quan (1682–1760), whose work *Prunus in Moonlight* is in the Yabumoto collection, as a likely candidate who was in Nagasaki from 1731–3. See Joan Stanley-Baker, 'Finger painting in Tokugawa Japan', in *Discarding the Brush, Gao Qipei (1660–1735) and the Art of Chinese Fingerpainting* (Amsterdam: Rijksmuseum, 1992), 74, 78. She also makes the interesting point that finger painting was not considered true literati painting in China, therefore its adoption by Japanese Nanga artists, who believed the heterodox spirit was alive and well in China, is ironic. Ibid., 72.

4 Taiga's finger paintings include *Dragon and Tiger*, a pair of hanging scrolls in a private collection, *Water Landscape* in the Metropolitan Museum of Art, and *Five Hundred Lohans* which are sliding doors in Manpukuji. Ibid., catalogue numbers 94, 97, and page 76.

5 Tsuji, 45.

6 Honolulu Academy of Arts, *Exquisite Visions: Rimpa Paintings from Japan* (Honolulu, Honolulu Academy of Arts, 1980), 17.

7 This is published in Murashige, *Rinpa*, vol. 2, 179.

49

Yoshimura Shūnan 吉村周南
1763–1812

The Poet Kiyohara Motosuke, c. 1790–1812

FAN PAINTING

INK AND COLOUR ON PAPER

SIGNATURE: *Gi Kōrin no tai, Hokkyō Shūnan* (IN THE MANNER OF KŌRIN, HOKKYŌ SHŪNAN)

SEALS: *Shū, Nan*

18.4 × 49.9 CM

X5443

Gift of Dr Michael Harari, from the collection of his father, Ralph Harari

The tenth-century courtier Kiyohara no Motosuke (908–990) was known to later generations as one of the thirty-six immortal poets. He had already achieved great fame in his lifetime through his verses and had edited poetic anthologies such as the *Gosenshū*. Murasaki Shikibu notes in her diary that collections of his poems were already valued shortly after his death.[1] His success made life difficult for his equally renowned daughter, Sei Shōnagon, author of *The Pillow Book*. She writes that if she produced a clever poem, people would expect this considering her ancestry, and if she produced a bad poem, she would be disgracing her father's memory.[2]

The poem inscribed here reads:

秋の野ゝ	I should like to see
はぎのにしきを	my childhood home
古里に	amidst an autumn field spread
鹿の音ながら	with a brocade of bush clover
うつしてしがな	where the cry of a deer is heard.[3]

Shūnan expresses the personality of the poet by comically exaggerating the tilt of his hat and the balloon-shaped trousers. The artist obviously delighted in drawing the large shapes and stocky proportions of the figure. Light washes of blue and green are used for the clothing on top of which gold paint has been added suggesting a patterned fabric.

Shūnan was the third generation of Yoshimura family artists of Osaka whose grandfather Shūzan studied with the Kano school. In 1790, Shūnan is referred to as 'Hokkyō Shūnan' for the first time,[4] therefore we know that he achieved the honorary rank at some time prior to this date, making the Ashmolean fan from the latter part of his life. It seems this era was a time of experimentation for the artist and perhaps coincides with a time after which he is said to have moved to Edo. Apart from this fan where he paints in the style of Ōgata Kōrin, the *Koga Bikō* states he tried his hand at *Ukiyo-e* as well.[5]

1 Richard Bowring, *Murasaki Shikibu, her Diary and Poetic Memoirs: A Translation and Study* (Princeton: Princeton University Press, 1982), 100–101.

2 Morris, 121–22.

3 This poem by Kiyohara no Motosuke is in the *Wakan rōeishū*, number 285. The use of the word *furusato* in the third line is an accepted variant of the poem. I am most grateful to John Carpenter for this translation.

4 See Osaka City Art Museum, *Kinsei Osaka gadan* (Kyoto: Dōhōsha, 1983) for this reference to the *Gōyū kenji* (1790), 295.

5 Zotei *koga bikō*, 1234.

50

Sakai Hōitsu 酒井抱一
1761–1828

Maple Tree

FAN PAINTING

INK, COLOUR AND SILVER-LEAF ON PAPER

NO SIGNATURE

SEAL: *Hōitsu*

19.1 × 50.2 CM

X5432

Gift of Dr Michael Harari, from the collection of his father, Ralph Harari

This fan painting of a single branch of maple tree with springtime green leaves is in remarkably good condition. The silver of the background is only tarnished a little at the edges and along the creases where the fan was once folded. Bright green leaves are painted in subtly different shades from one another, progressing from light to dark with veins thinly painted in gold. The overall effect of the similarly shaped leaves, though, is one of repetition. The branch of the tree is done in the *tarashikomi* technique whereby several wet pigments are combined on the painting surface. Since the painting is done on silver leaf, the pooling and bleeding effect is more controlled than if it had been done directly on absorbent paper.

Hōitsu was born in Edo as the second son of the lord of Himeji castle. Due to his high status, he had many opportunities to develop his abilities as a *haiku* and *kyōka* poet, and as a painter. Despite the Sakai family owning a large number of works by Ogata Kōrin, Hōitsu actually experimented with many current styles of painting[1] before taking Kōrin as his stylistic master. Once his decision was made, however, Hōitsu endeavoured to make Kōrin's art well known by compiling the *Kōrin hyakuzu* (*One Hundred Works by Kōrin*), the *Kōrin hyakuzu kōhen* (*One Hundred Works by Kōrin*, second edition) and the *Ogata-ryū ryaku impu* (*Abbreviated Collection of Seals of the Ogata Lineage*). In addition to his family's collection, Hōitsu may have studied the Kōrin style with Tawaraya Sōri (fl. c. 1764–80). Though the two were separated by about a century, Kōrin was Hōitsu's true teacher.

Of Hōitsu's works, many are copies or odes based on the compositions of Kōrin. Apart from his own version of Kōrin's *Wind and Thunder Gods*, Hōitsu also executed his own unique response to this work by painting delicate flowers on silver ground drenched with rain or blown by the wind on the back of the original. That composition, known as *Summer and Autumn Grasses*, is Hōitsu's most well-known work on silver-leaf ground, evidently an effect he especially preferred. Though silver-leaf background like that used on the Ashmolean fan is not unusual among compositions by Hōitsu, green maple leaves are a rarity compared to red ones. A pair of screens by Hōitsu dated 1818 do, however, have similarly painted green maple leaves.[1]

1 Yamane Yūzō 'The screen painting *Green and Red Maples* by Sakai Hōitsu', *Kokka* 1211 (1996), 7–14.

51

Anonymous

Record of Famous Sights of the Tōkaidō Road (Tōkaidō meisho no ki),
17th century

Six volumes of accordion-
folded albums with
double-page pictures
alternating with text of
varied lengths

In Edo period Japan, travel between cities became both safer and more efficient under the rule of the Tokugawa shoguns. Reasons to undertake a trip were appealing to all levels of society and included the prospect of employment, trade, religious pilgrimage and official duty. Travel guides which included practical information as to distances, where to stay and what sights to see along the main roads were produced in great numbers from the mid-seventeenth century onwards, and were a staggering commercial success. Rare was the traveller for whom time was not a factor, so having all the facts as well as the important sites to hit at hand was of key importance. The earliest of such guides to be produced were those chronicling the Tōkaidō road that led from Edo to Kyoto and included not only useful information but famous poems about each area. The Ashmolean's set conforms to these early editions and comprises six brocade-covered albums in their own box. Each volume contains from five to twelve scenes of double-page illustrations in miniature that are bustling with human activity. After each scene is a textual description of that station town.

The initial volume opens with a preface detailing where horses, guides and even a porter to carry your bags can be found. The famous dishes or *sake* of the area, as well as tea houses, are all described for the first-time visitor. The language of this preface,[1] as well as the volume divisions, conforms closely to that of Asai Ryōi's *Tōkaidō meishoki*, first printed in 1657–61.

The first image is that of the capital of Edo framed by a band of gold-dust clouds above and below. Above is a distant view of Edo castle, and while the castle is not rendered in complete factual detail, certain elements of its appearance are unmistakable. The main tower of the castle, or *donjon*, is painted with five levels, as it stood before the fateful fire of Meireki 3 (1657). The artist may well have been using a model of before 1657 or painting from memory. The appearance of the castle does not necessarily indicate that the volumes were produced before the fire, however, considering the desire for accuracy, the likelihood is that the album dates close to this time. Below the castle, we are given a view of one street in Edo centring on the Nihonbashi bridge over the Edo river. Commoners as well as samurai on horseback can be seen moving through the densely populated area.

17.5 × 28.1 CM (EACH DOUBLE-PAGE
TEXT OR ILLUSTRATION)

NO SIGNATURE

NO SEAL

1959.85

Gift of C. W. Christie-Miller

ANONYMOUS, Edo, double-page illustration from *Record of Famous Sights of the Tōkaidō Road*.

The minute figures are rendered very distinctively with claw-like hands extending out in the direction they are moving. Their toes are painted with a series of formulaic parallel lines and, often, their clothing is outlined in gold.

The earliest *dōchūki* (travel guides) probably date to the Meireki era (1655–7), and detail the Tōkaidō from Edo and 'going up' (*nobori*) to Kyoto. Versions describing the return journey (*kudari*, 'going down'), as well as guides to other roads such as the Kisō highway, seem to date from the Manji era (1658–60). Already, by the seventeenth century, certain poetic and legendary associations were entrenched firmly in the spirit of a specific location. Edo period travel guides included many of these legends to inform the reader along his journey, and the Ashmolean's set is no exception. Many guides dating to the earliest period took the form of paintings on screens or sliding doors, so it should be noted that not all were practical to take on a journey. It seems unlikely that the Ashmolean's volumes, due to the precious materials used, were meant for the average traveller, if they were taken on a trip at all.

Stylistically, the Ashmolean set conforms to other seventeenth-century examples done by anonymous town painters in the Tosa style. A set of fifty anonymous *meisho-e* (pictures of famous places) of scenes in and around Kyoto of c. 1670–92 shows figures drawn in the same poses with similar gold outlines.[2] A pair of screens of the Hie Shrine and the Sannō Shrine Festival in the British Museum[3] of c. 1624–44 have figures, though painted larger than those in the Ashmolean's albums, that share the emphatic noses and large drooping eyes. In addition, the depiction of horses is particularly close in the Ashmolean albums and the British Museum screens.

According to a copy of the original receipt, Christie-Miller purchased these albums from S. Nomura in Kyoto in 1906.

1 Asai Ryōi, *Tōkaidō meisho no ki*, *Tōyō bunko* 346 (Tokyo: Heibonsha, 1979), 3–4.

2 Anne Farrer, *A Garden Bequest: Plants from Japan: Portrayed in Books, Paintings and Decorative Art of 300 Years* (London: Japan Society, 2001) 21–24.

3 Hirayama Ikuo and Kobayashi Tadashi, eds, *Daiei hakubutsukan, Hizō nihon bijutsu taikan* vol. 1, plates 16–17.

ANONYMOUS, Kyoto from *Record of Famous Sights of the Tōkaidō Road*.

52

Anonymous

Scene in the Pleasure Quarters, c. 1670–85

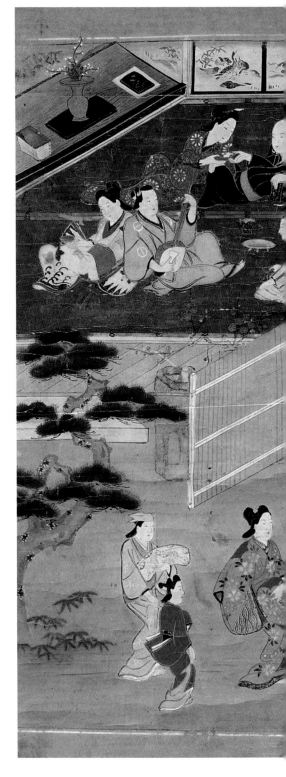

In the pleasure quarters of the Yoshiwara district of Tokyo, the stringent codes of Edo period society were meant to be forgotten. In this painting, a client relaxes at a teahouse outside the gate, while others rush through to join the amusements within. One man enters through the gate covering his face with a fan and wearing a large basket hat to hide his identity. The man behind him seems much less concerned with discretion and bounds ahead after removing his sandals. Beyond the gate, women flirt with potential clients through latticed walls. One man with his head covered by his outer robe has been lured to the wall by the *shamisen* music emanating within. To the right, a woman is welcoming a client indoors and playfully gestures to remove his hat. On the street, the women are a bit more aggressive. One man is being pulled in two directions by a pair of sumptuously clothed courtesans. In the upper left, we see a view into the back room of a brothel where clients drink *sake* and play music in the company of the women. The season is late winter into early spring, evidenced by the blossoming plum and *nanten* berry branch in the vase.

The style of their figures, their hairstyles and the patterns of their clothing point to a date in the late seventeenth century, before the Genroku era (1688–1703). The lacquer box in the back room of the brothel on the shelf, for example, is decorated with a *nami ni chidori* (plovers and waves) motif, typical of the era. Many elements of this painting have much in common with the work of Hishikawa Moronobu (1618–1694), famous for his depictions of the Yoshiwara. When comparing Moronobu's *Hokurō oyobi engeki zu* (*Illustrations of the Northern Quarter* [*Yoshiwara*] *and Kabuki Theatres*),[1] we notice many similar characters. For example, the courtesan on parade with her assistants and the samurai entering through the gate followed by his footman with sandals in hand are sets of figures that the handscroll and the Ashmolean painting have in common. The figures in the Ashmolean scene also share the faces, gestures, and hairstyles of Moronobu's figures to a large extent.

Uncharacteristic of Moronobu, however, is the condensed nature of the scene shown in the Ashmolean's painting. Here, the scene is so compact that we see the teahouses outside the gate and the activity within the pleasure quarters at the

HANGING SCROLL

INK AND COLOUR ON PAPER

NO SIGNATURE

NO SEAL

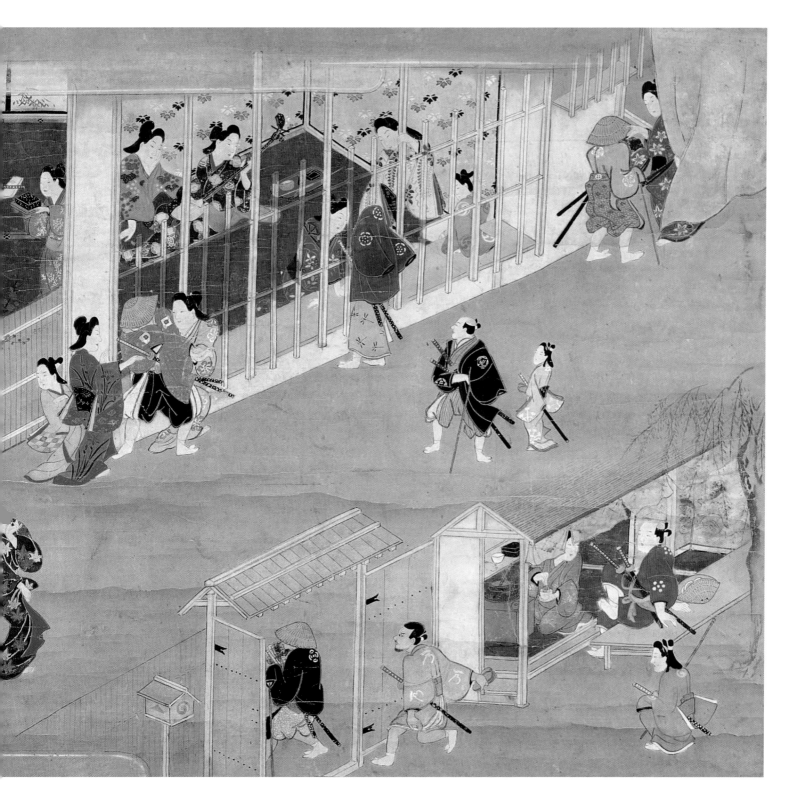

52.7 × 77.7 CM

1959.87

Gift of C. W. Christie-Miller

same time. Rarely does Moronobu show these two views, for he was known for his realistic depictions of the streets and layout of the Yoshiwara, and the teahouses and brothels were not this close to each other in actuality.[2] The work in the Ashmolean is probably by a town painter versed in the Moronobu style, yet not a member of Moronobu's immediate studio. Moronobu's illustrated books were plentiful, and a talented artist could use them as models to create his own Moronobu style that would no doubt be popular with his patrons. The absence of a signature here could mean that this is the work of a lesser known painter whose signature was cut off, or that the painting was never signed at all.

This hanging scroll was purchased from S. Nomura in Kyoto in 1906 by Mr Christie-Miller as the work of artist Miyagawa Chōshun (1683–1753).

1 This is published in Chiba-shi bijutsukan, *Hishikawa Moronobu ten, Chiba-shi Bijutsukan kaikan goshūnen kinen* (Chiba: Chiba-shi bijutsukan, 2000), 50–51.

2 The compact nature of the scene and its lack of accurate topography is noted by Ōkubo Jun'ichi in his entry on this painting in Hiryama Ikuo and Kobayashi Tadashi, eds, *Daiei toshokan, Ashumorian bijutsukan, Vikutoria Arubaato hakubutsukan, Hizō nihon bijutsu taikan* vol. 4 (Tokyo: Kōdansha, 1994), 165–6.

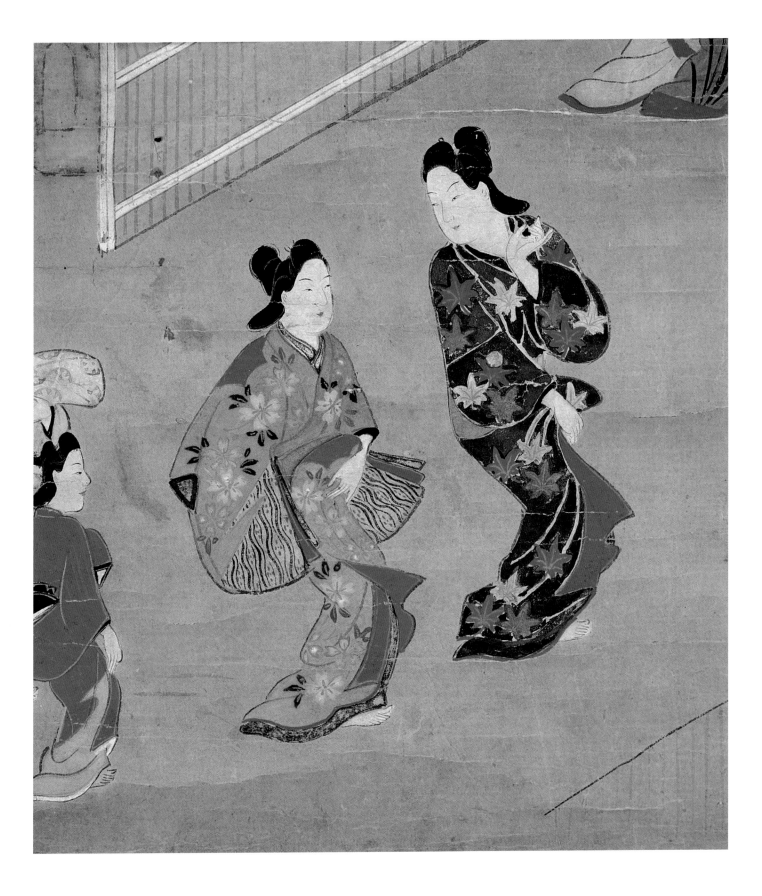

53

Katsushika Hokusai 葛飾北斎
1760-1849

Pilgrims at Kasuga Taisha Shrine, c. 1820–35

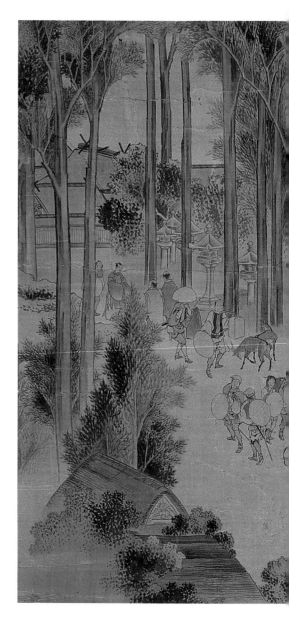

A long line of travellers make their way to and fro along the path leading up to the just visible Wakamiya Shrine in the Kasuga Taisha shrine complex in Nara. The artist Katsushika Hokusai was a master at illustrating, often whimsically, the character of his fellow countrymen. Here, Hokusai presents the viewer with a slice of contemporary Japanese life by showing people of different classes interacting. In the painting, a man bows to a samurai, identifiable by his fine clothes and sword. Further up along the path, a peasant couple can be seen carrying their bundles and their travellers' straw hats. A wealthy woman holds out her hand, probably filled with food, to a deer as her maid totes her lady's belongings. The characters of the deer are carefully described as well. They are endowed with sweet, almost human expressions, and either trot toward a potential food source or lazily lie down among the lanterns, appearing more docile than deer in Nara would be today. Tall trees tower above the figures, and give way to a distant view of Mount Mikasa with a large round sun next to it at the far right of the composition.

The Kasuga Taisha shrine dates from the eighth century when it was constructed by the Fujiwara nobles. The deer that wander the area are a long-standing symbol of the shrine, and are depicted as the embodiment or messengers of the local *kami* (gods) in extant mandala of the Kamakura period. The nearby Mount Mikasa, the original site of the shrine, is also upheld as a sacred site, often appearing in the mandala as well, with a large round sun (sometimes a mirror) rising above it. The simple geometrically bold sun at the right of Hokusai's painting can be taken as a direct reference to such mandala paintings. The view here of the path leading to the Wakamiya shrine that is lined with lanterns can be seen in guidebooks of the time, and would have been a familiar location to Hokusai's patrons.[1] In the Edo period, people would travel to the shrine especially for the festival in the second month (roughly March in today's calendar) and the eleventh month (roughly December).

Hokusai's paintings are notoriously difficult to authenticate. A core of works is generally agreed upon as being by the artist himself and is regarded as the highest

Hanging scroll (framed); ink and slight colour on silk

Signature: *Katsushika Iitsu hitsu* (brush of Katsushika Iitsu)

Seal: *Yoshinoyama*

83.3 × 166.1 cm

x5361

Gift of Dr Michael Harari, from the Collection of his father, Ralph Harari

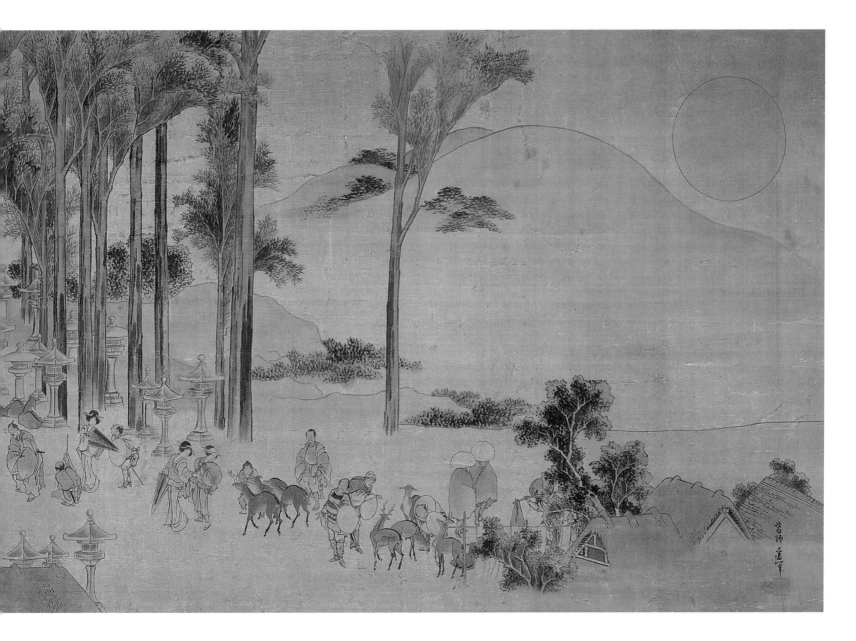

grade of surviving Hokusai paintings. Below that are works that are less unanimously agreed upon among scholars. Paintings considered studio works done by Hokusai's pupils under his direction, and paintings with no connection to the master whatsoever are yet other, lower categories.[2] In general, however, it is difficult to compare like paintings as so few paintings by Hokusai survive. One reason for this, as Richard Lane notes, is that his work appealed to the middle classes for whom his prices were too expensive. Or perhaps the artist personally preferred to work in other media.[3] The situation is further complicated in the case of the Ashmolean painting as it is one of Hokusai's rare landscape paintings. The skill with which the artist is able to express human and animal sentiment, the variety of activity going on, and the first-rate drafting makes it highly likely that the master was at least somewhat involved in this work. This painting was published as the work of Katsushika Hokusai in *Japanese Art: The Great European Collections* in 1994.[4]

Pilgrims at Kasuga Taisha Shrine can be tentatively dated to c. 1820–1834 because of the artist's signature, which reads 'Katsushika iitsu hitsu'. Hokusai was known to have used the name Katsushika Iitsu (Iitsu meaning 'one year old again') in various forms throughout those years, but more specifically, he used the signature of 'Katsushika Iitsu' from 1821–6.[5] This period of Hokusai's career is marked by the beginning of the production of his most famous landscape series such as *Thirty-six Views of Mount Fuji* (*Fugaku sanjūrokkei*) of c. 1830. Though creased and unfortunately faded, this painting should be considered important as a rare example of a large format finished painting in the landscape style of Hokusai's most beloved print series of the same period in his life.

1 See the *Nanto meishoki* of 1774, reproduced in Ikeda Yasaburō, Noma Kōshin and Minakami Tsutomu, eds, *Nara no maki, Nihon meisho fūzoku zue* vol. 9 (Tokyo: Kadokawa shoten, 1983), 211.

2 A detailed analysis of the problem is given by Tsuji Nobuo in 'Hokusai Studio Works and Problems of Attribution', in Gian Carlo Calza, ed., *Hokusai paintings: Selected Essays* (Venice: The International Hokusai Research Centre, University of Venice, 1994) 31–41.

3 Richard Lane, 'Labyrinth or Hornet's Nest? A note on authenticity in Hokusai Paintings', in ibid., 46.

4 Hiryama Ikuo and Kobayashi Tadashi, eds, *Daiei toshokan, Ashumorian bijutsukan, Vikutoria Arubaato hakubutsukan, Hizō nihon bijutsu taikan*, vol. 4, (Tokyo: Kōdansha, 1994), 166.

5 Matthi Forrer; with texts by Edmond de Goncourt, *Hokusai* (New York: Rizzoli, 1988), 371.

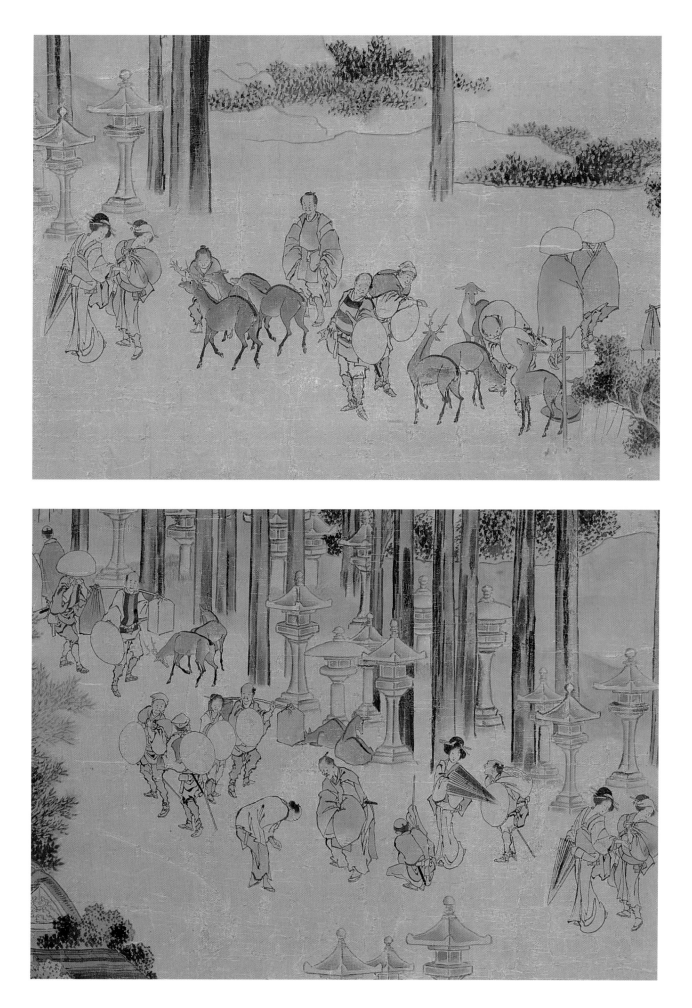

54

Attributed to Bokusentei Yukimaru 墨川亭雪麿
1797–1856

Beauty Reading a Letter

Pictures giving a behind the scenes look at the women of the pleasure quarters were enormously popular among those who could only dream of such indulgences, as well as those who could partake of it only in secret. The courtesan reading a letter, probably from a lover or admirer whom she was with the previous night, is a long-standing theme in this genre. The woman here is shown in an intimate moment with her eyes fixed and her mouth open in enjoyment as she reads. The courtesan has slipped at least one arm out of her layers of clothing, which she is about to take off.

The artist has taken great care in rendering details such as the calligraphy on the letter and each individual strand of the perfectly combed hair. In fact, the writing on the letter has actually been painted backwards and then covered thinly with white pigment, to make it appear as if we are seeing the letter from the back. Also noticeable, upon close examination, is a faintly visible geometric pattern done in black on the black sash (*obi*).

The artist of this painting is difficult to identify. Bokusentei Yukimaru was a pupil of Kitagawa Tsukimaro (fl. c. 1830), who in turn was a follower of the famous Kitagawa Utamaro (1753–1806). He was originally from Echigo province on the West side of Japan before moving to Edo, the centre of *Ukiyo-e*. Few prints are known by this artist, who signed his name 'Yukimaro' with different characters than those seen here, but pronounced the same.[1] In this painting, the artist's signature reads 'Settei Yukimaro'. The use of different characters with the same reading is not unusual, however Bokusentei Yukimaru was not known to use the name Settei, nor the distinctive snail-shaped seal seen here. Stylistically, the painting does conform to the post-Utamaro Kitagawa school paintings of beauties.[2]

HANGING SCROLL (FRAMED)
INK AND COLOUR ON PAPER
SIGNATURE: *Settei Yukimaro ga*
(PAINTING BY SETTEI YUKIMARO)
SEAL: *Yukimaro*
107.5 × 30.5 CM
X5587

1 Genshoku Ukiyo-e daihayakka jiten henshū iinkai, *Genshoku Ukiyo-e daihyakka jiten* vol. 2 (Tokyo: Taishūkan shoten, 1982), plate 514.

2 See Timothy Clark, *Ukiyo-e Paintings in the British Museum* (London: British Museum Press, 1992), 121, 212 for images by Kitagawa Fujimaro and Kitagawa Tsukimaro respectively.

Artists of the Modern Age

In 1868, the Japanese emperor was restored as the supreme authority of Japan after centuries of warrior rule. The name of the capital of Edo was changed to Tokyo, and the new government was eager to remove the last vestiges of the feudal system in an effort to 'catch-up' to the West economically and militarily. The government tried to determine the best way to achieve progress and foster a proud identity unique to Japan, and quickly succeeded in moving the nation towards becoming a world power.

To fill the need for a more democratic training, the art world at this time was overwhelmed with a profusion of art schools and societies. An important link between the premodern Edo period and the Meiji era was the Joun-sha (Cloud-like Society) of Kyoto, active from 1866 into the early twentieth century. Its members included artists from many of the well-established painting schools such as the Nanga, Maruyama, Shijō, Mori and Tosa schools. Of the artists represented in this exhibition, Morikawa Sobun (Cat. 55) and Suzuki Shōnen (Cat. 57) were founding members. The group held major gatherings and art exhibitions beginning in earnest in the 1870s, thereby defining the meaning of Japanese painting in a swiftly changing society. The Joun-sha was less exclusionary than the individual school-based *juku* (studios) of the late Edo period, yet not as inclusive as the later Tokyo and Kyoto painting schools.

The artists of the Meiji period whose works are in the Ashmolean's collection, namely Sobun, Shōnen and Watanabe Seitei (Cat. 56) were trained in the traditional painting studios in which the master-student relationship reigned. But how did the artists' style change from the Edo to the Meiji period? Most of the artists featured in this section are of the first two generations after the Meiji restoration and, as Ellen Conant notes, were initially more interested in their survival as artists than in experimenting with new styles.[1] The paintings of their maturity, however, express the flexibility of this training to respond to modern art movements. The many international expositions in which these artists participated were encouraged by the government as it was a way for Japan to display unique products and break into foreign markets. The Paris Exposition Universelle of 1878, the 1873 Vienna World Exposition and the World's Columbian Exposition in Chicago in 1893 featured a growing number of Japanese exhibits. Not only their artwork, but the artists themselves were ambassadors to the West. Seitei, two of whose works are featured here, was the first artist of the period to spend time studying in Europe.

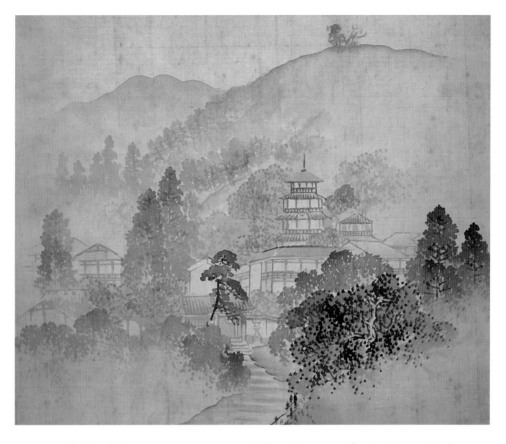

MORIKAWA SOBUN, page from cat. 55
*Album of Craftsmen, Landscapes,
Birds, Flowers and Insects.*

One of the defining organizations of the Meiji period, the Kyoto Prefecture Painting School was based in part on a proposal by the Joun-sha members to the governor of Kyoto. The forty-three initial appointees in 1880 included Kunii Ōbun and Morikawa Sobun. The school comprised of four sections: East (*Yamato-e* and *shasei*), West (watercolour and oil painting), North (Kano school tradition) and South (Nanga). The founding of this school paralleled the establishment of the Tokyo School of Fine Arts in 1887. In the same year, the new Japan Art Association established by Ernest Fennollosa (1853–1908), Okakura Kakuzō (Tenshin) (1862–1913) and others provided a place for artists of the Tokyo School of Fine Arts to continue their education. Yokoyama Taikan, whose *Lake in the Rain* (Cat. 58) is included in this volume, was active at both of these institutions as a student and instructor.

Taikan was instrumental in defining a new Japanese aesthetic in relation to the West, and is therefore seen as the quintessential Nihonga painter. Nihonga refers to Japanese-style painting that used traditional pigments and formats, defined in opposition to *yōga* or Western-style oil painting in the Meiji period. Prior to World War II, Nihonga artists, and Taikan in particular, struck a cord with the patriotism engendered by an increasingly militaristic regime by painting nostalgic Japanese subjects albeit with revolutionary techniques.

1 Ellen P. Conant, 'Tradition in transition, 1868-1890', in Ellen P. Conant, *Nihonga, Transcending the Past : Japanese-style Painting, 1868–1968* (St Louis, MO: Saint Louis Art Museum; Tokyo: Japan Foundation, 1995), 15.

55

Morikawa Sobun 森川曽文
1847–1902

Album of Craftsmen, Landscapes, Birds, Flowers and Insects

Morikawa Sobun was of the second generation after the establishment of the Kyoto Prefecture Painting School, where he was appointed an instructor in 1888. Well into the Meiji period, Sobun continued to work in a style that owed much to the traditional Shijō manner of his training.[1] This conservative trait (as well as other factors such as his late start in painting) led to him be berated by his contemporaries such as Kōno Bairei, who told him that he might be better off pursuing a career in creating designs for *yūzen*-dyed fabrics.[2] His popularity among the people of Kyoto was high, however. Sobun was a prominent artist who participated in many of the expositions of the time, winning awards for his landscapes and paintings of deer, the latter he exhibited in both the Chicago World's Columbian Exposition in 1893 and the Paris Expo of 1898.[3]

The twenty-nine images in this album run the gamut of Sobun's repertoire and include images of craftsmen's studios, landscapes, birds, flowers and insects. Most of the paintings in the album are of identifiable shops and locations within Kyoto, known very well to the artist and his circle of Chinese culture aficionados. A small work such as the Ashmolean's album would probably not have been made for display in a competitive exposition, but could have been part of the prevalent group exhibitions held at temples throughout Kyoto in the 1870s attended by the artistic and literary-minded.

The figural images are the highlight of the album and provide snapshots of the residents of Kyoto at work and at play. In a fan shop, the proprietors and a worker mount paintings of bamboo and chrysanthemums onto wooden slats. In another scene in the home of a well-to-do merchant, perhaps the commissioner of the album, several men sit and enjoy *sencha* tea, a pastime popular with the artistic and literary community. A screen of a landscape painted in the literati manner is behind the host, and they sit on what appears to be an imported rug.[4] In one of the most charming images in the album, a group of children make a *yukidaruma* (snow Bodhidharma), the equivalent of a snowman in the West. A *mochi* (pounded rice cake) vendor wheels past the tools of his trade on the way to setting up his stand.

The landscapes are given the same nostalgic and delicate treatment as the

Twenty-nine paintings interspersed with twenty-one pages of calligraphy

Paintings are ink and colour on silk, calligraphy is ink on paper

No signature

Seal: *So; bun* (on one page)

24.8 × 27.3 cm

1973.128

Purchased with the aid of the Friends of the Ashmolean and Mr and Mrs J. Hillier

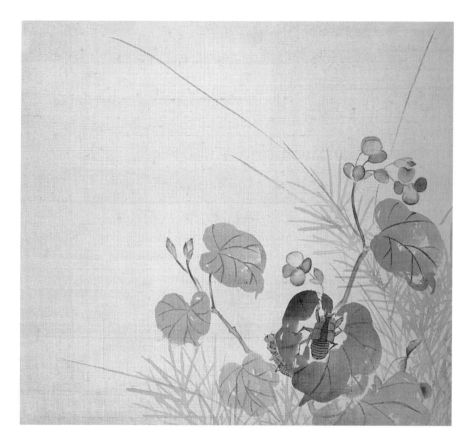

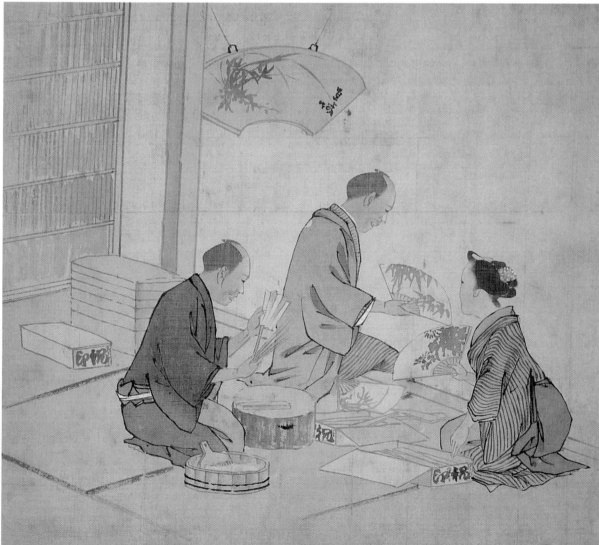

figural scenes. Well-known locations in Kyoto such as Kiyomizu temple and Arashiyama are included. In the page reproduced here, a snow-covered curved bridge in a garden is painted with soft blue and peach tones. Though more cursory in style than the landscapes or figures, the image of cicada shows the artist's characteristic delicate touch and eye for a pleasing composition. A few of the bird and flower paintings in the album, however, are not rendered with the same skill, leading to the conclusion that perhaps a second artist's work in the style of Sobun is included here.

The pages of calligraphy, all by one hand, mostly include *kanshi* (Chinese poems), and are signed with variations of the name Sessō Keigi. Two of the poems bear dates of Meiji 10 (1878) and Meiji 12 (1880), and a few identify the source from which the poem came or where the poem was composed. If the calligraphy was done at the same time as the paintings, this album would be an early work by Sobun before he began participating in the national and international expositions.

1 His teachers were prominent figures in the Shijō school at the time, Hasegawa Gyokuhō (1822–79) and Maekawa Gorei (1806–71).

2 Michiyo Morioka and Paul Berry, *Modern Masters of Kyoto: The Transformation of Modern Painting Traditions, Nihonga from the Griffith and Patricia Way Collection* (Seattle: Seattle Art Museum, 1999), 84.

3 Published in Kyoto-shi bijutsukan, *Kyoto gadan, Edo Matsu Meiji no gajintachi* (Kyoto: Aato shuppansha, 1977), plates 117–18.

4 I thank Timon Screech for making this observation.

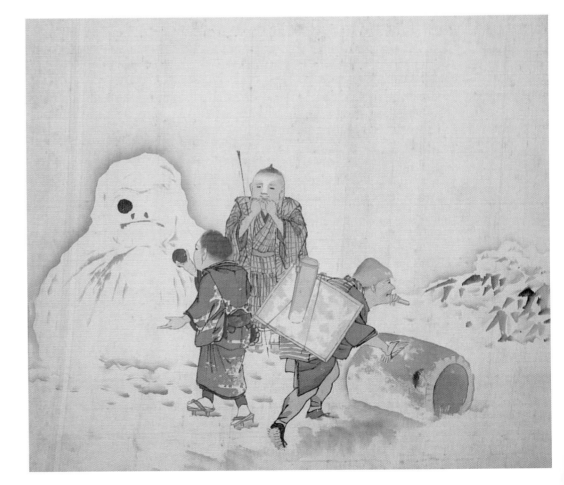

56

Watanabe Seitei 渡辺省亭
1851–1918

Carp and Wisteria

AND

A Beetle Among Autumn Leaves

(*Opposite*)

FRAMED PAINTING

INK AND COLOUR ON PAPER

SIGNATURE: *Seitei*

SEAL: *Seitei*

51.5 × 33.2 CM

1996.130

Story Fund

With Seitei, the birds and flowers of the Shijō school combined with the new Nihonga manner of the Meiji era. The Ashmolean has two examples of his painting, both in their original frames.

Seitei excelled in painting images of wildlife, and carp and wisteria is a subject the artist returned to often.[1] Though pared down to just the carp and the wisteria, we can imagine the implied setting of a garden pond in spring. The bright blue of the wisteria is the only colour in an otherwise muted, almost monochromatic image. In the small painting of the beetle, Seitei has captured the insect in mid-movement as he rustles across the brightly coloured leaves. His compositions show

FRAMED PAINTING

INK AND COLOUR ON PAPER

SIGNATURE: *Seitei*

SEAL: *Seitei*

17.2 × 25.5 CM

1993.13

Story Fund

a restrained use of colour usually with clearly defined focal points. Seitei's ability as a draughtsman, colourist and designer endeared him to a European audience who became familiar with him through works exhibited in Paris (1878), Amsterdam (1883) and Chicago (1893). The scholar Satō Dōshin claims that Seitei's appeal to Westerners lay in his high level of technical virtuosity and his ability to render his subjects with lifelike energy.[2]

Seitei studied under Kikuchi Yōsai (1788–1878) and also briefly with Shibata Zeshin, two artists known for their experimentation with long-standing techniques of the Shijō school. Seitei's search for new means of expression led him to Europe, becoming the first Nihonga painter to study there in 1878.

In addition to these two paintings, the Ashmolean also counts two cloisonné trays (1994.35, 2000.50) based on Seitei's designs among its collection. These are by the renowned Meiji artist Namikawa Sōsuke (1847–1910) who often collaborated with Seitei, capitalising on the popularity of the painter's images.

1 For example, carp and wisteria features as the composition for summer in *Birds and Flowers of the Four Seasons* of 1891 in The National Museum, Warsaw, published in Hirayama Ikuo and Kobayashi Tadashi, eds, *Kurakufu kokuritsu bijutsukan, Hizō nihon bijutsu taikan*, vol. 10 (Tokyo: Kōdansha, 1993), plate 10.

2 See Satō Dōshin's essay 'Watanabe Shōtei naze ōbeijin ga konomareta ka', in ibid., 225–229.

57

Suzuki Shōnen 鈴木松年
1849–1918

Snowscape, 1902

An elderly crouching man with a cane makes his way along a bridge almost knee-deep in snow. A pair of thatched-roof houses under a canopy of leafless trees await him on the other side. Our eye travels upward from the figure to the white, snow-covered mountains that are stacked up in the distance. A grey sky completes the scene that effectively evokes a feeling of the burdens and the beauty of winter.

The various ink tonalities and forceful brushstrokes are elements of Shōnen's signature style. The artist uses a wet brush to render the contour lines of the mountains and rooftops, and a dry brush for the tree trunks and the beams of the bridge. This is done not only to express various textures but various distances as well. The underside of the bridge and the trees in the foreground done with dark black ink and a dry brush come forward as more distant trees done in ink wash fade into the background.[1]

Shōnen was an integral figure in the Kyoto Nihonga movement. Like many artists of the movement, his background was in the Shijō school of which his father Suzuki Hyakunen (1825–1891) had been a leader. He studied at the Kyoto Prefecture Painting School, founded by the Meiji government, that included four basic divisions of painting known as the Northern, Southern, Eastern and Western school sections. Shōnen controversially became head of the Northern School division in 1881 after antagonism led the two former heads, his father and Kōno Bairei (1844–1895), to leave their positions. His apathy for his role at the school however did some damage. He was an independent personality and excelled in painting many subjects such as landscapes, birds, dragons[2] and figures. The Ashmolean's painting is typical of his landscapes that capture a Japanese nostalgia for an earlier period, which explains his extreme popularity as an artist during his lifetime and beyond.

HANGING SCROLL

INK AND SLIGHT COLOUR ON PAPER

SIGNATURE: *Settchū kaijin meiji mizunoe-tora nigatsu Shōnen hitsu* (A FAMILIAR-LOOKING FIGURE IN SNOW, PAINTED BY SHŌNEN IN THE SECOND MONTH OF 1902)

SEALS: *Shōnen Suzuki Ken no in; Shōnen senshi*

124.5 × 29.9 CM

1965.133

1 This device can also be seen in Shōnen's *Landscape with Two Travelers*, of 1912, published in Michiyo Morioka and Paul Berry, *Modern Masters of Kyoto: The Transformation of Modern Painting Traditions, Nihonga from the Griffith and Patricia Way Collection* (Seattle: Seattle Art Museum, 1999), 109.

2 Most famous are the dragons he painted on the ceiling of the main building of the Tenryūji in Kyoto.

58

Yokoyama Taikan 横山大観
1868–1958

Lake in the Rain, c. 1926

HANGING SCROLL
INK ON SILK
SIGNATURE: *Taikan*
SEAL: *Shōkodō*
68.1 × 100.5 CM
1964.196
Gift of Helen Binyon

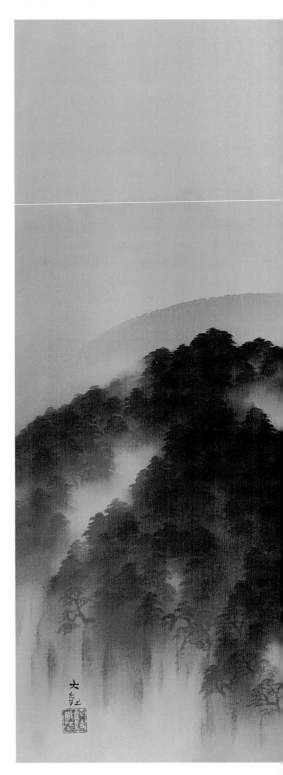

A work of bold tonal contrasts, *Lake in the Rain* was first exhibited in 1926 at the First Shōtoku Taishi Memorial exhibition. In the painting, we are given a bird's eye view of a forest-covered mountain with heavy mist wafting in the ridges. The focal point is the temple complex, made up of a series of painted roofs nestled among the trees just left of center. A wide brush has been used to lay down the overall ink wash and blend it into the silk, making the boundaries of mountain and mist, land and sky less distinct. The foliage and branches of the trees have been done with a thinner brush, but rather than stand out among the wash of the mountains, they blend in with the complex network of ink tones that make up the mountainside. To the right, a flock of birds surround a lone mountain peak that juts up through the blanket of mist covering that portion of the landscape.

Yokoyama Taikan was the main artist to emerge from the Meiji period Nihonga movement in Japan, and he was often hailed as a champion of incorporating Western ideas into his paintings while maintaining an emphasis on traditional Japanese aesthetics. Taikan's well-documented support for the Japanese armed forces during World War II, and his ardent nationalism as seen through his many paintings of Mt Fuji in the 1930s and 40s has at times overshadowed interest in his artistic development. Taikan early on showed a talent for drawing in pencil, and followed this interest until it became the central focus of his life upon entering the Tokyo School of Fine Arts in 1889. He later taught at the school, but resigned at the same time as his mentor Okakura Kakuzō (Tenshin) (1862–1914). From that time on, the Japan Art Institute, a place for graduates of the Tokyo Art School to share their ideas, founded by Kakuzō, became the focus of Taikan's career. From 1899–1909, Taikan gradually developed the signature style of artists of the Institute, the *mōrōtai* or hazy style. This is a method of painting in which line is deemphasised in favour of broad expanses of colour that define a form's contours, and often includes complex Western-inspired shading techniques.

Taikan travelled in America and Europe in 1904–5 when the Institute was having some financial difficulties, which served to spread his name in the West. It seems he was eager to seek approval for his works, and must have been very pleased to make the acquaintance of Laurence Binyon (1896–1943). Binyon was

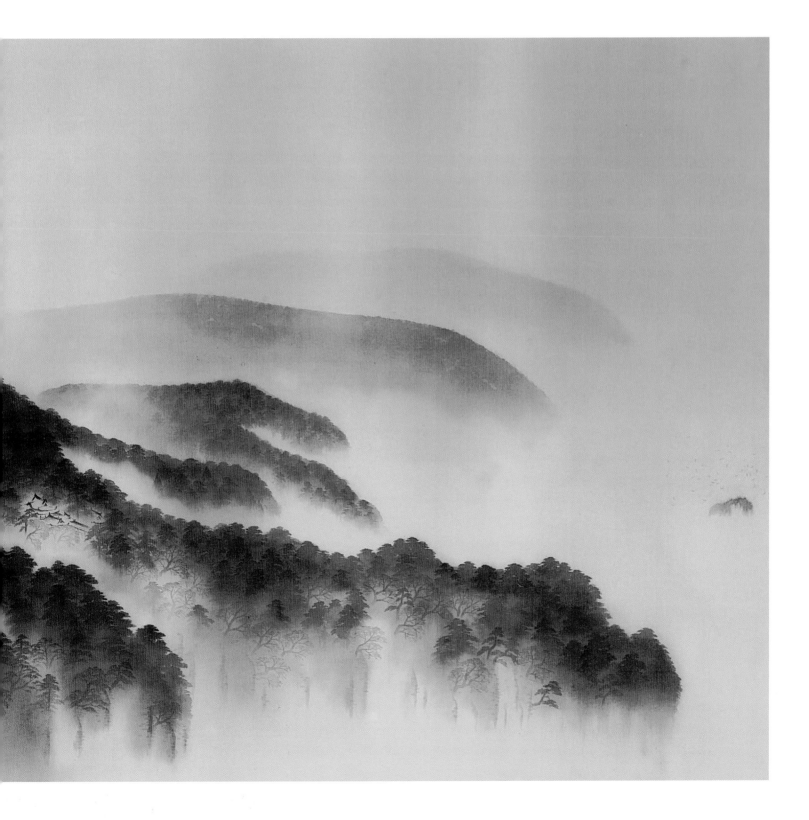

then the chief Asian art curator of the British Museum, and was probably given this painting by the artist in 1929 in Japan. In 1964, the painting was given to the Ashmolean by his daughter, Helen Binyon.

Lake in the Rain shows a maturation of Taikan's brush technique from the time of his colourful *mōrōtai* works, now being applied to classic ink painting subjects such as landscapes. The first ink painting of this type is one of Taikan's masterpieces, a thirty-six-metre handscroll entitled *The Wheel of Life* (also referred to as *Metempsychosis*), which was exhibited in 1923 and is now in the National Museum of Modern Art in Tokyo.[1] Throughout the next few years, Taikan produced significant works in this style. The true subject of *Lake in the Rain*, one of his earliest ink paintings in this stylistic group, is a matter of some debate. The catalogue printed for the First Shōtoku Taishi Memorial Exhibition lists the title as *Lake in the Rain*, however the painting has features in common with works by Taikan of *Evening Bell at Distant Temple* (one of the Eight Views of Xiao and Xiang) of 1926 and 1927, in particular a temple nestled in mist-covered mountains.[2] The lack of a pagoda in the temple complex, however, may suggest that the subject is Mount Hōrai, the mythical island of the immortals inhabited by auspicious creatures such as cranes. Most of Taikan's paintings of Mount Hōrai date to the 1940s, though there are a few examples from the 1920s as well.[3] It has been suggested, almost certainly erroneously, that the birds (which are surely not cranes) were painted in after the work was exhibited.[4]

The seal used here reads *Shōkodō* (meaning 'bell drum cave'), the name Taikan gave to his painting studio. This name was inspired by the sounds of the ocean waves in a grotto at night that the artist would hear when he was living for a short time in a fishing village in Ibaraki in 1906.

1 Kobayashi Tadashi, *Nihon bijutsuin, Gendai genshoku nihon no bijutsu*, vol. 2 (Tokyo: Shogakkan, 1979), plates 10–13.

2 The work of 1926 is published in Yokoyama Taikan kinenkan, *Taishō, Yokoyama Taikan* vol. 2 (Tokyo: Dainihon kaiga, 1993), 343, and the 1927 painting is reproduced in *Shōwa I*, vol. 3 of the same series, page 20.

3 See ibid., 37, for the 1928 painting of Mount Hōrai and pages 246–7 for several examples from the early 1940s.

4 Hiryama Ikuo and Kobayashi Tadashi, eds, *Daiei toshokan, Ashumorian bijutsukan, Vikutoria Arubaato hakubutsukan, Hizō nihon bijutsu taikan* vol. 4 (Tokyo: Kodansha, 1994), 165.

Supplementary Paintings

This supplementary section is made up of a selection of about one hundred works from the Ashmolean's collection of over four hundred Japanese paintings. Included in this list is any painting whose publication might benefit future studies on these artists. Therefore, the authenticity of many works in this section awaits further confirmation. All artists are listed alphabetically by surname, and paintings with several artists are listed last.

1
ANONYMOUS

Daruma, Kanzan and Jittoku

Hanging scrolls, triptych
Ink on paper
73.2 × 29.1 CM APPROX. EACH
1962.114–115, 1972.39
Gift of Mrs Isa Cohn in memory of Dr W. Cohn

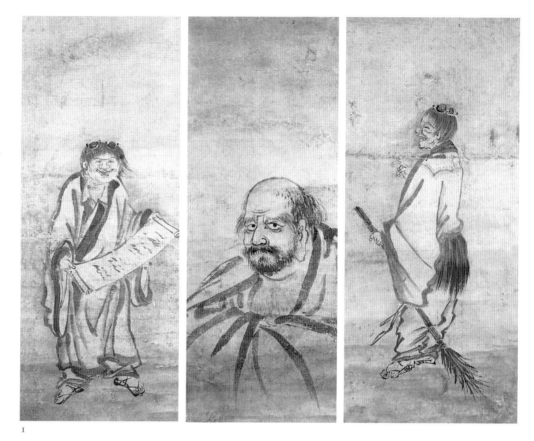

1

2
ANONYMOUS

Death of the Buddha, 17th century

Framed hanging scroll
Ink, colour and gold on silk
192.5 × 127.6 CM
2002.65
Reyes Collection

3
ANONYMOUS

One Thousand Benten

Hanging scroll
Ink and colour on paper
122.5 × 55.4 CM
1956.537
Gift of Sir George Sansom

2

3

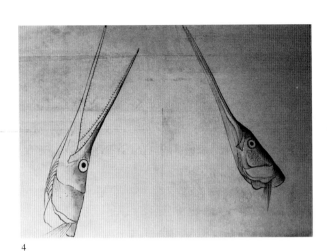

4

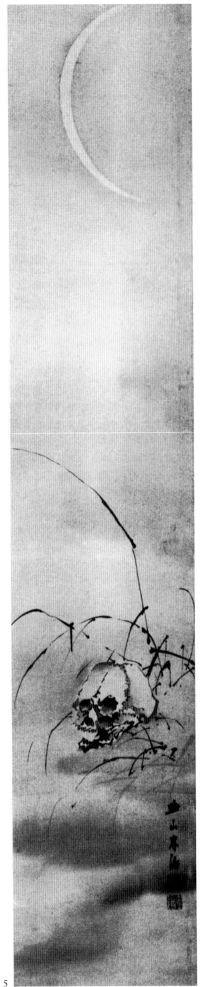

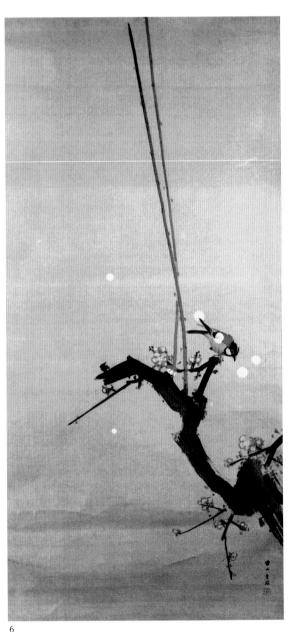

4
ANONYMOUS

Two Studies of the Head of a Swordfish, 20th century

Sketch
Ink and light colour on paper
40.1 × 27.8 CM
1965.11
Lady Cash bequest

5
AOKI (KISHI) RENZAN
1805–1859

Skull and Crescent Moon

Hanging scroll
Ink on silk
118.4 × 14.7 CM
1973.195
Purchased with the aid of the Friends of the Ashmolean and Mr and Mrs J. Hillier

6
AOKI (KISHI) RENZAN
1805–1859

Sparrow on a Plum Branch

Hanging scroll
Ink and slight colour on silk
108.3 × 49.5 CM
1973.161
Purchased with the aid of the Friends of the Ashmolean and Mr and Mrs J. Hillier

5

6

7
ASAI HAKUZAN
1842–1907

Epidendrum

Fan painting
Ink on paper
15.3 × 47.0 CM
1966.106

Purchased with the aid of grants from the Higher Studies Fund and the Victoria and Albert Museum, also with donations from the friends of P. C. Swann

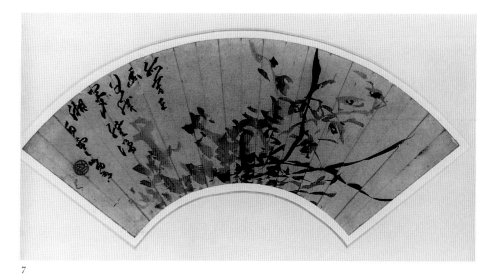

7

8
BŌKEI

River Landscape, 1853

Fan painting
Ink and colour on paper
14.6 × 47.2 CM
1973.98

Purchased with the aid of the Friends of the Ashmolean and Mr and Mrs J. Hillier

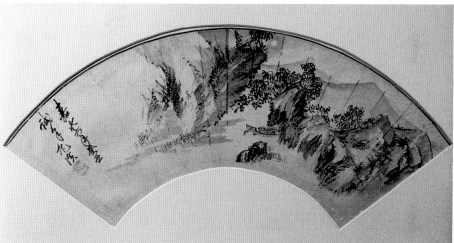

8

9
CHŌ GESSHŌ
1772–1832

Wasabi and Beans

Fan painting
Ink and colour on paper
18.2 × 48.0 CM
1973.39

Purchased with the aid of the Friends of the Ashmolean and Mr and Mrs J. Hillier

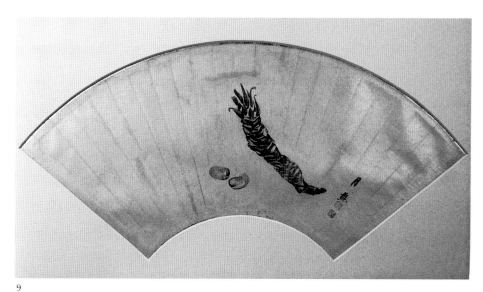

9

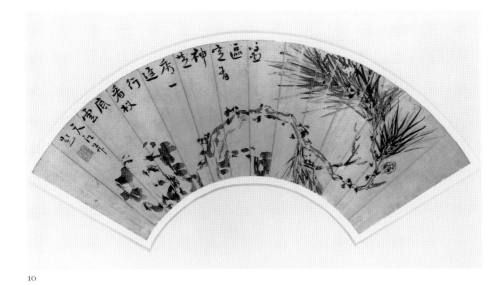

10

10

EMA TENKO

1825–1901

Pine Branch

Fan painting

Ink on paper

Inscription by the artist

14.0 × 45.6 CM

1966.107

Purchased with the aid of grants from the Higher Studies Fund and the Victoria and Albert Museum, also with donations from the friends of P. C. Swann

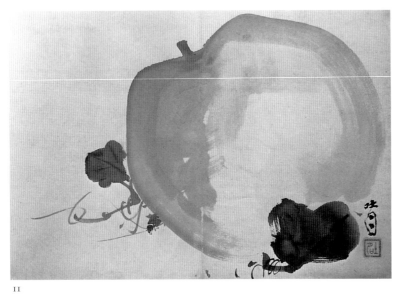

11

11

FUJII SŌDŌ AND OTHERS

ACTIVE C. 1854–59

Calligraphy and Painting Album, 1853

Accordion-folded album

Title, plus nine double-page paintings and one double-page of calligraphy

Ink and colour on paper

26.6 × 39.9 CM

1967.20

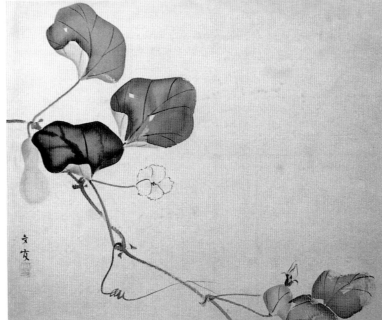

12

12

FUMITOMO BUN'YŪ

1823–1900

Gourd Plant

Matted painting

Ink and colour on silk

33.8 × 42.4 CM

1973.21

Purchased with the aid of the Friends of the Ashmolean and Mr and Mrs J. Hillier

13
GESSEN
1721–1809

Dao Hung-ging

Fan painting
Ink and colour on paper
17.9 × 48.9 CM
X5429
Gift of Dr Michael Harari, from the collection of his father, Ralph Harari

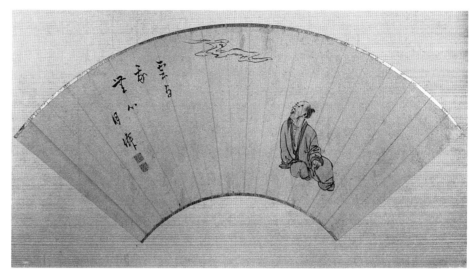

13

14
GESSEN
1721–1809

Peasant Winnowing Grain

Fan painting
Ink and colour on paper
18.1 × 49.0 CM
X5390
Gift of Dr Michael Harari, from the collection of his father, Ralph Harari

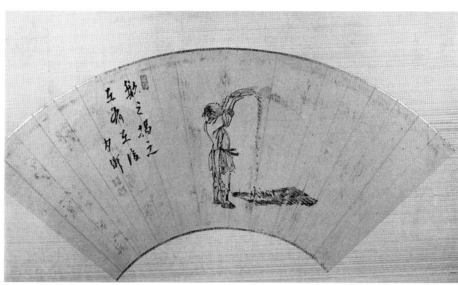

14

15
HATTA KOSHŪ
1760–1822

Tortoises

Fan painting
Ink and light colour on paper
18.8 × 52.2 CM
X5405
Gift of Dr Michael Harari, from the collection of his father, Ralph Harari

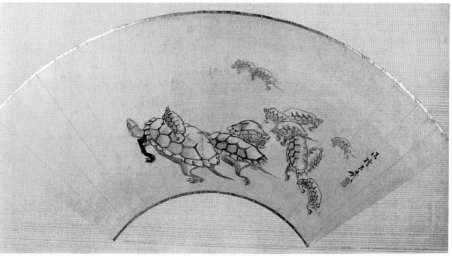

15

16

after IKE TAIGA

1723–1776

Plum Branch

Hanging scroll

Ink on paper

129.5 × 52.7 CM

1966.148

Purchased with the aid of grants from the Higher Studies Fund and the Victoria and Albert Museum, also with donations from the friends of P .C. Swann

17

KAMEOKA KIREI

1770–1835

Sparrow and Rice Ear

Fan painting

Ink and slight colour on paper

18.9 × 50.7 CM

X5445

Gift of Dr Michael Harari, from the collection of his father, Ralph Harari

18

KANEKO KINRYŌ

d 1817

Bird on a Flowering Cherry Tree

Fan painting

Ink and colour on paper

19.2 × 52.1 CM

X5440

Gift of Dr Michael Harari, from the collection of his father, Ralph Harari

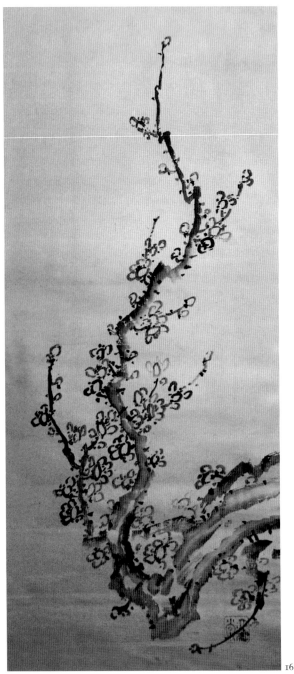

16

17

18

19
Kano Isen'in
1775–1828

Hotei, c. 1802–1816

Fan painting
Ink on paper
24.0 × 50.0 CM
X5377
Gift of Dr Michael Harari, from the collection of his father, Ralph Harari

19

20
Attr. to Katsushika Taitō II
FL. 1810–1853

Sketches of Figures and Animals

Accordion-folded album
Sixteen pages of images
33.4 × 24.4 CM
1962.208
van Houten gift

20

21
Kawamura Bumpō
1779–1821
Three Sages
Fan painting
Ink and colour on paper
18.5 × 52.0 CM
X5459
Gift of Dr Michael Harari, from the collection of his father, Ralph Harari

21

22

KAWANABE KYŌSAI

1831–1889

Bon-odori

Hanging scroll

Ink and colour on paper

124.5 × 60.3 CM

1965.130

23

KINO HIRONARI

1777–1839

Studying a Painting

Fan painting

Ink, gold paint and colour on paper

18.2 × 51.5 CM

X5394

Gift of Dr Michael Harari, from the collection of his father, Ralph Harari

24

KISHI GANKU

1749–1838

Crane in Flight

Fan painting

Ink on paper

18.8 × 52.0 CM

X5403

Gift of Dr Michael Harari, from the collection of his father, Ralph Harari

22

23

24

25

KISHI GANTAI

1782–1865

Mallard ducks

Fan painting

Ink and slight colour on paper

18.0 × 47.1 CM

1973.38

Purchased with the aid of the Friends of the Ashmolean and Mr and Mrs J. Hillier

25

26

KISHI GANTAI

1782–1865

Three Heroes in a Peach Orchard

Fan painting

Ink and colour on paper

18.9 × 52.0 CM

X5447

Gift of Dr Michael Harari, from the collection of his father, Ralph Harari

26

27

KŌ SŪKOKU

1730–1804

Fukurokuju and Boy Studying a Painting

Ink and colour on paper

23.0 × 48.9 CM

X5365

Gift of Dr Michael Harari, from the collection of his father, Ralph Harari

27

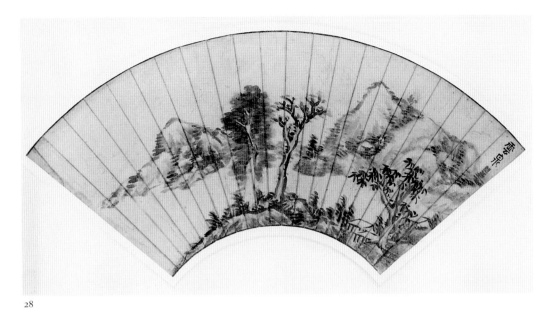

28

28
Kushiro Unsen
1759–1811

Landscape with Mountains

Fan painting
Ink and slight colour on paper
17.9 × 47.1 CM
1966.109
Purchased with the aid of grants from the Higher Studies Fund and the Victoria and Albert Museum, also with donations from the friends of P. C. Swann

29

29
MARUYAMA ŌKYO
1733–1795

Three Ayu in a Stream

Fan painting
Ink and colour on paper
17.7 × 50.5 CM
X5410
Gift of Dr Michael Harari, from the collection of his father, Ralph Harari

30
MARUYAMA ŌZUI
1776–1829

Cherry Blossoms

Fan painting
Ink and colour on paper
19.5 × 52.0 CM
X5374
Gift of Dr Michael Harari, from the collection of his father, Ralph Harari

30

31
MARUYAMA ŌZUI
1766–1829

Rice Plants

Fan painting
Ink on paper
19.3 × 50.5 CM
1973.93
Purchased with the aid of the Friends of the Ashmolean and Mr and Mrs J. Hillier

31

32
MATSUMURA GOSHUN
1752–1811

Praying Mantis

Fan painting
Ink and colour on paper
17.9 × 51.0 CM
X5442
Gift of Dr Michael Harari, from the collection of his father, Ralph Harari

33
MATSUMURA GOSHUN
1752–1811

Rats Carrying the Possessions of Daikoku

Handscroll
Ink on paper
15.7 × 123.3 CM
1973.130
Purchased with the aid of the Friends of the Ashmolean and Mr and Mrs J. Hillier

32

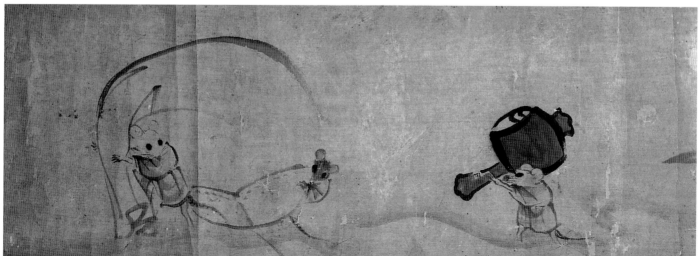

33

34
Matsumura Keibun
1779–1843

Tobosaku (Ch: Tung Fang-so)

Fan painting
Ink and colour on paper
18.5 × 51.8 cm
x5424

Gift of Dr Michael Harari, from the collection of his father, Ralph Harari

35
Miura Gomon
1809–1860

Plum Tree, 1851

Fan painting
Ink on paper
16.6 × 47.6 cm
1966.100

Purchased with the aid of grants from the Higher Studies Fund and the Victoria and Albert Museum, also with donations from the friends of P. C. Swann

36
Miyake Gogyō
1864–1919

Cherry Blossom Viewing

Hanging scroll
Ink and colour on paper
129.4 × 50.6 cm
1965.127

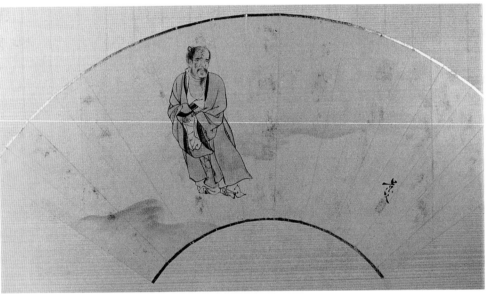

34

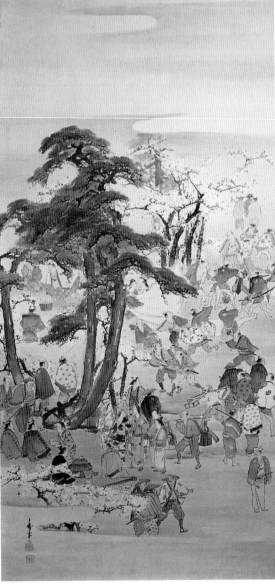

36

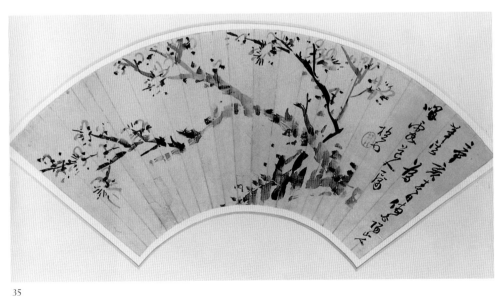

35

37
MORI KANSAI
1814–1894

Chrysanthemums and Sparrow

Hanging scroll
Ink and slight colour on paper

135.5 × 30.7 CM

1973.189

Purchased with the aid of the Friends of the Ashmolean and Mr and Mrs J. Hillier

38
MORI KANSAI
1814–1894

Kinkō on a Carp

Hanging scroll
Ink and slight colour on paper

96.0 × 55.2 CM

1973.160

Purchased with the aid of the Friends of the Ashmolean and Mr and Mrs J. Hillier

38

39
MORI KANSAI
1814–1894

Squash and Aubergines

Matted painting
Ink and colour on paper

19.8 × 18.7 CM

1973.57

Purchased with the aid of the Friends of the Ashmolean and Mr and Mrs J. Hillier

39

37

40
Mori Tetsuzan
1775–1841
Two Deer
Fan painting
Ink and colour on paper
18.5 × 51.2 CM
X5391
Gift of Dr Michael Harari, from the collection of his father, Ralph Harari

40

41
Morikawa Sobun
1847–1902
Heron and Willow Tree in Rain
Hanging scroll
Ink and colour on paper
113.6 × 39.0 CM
1965.131

42
Nagasawa Rosetsu
1754–1799
Tiger Standing on its Hind Legs and *Tiger in the Rain*
Pair of hanging scrolls
Ink and colour on paper
128.2 × 53.5 CM EACH
1973.185, 186
Purchased with the aid of the Friends of the Ashmolean and Mr and Mrs J. Hillier

41

42

43

43

NAGAYAMA KŌIN

1765–1849

Two Chinese Boys Reading

Fan painting

Ink and colour on paper

18.6 × 51.0 CM

X5385

Gift of Dr Michael Harari, from the collection of his father, Ralph Harari

44

NAKAI RANKŌ

1766–1830

Deer

Album leaf

Ink and colour on paper

19.6 × 26.9 CM

1973.94

Purchased with the aid of the Friends of the Ashmolean and Mr and Mrs J. Hillier

42

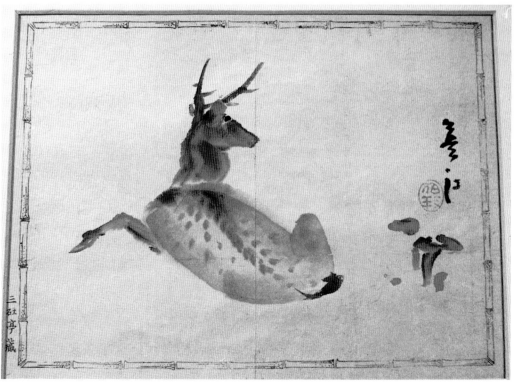

44

45

45
NAKABAYASHI CHIKKEI
1816–1867
and
OKAMOTO SUKEHIKO
1823–1883

Tortoise and Bamboo

Fan painting
Ink on paper
15.0 × 47.2 CM
1973.97
Purchased with the aid of the Friends of the Ashmolean and Mr and Mrs J. Hillier

46
NOGUCHI SHŌHIN
1847–1917

Bamboo

Fan painting
Ink on paper
Inscription by the artist
13.3 × 41.4 CM
1966.97
Purchased with the aid of grants from the Higher Studies Fund and the Victoria and Albert Museum, also with donations from the friends of P. C. Swann

46

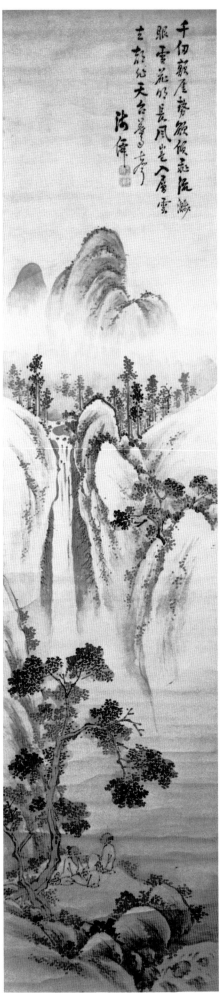

47

47
ODA KAISEN

1785–1863

Scholars Viewing a Waterfall

Hanging scroll
Ink and light colour on paper
Inscription by the artist
136.1 × 30.1 CM
1964.92

48
ODA KAISEN

1785–1863

Shoki as a Literatus

Hanging scroll
Ink and colour on silk
93.2 × 31.5 CM
1966.133

Purchased with the aid of grants from the Higher Studies Fund and the Victoria and Albert Museum, also with donations from the friends of P. C. Swann

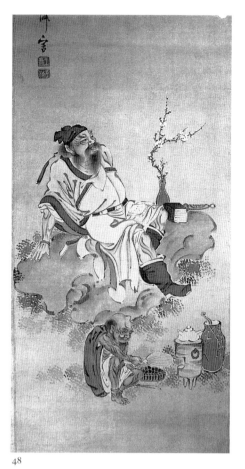

48

49
ODA NANPŌ

FL. C. 1840

Bush Clover

Fan painting
Ink and colour on paper
19.5 × 53.5 CM
1973.82

Purchased with the aid of the Friends of the Ashmolean and Mr and Mrs J. Hillier

50
OHARA TONSHŪ

D. 1857

Ōsho (Ch: Wang Zhu)

Hanging scroll
Ink and colour on silk
128.0 × 51.2 CM
1973.155

Purchased with the aid of the Friends of the Ashmolean and Mr and Mrs J. Hillier

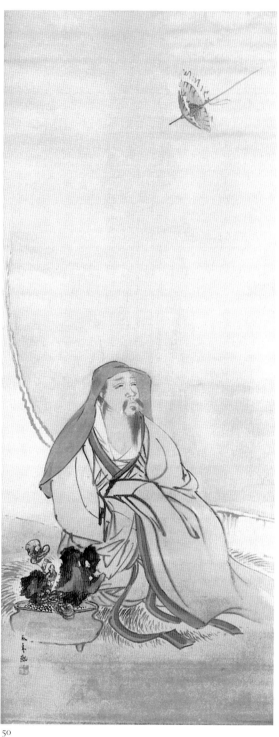

50

49

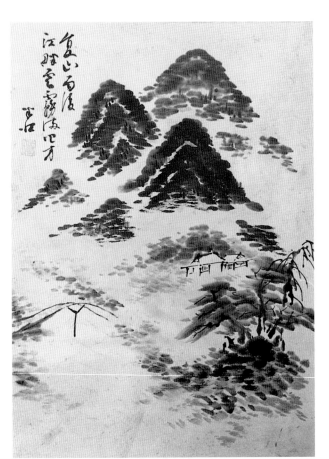

51

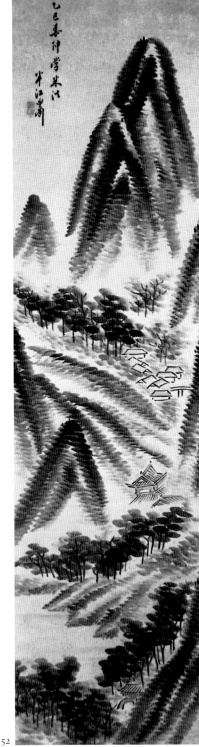

52

51
OKADA HANKŌ
1782–1846

Summer Mountains

Hanging scroll
Ink on paper
39.6 × 28.5 CM
1966.128
*Purchased with the aid of grants from the
Higher Studies Fund and the Victoria and
Albert Museum, also with donations from the
friends of P. C. Swann*

52
OKADA HANKŌ
1782–1846

Summer Mountains, 1845

Hanging scroll
Ink and slight colour on paper
128.2 × 34.1 CM
1966.129
*Purchased with the aid of grants from the
Higher Studies Fund and the Victoria and Albert
Museum, also with donations from the friends
of P. C. Swann*

53
OKADA KANRIN
1775–1849

White Pigeon on a Branch

Fan painting
Ink and colour on paper
15.0 × 46.2 CM
1973.56
*Purchased with the aid of the Friends of the
Ashmolean and Mr and Mrs J. Hillier*

53

54
Okamoto Toyohiko
1773–1845

Chinese Sage

Fan painting
Ink, colour and gold paint on paper
18.2 × 52.0 CM
X5401
Gift of Dr Michael Harari, from the collection of his father, Ralph Harari

54

55
Oku Bunmei
D. 1813

Fisherman and Boy

Fan painting
Ink and light colour on paper
19.2 × 52.6 CM
X5407
Gift of Dr Michael Harari, from the collection of his father, Ralph Harari

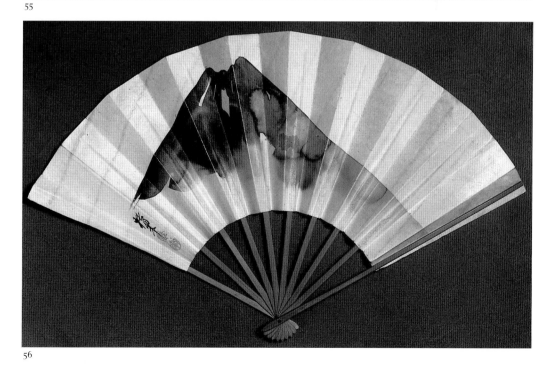

55

56
Onishi Chinnen
1792–1851

Mount Fuji

Fan painting
Ink on mica-coated paper on sticks
15.0 × 42.8 CM
1973.115
Purchased with the aid of the Friends of the Ashmolean and Mr and Mrs J. Hillier

56

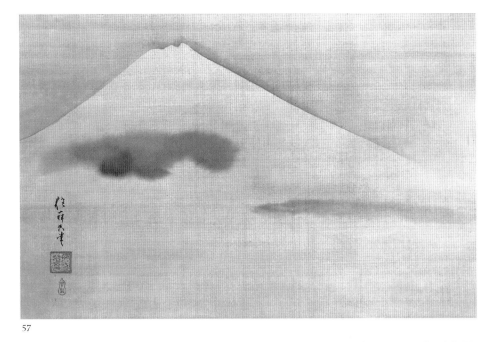

57

58

59

57
SAKAI HŌITSU
1761–1828

Mount Fuji

Hanging scroll
Ink and colour on silk
38.7 × 60.8 CM
1956.541
Gift of Sir George Sansom

58
SATŌ MASUYUKI (SUISEKI)
FL. C. 1810

Nō Actor as Priest

Matted painting
Ink and colour on paper
19.0 × 25.5 CM
1973.104
Purchased with the aid of the Friends of the
Ashmolean and Mr and Mrs J. Hillier

59
SHIBATA GITŌ
1780–1819

Bon-odori

Fan painting
Ink, colour and gold paint on paper
17.8 × 49.1 CM
X5428
Gift of Dr Michael Harari, from the collection of
his father, Ralph Harari

60

SHIBATA GITŌ

1780–1819

Two Wood Carriers

Fan painting
Ink and slight colour on paper
16.5 × 51.0 CM
1973.40
Purchased with the aid of the Friends of the Ashmolean and Mr and Mrs J. Hillier

61

SHIBATA ZESHIN

1807–1891

Large Brush, Fishing Rod and Float

Pair of matted *tansaku* paintings
Ink and colour on gold-flecked paper
36.2 × 6.1 CM EACH
1973.112, 113
Purchased with the aid of the Friends of the Ashmolean and Mr and Mrs J. Hillier

61

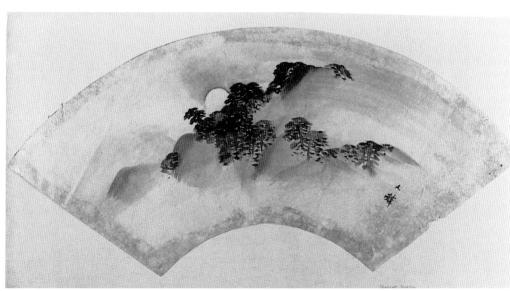

62

62

SHIOKAWA BUNRIN

1808–1877

Moonlit Landscape with Pine Trees

Fan painting
Ink, colour and gold paint on paper
18.5 × 49.5 CM
1973.20
Purchased with the aid of the Friends of the Ashmolean and Mr and Mrs J. Hillier

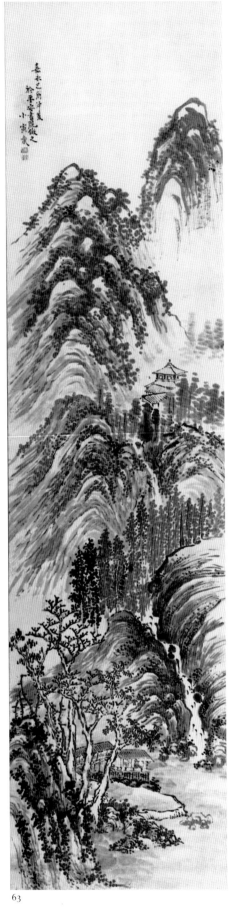

63

64

63
Signed SHOINSAI

DATES UNKNOWN

Landscape, 1849

Hanging scroll
Ink on paper
124.5 × 32.0 CM
1966.143

Purchased with the aid of grants from the Higher Studies Fund and the Victoria and Albert Museum, also with donations from the friends of P. C. Swann

64
SŌFU BAISEN

DATES UNKNOWN

Landscape

Fan painting
Ink and colour on paper
18.1 × 44.0 CM
1966.113

Purchased with the aid of grants from the Higher Studies Fund and the Victoria and Albert Museum, also with donations from the friends of P. C. Swann

65
SŪGETSU

D. 1830

Ariwara no Narihira

Fan painting
Ink and colour on paper
18.0 × 48.2 CM
X5379

Gift of Dr Michael Harari, from the collection of his father, Ralph Harari

65

66

66

SUZUKI HYAKUNEN

1825–1891

Bat and Willow Tree

Fan painting

Ink and colour on paper

14.5 × 44.3 CM

1973.52

Purchased with the aid of the Friends of the Ashmolean and Mr and Mrs J. Hillier

67

67

SUZUKI HYAKUNEN

1825–1891

Wren on a Berry Tree

Hanging scroll

Ink and colour on silk

34.0 × 50.3 CM

1973.174

Purchased with the aid of the Friends of the Ashmolean and Mr and Mrs J. Hillier

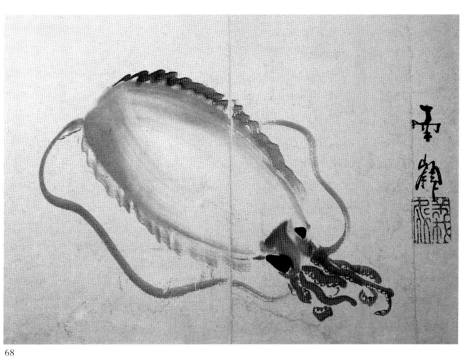

68

68

SUZUKI NANREI

1775–1844

Squid

Matted painting

Ink and colour on paper

24 × 30 CM

1973.84

Purchased with the aid of the Friends of the Ashmolean and Mr and Mrs J. Hillier

69
TAKENOUCHI GARYŪ
DATES UNKNOWN

Kanzan and Jittoku

Fan painting
Ink on paper on sticks
12.1 × 34.7 CM
1972.33
*From the estate of the late
Mrs Isabella Cohn*

70
TAKENOUCHI GARYŪ
DATES UNKNOWN

Landscape

Fan painting
Ink on paper on sticks
12.2 × 34.2 CM
1972.34
*From the estate of the late
Mrs Isabella Cohn*

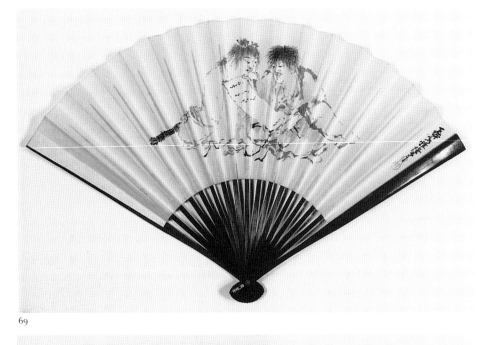

69

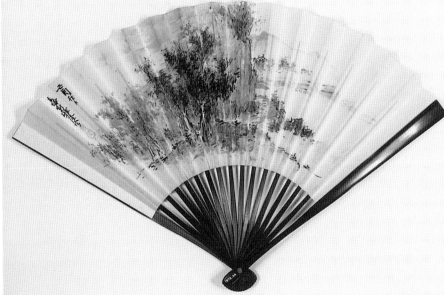

70

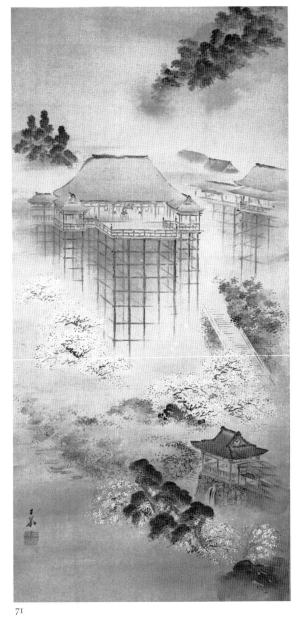

71

71
TANAKA NIKKA
D. 1845

Kiyomizu Temple (Kiyomizudera)

Hanging scroll
Ink and colour on silk
92.5 × 34.5 CM
1973.180
*Purchased with the aid of the Friends of the
Ashmolean and Mr and Mrs J. Hillier*

72

TANAKA SHISEKI

1712–1786

Landscape

Fan painting

Ink and gold leaf on paper

13.3 × 41.5 CM

1966.104

Purchased with the aid of grants from the Higher Studies Fund and the Victoria and Albert Museum, also with donations from the friends of P. C. Swann

72

73

TANI BUN'ICHI

1787–1818

Two Crickets Among Flowers

Fan painting

Ink and colour on paper

18.2 × 52.5 CM

X5406

Gift of Dr Michael Harari, from the collection of his father, Ralph Harari

73

74

TANI BUN'ICHI

1787–1818

Wang Xizhi Writing Calligraphy on a Fan Painting

Fan painting

Ink and colour on paper

18.4 × 52.0 CM

X5454

Gift of Dr Michael Harari, from the collection of his father, Ralph Harari

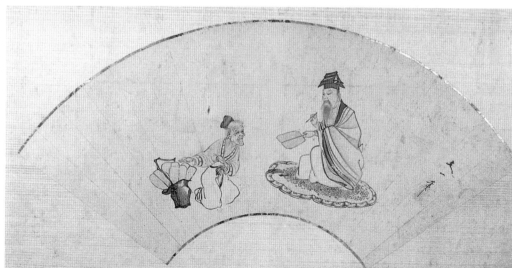

74

75
TANI BUNCHŌ
1763–1840

Autumn Landscape

Hanging scroll

Ink and colour on silk

100.1 × 27.6 CM

1966.121

Purchased with the aid of grants from the Higher Studies Fund and the Victoria and Albert Museum, also with donations from the friends of P. C. Swann

76
TANIGUCHI AIZAN
1816–1899

Landscape with Lake

Fan painting

Ink on paper

Inscription by the artist

13.8 × 44.5 CM

1966.95

Purchased with the aid of grants from the Higher Studies Fund and the Victoria and Albert Museum, also with donations from the friends of P. C. Swann

77
TANOMURA CHIKUDEN
1777–1835

Orchids, 1798

Hanging scroll

Ink on paper

Inscription by Rai Sanyō (1780–1832)

148.2 × 31.5 CM

1966.122

Purchased with the aid of grants from the Higher Studies Fund and the Victoria and Albert Museum, also with donations from the friends of P. C. Swann

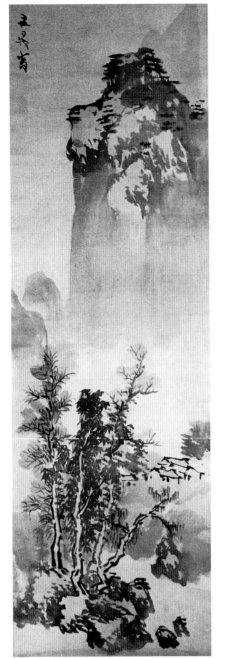

75

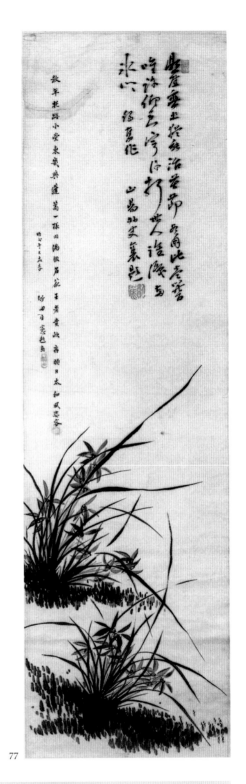

77

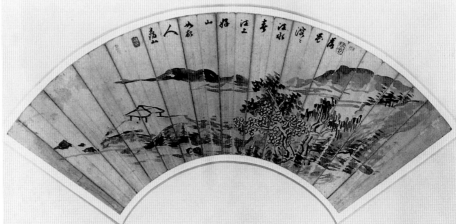

76

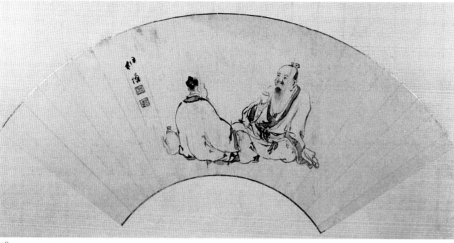

78

78
(Katagiri) Tōin
1744–c. 1807

Two Chinese Men Drinking Tea

Fan painting
Ink and light colour on paper
16.8 × 48.5 cm

x5414

Gift of Dr Michael Harari, from the collection of his father, Ralph Harari

79
Attributed to
Utagawa Kuniyoshi
1798–1861

Hekirekka Shimmei (Qin Ming), Suikoden chapter 33, c. 1827–30

Preparatory drawing for an unissued print
Ink and colour on paper
ōban size

1971.45

Given in memory of Derick Grigs by George Grigs, Elizabeth Grigs and Susan Messer

79

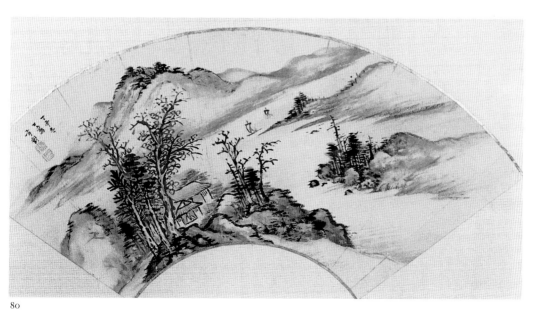

80

80
Watanabe Gentai
1749–1822

Landscape, 1807

Fan painting
Ink and light colour on paper
19.2 × 52.0 cm

x5389

Gift of Dr Michael Harari, from the collection of his father, Ralph Harari

81

Watanabe Kazan

1793–1841

Flowers and Insects, after Matsumura Goshun (1752–1811)

Handscroll
Ink and colour on paper
27.5 × 380.0 CM
1973.135
Purchased with the aid of the Friends of the Ashmolean and Mr and Mrs J. Hillier

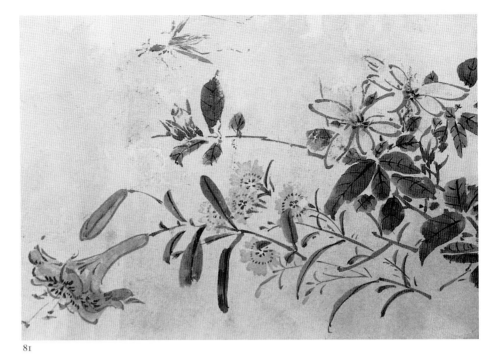

81

82

Watanabe Kazan

1793–1841

Vegetables, after Matsumura Goshun (1752–1811)

Handscroll
Ink and colour on paper
26.6 × 742.2 CM
1973.134
Purchased with the aid of the Friends of the Ashmolean and Mr and Mrs J. Hillier

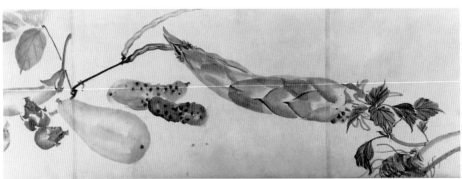

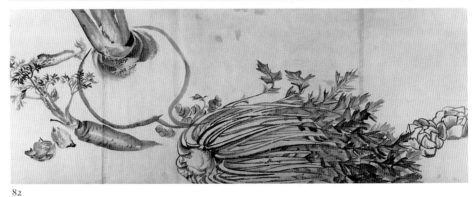

82

83

Watanabe Kiyoshi

19TH CENTURY

The Hyakunin Isshū

Fan painting
Ink, colour and gold on paper
16.7 × 49.5 CM
X5376
Gift of Dr Michael Harari, from the collection of his father, Ralph Harari

83

84
WATANABE NANGAKU
1767–1813

Two Carp

Fan painting
Ink and colour on paper
18.5 × 52.0 CM
X5380
Gift of Dr Michael Harari, from the collection of his father, Ralph Harari

85
WATANABE SEITEI (SHŌTEI)
1851–1918

Crane, Mount Hōrai, and Sparrow with Plum Branch

Hanging scrolls, triptych
Ink and colour on silk
105.5 × 43.3 CM
2000.113
Story Fund

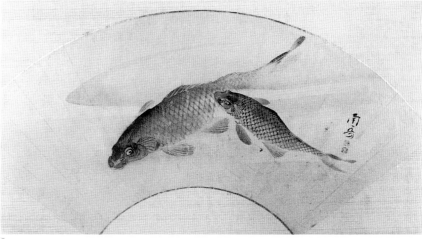
84

86

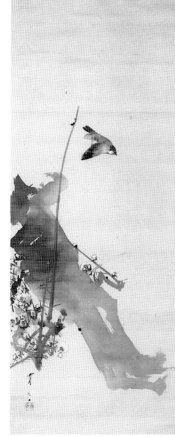
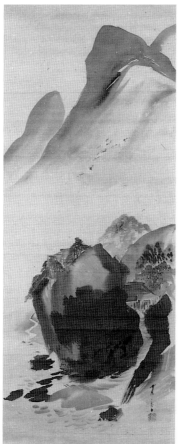
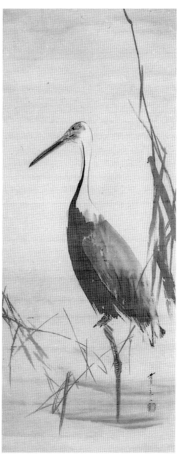
85

86
YAMAGUCHI SOKEN
1759–1818

Gourd

Fan painting
Ink and light colour on paper
18.6 × 51.9 CM
X5423
Gift of Dr Michael Harari, from the collection of his father, Ralph Harari

87

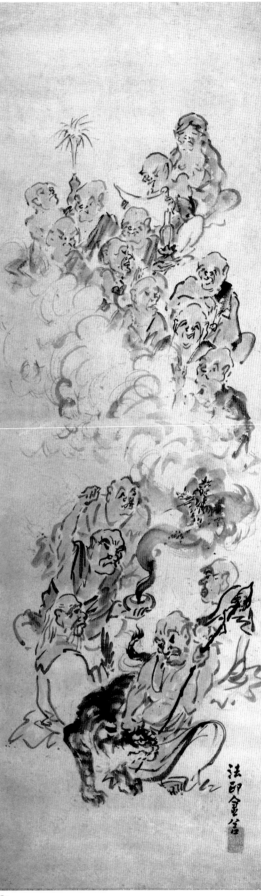

87
YAMAMOTO BAIITSU
1783–1856

Landscape with Pine Trees

Handscroll
Ink and colour on paper
26.0 × 389.1
1964.87

88
YOKOI KINKOKU
1761–1832

Nara Hōshi

Hanging scroll
Ink and slight colour on paper
Inscription by the artist
30.2 × 42.6 CM
1967.130

88

89

89

YOKOI KINKOKU

1761–1832

Sixteen Lohans

Hanging scroll

Ink and slight colour on paper

128.3 × 40.6 CM

1966.137

Purchased with the aid of grants from the Higher Studies Fund and the Victoria and Albert Museum, also with donations from the friends of P. C. Swann

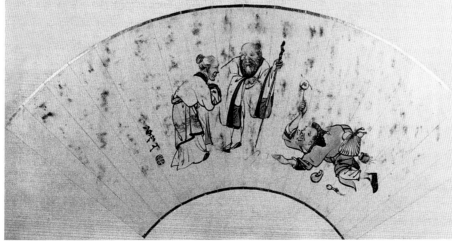

91

90

YOKOYAMA KAZAN

1784–1837

Toy Seller

Fan painting

Ink and colour on paper

18.9 × 52.0 CM

X5411

Gift of Dr Michael Harari, from the collection of his father, Ralph Harari

91

YOKOYAMA SEIKI

1792–1865

Landscape with Young Pine Trees

Hanging scroll

Ink and colour on paper

39.5 × 56.5 CM

1973.140

Purchased with the aid of the Friends of the Ashmolean and Mr and Mrs J. Hillier

(overleaf)

92

TOMIOKA TESSAI

1836–1924

MURATA KOKOKU

1831–1912

HIMESHIMA CHIKUGAI

1840–1928

TANOMURA CHOKUNYŪ

1814–1907

AND OTHERS

Collaborative Painting of Flowers and Other Plants

Hanging scroll

Ink and colour on silk

148.7 × 52.1 CM

1966.151

Purchased with the aid of grants from the Higher Studies Fund and the Victoria and Albert Museum, also with donations from the friends of P. C. Swann

90

93

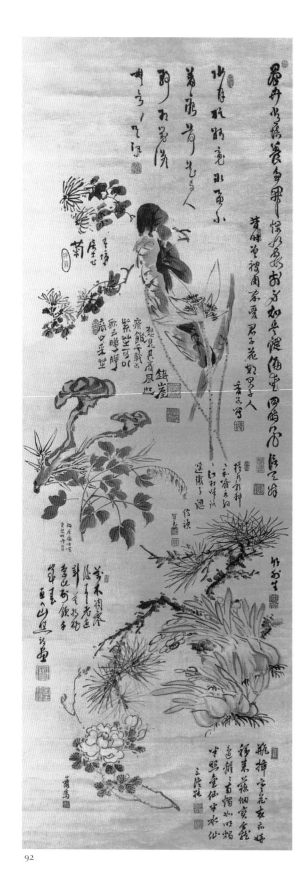

92

93
TOSA MITSUZANE
1782–1852
NAGAYAMA KŌIN
1765–1849
SHIBATA GITŌ
1780–1819
AND OTHERS

*Miniature Painting and Calligraphy
Album, 1817*

Accordion-folded album
Preface plus fifty paintings
Ink and colour on paper
13.4 × 14.3 CM EACH IMAGE
1973.126

*Purchased with the aid of the Friends of the
Ashmolean and Mr and Mrs J. Hillier*

94
YAMAMOTO BAISŌ
1846–1921
and
YOSHIKAWA SUSUMU
FL. LATE 19TH CENTURY

Plum, Narcissus and Rock

Fan painting
Ink and colour on paper
11.1 × 41.5 CM
1966.96

*Purchased with the aid of grants from the
Higher Studies Fund and the Victoria and
Albert Museum, also with donations from the
friends of P. C. Swann*

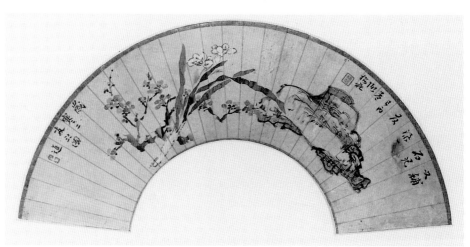

94

Select Bibliography

Adams, Celeste, *Heart Mountains and Human Ways, Japanese Landscape and Figure Painting: A Loan Exhibition from the University of Michigan Museum of Art*. Houston: Museum of Fine Arts, 1983.

Addiss, Stephen, ed., *Japanese Quest for a New Vision : The Impact of Visiting Chinese Painters, 1600–1900: Selections from the Hutchinson Collection at the Spencer Museum of Art*. Lawrence: Spencer Museum of Art, University of Kansas, 1986.

Akiyama, Ken, and Taguchi, Eiichi, eds, Gōka 'Genji-e' no sekai: Genji monogatari. Tokyo: Gakushū kenkyūsha, 1999.

Amagasaki sōgō bunka sentaa, *Goshun ten*. Amagasaki: Amagasaki sōgō bunka sentaa, 1979.

Araki, Tadashi, ed., *Dai Nihon shoga meika taikan*, 4 vols. Tokyo: Daiichi Shobō, 1975.

Asaoka, Okisada, *Zōtei koga bikō*. Kyoto: Shibunkaku, 1970.

Berry, Paul, *Unexplored Avenues of Japanese Painting: the Hakutakuan Collection*. Seattle: University of Washington Press, 2001.

Cahill, James, *The Distant Mountains, Chinese Painting of the Late Ming Dynasty, 1570–1644*. New York and Tokyo: Weatherhill, 1982.

_____, *Parting at the Shore: Chinese Painting of the Early and Middle Ming Dynasty, 1368–1580*. New York: Weatherhill, 1978.

_____, *Scholar-painters of Japan: The Nanga School*. New York: Asia Society, Inc., 1972.

Calza, Gian Carlo ed., with the assistance of John T. Carpenter, *Hokusai paintings: Selected Essays*. Venice: The International Hokusai Research Centre, University of Venice, 1994.

Chiba City Art Museum (Chiba-shi bijutsukan), *Edo no ikoku shumi: nanpinfū dairyūkū: shinseiki, shisei shikō 80-shūnen kinen*. Chiba: Chiba-shi bijutsukan, 2001.

_____, *Hishikawa Moronobu ten, Chiba-shi Bijutsukan kaikan goshūnen kinen*. Chiba: Chiba-shi bijutsukan, 2000.

Clark, Timothy T., *Ukiyo-e Paintings in the British Museum*. Washington, DC: Smithsonian Institution Press, 1992.

Conant, Ellen P., in collaboration with Steven D. Owyoung and J. Thomas Rimer, *Nihonga, Transcending the Past: Japanese-style Painting, 1868–1968*. St Louis, MO: St Louis Art Museum; Tokyo: Japan Foundation, 1995.

Doi, Tsugiyoshi, 'Mori-ha zakkō', in *Kinsei hihon kaiga no kenkyū*. Tokyo: Bijutsu shuppansha, 1970, 648–56.

Earle, Joe, *Shibata Zeshin: Masterpieces of Japanese Lacquer from the Khalili Collection*. Edinburgh: National Museums of Scotland; London: Kibo Foundation, 1997.

Forrer, Matthi, with texts by Edmond de Goncourt. *Hokusai*. New York: Rizzoli, 1988.

Genshoku ukiyo-e daihayakka jiten henshū iinkai, ed., *Genshoku ukiyo-e dai hyakka jiten*, 11 vols. Tokyo: Taishūkan shoten, 1980–82.

Gotō Museum (Gotō bijutsukan), *Teikayō: Tokubetsuten*. Tokyo: Gotō bijutsukan, 1987.

Graham, Patricia, 'Ōkubo Shibutsu, Vagabond Poet of Edo, and His Nanga Painter-friends'. *Kaikodo Journal*, vol. 20 (Autumn 2001), 63–73.

Graham, Patricia Jane, 'Yamamoto Baiitsu: His life, literati pursuits, and related paintings'. Ph. D. thesis, University of Kansas, 1983.

Guth, Christine, *Japanese Art of the Edo Period*. London: Weidenfeld and Nicolson, 1996.

Harper, Thomas James, 'Motoori Norinaga's criticism of the Genji Monogatari: A study of the background and critical content of his Genji Monogatari Tama no Ogushi'. Ph. D. thesis, The University of Michigan, 1971.

Hillier, Jack Ronald, *The Art of the Japanese Book*, 2 vols. London: published for Sotheby's Publications by Philip Wilson Publishers, 1987.

_____, *The Uninhibited Brush: Japanese art in the Shijō Style*. London : Hugh M. Moss (Publishing) Ltd, 1974.

_____, *The Harari Collection of Japanese paintings and drawings*, 3 vols. London: Lund Humphries, 1970–73.

_____, *The Harari Collection of Japanese Paintings and Drawings: An Exhibition Organized by the Arts Council at the Victoria and Albert Museum, 14 January–22 February 1970*. London: Arts Council of Great Britain, 1970.

_____, 'Nanga paintings in the Ashmolean Museum, Oxford' *Oriental Art* 13, no. 3 (1967) 161–9.

Hiryama, Ikuo and Kobayashi, Tadashi, eds, *Hizō nihon bijutsu taikan (Japanese Art: The Great European Collections)*, 12 vols. Tokyo: Kōdansha, 1992–4.

Honolulu Academy of Arts, *Exquisite Visions: Rimpa Paintings from Japan*. Honolulu: The Honolulu Academy of Arts, 1980.

Hori, Chokkaku, *Fusō meigaden*. Tokyo: Tetsugaku shoin, 1899.

Hosono, Masanobu, ed, *Kindai kaiga no reimei: Bunchō/Kazan to yōfūga, Nihon bijutsu zenshū* vol. 25. Tokyo: Gakushū Kenkyusha, 1979.

Hyōgo Prefectural Museum of History (Hyōgo kenritsu rekishi hakubutsukan), *Maruyama Ōkyo ten: botsugo nihyakunen kinen*. Hyōgo: Hyōgo kenritsu rekishi hakubutsukan, 1994.

Ikeda Yasaburō, Noma Kōshin and Minakami Tsutomu, eds, *Nihon meisho fūzoku zue*, 19 vols. Tokyo: Kadokawa shoten, 1979–88.

Impey, Oliver R. *The Art of the Japanese Folding Screen: The Collections of the Victoria and Albert Museum and the Ashmolean Museum*. Oxford: Ashmolean Museum, 1997.

Itabashi Art Museum (Itabashi kuritsu bijutsukan), *Shibata Zeshin ten: bakumatsu meiji no seika kaiga to shikkō no sekai*. Tokyo: Itabashi kuritsu bijutsukan, 1980.

Izumi, Kan'ichi. *Kanazawa jō to Yamamoto Baiitsu no sokuseki*. Takaoka: Iwanami bukku saabisu sentaa, 1998.

Kansai University Library (Kansai daigaku toshokan), *Kansai daigaku shozō, Osaka gadan mokuroku (A Catalogue of the Japanese-style Paintings of Osaka Painting Circles in the Kansai University Library)*. Suita, Osaka: Kansai daigaku toshokan, 1997.

Kimura, Shigekazu, *Gajō yōryaku, kinsei itsu-jin gashi. Nihon kaigaron taisei*, vol. 10. Tokyo: Perikansha,1998.

Kobayashi, Tadashi, *Edo no gakatchi*. Tokyo: Perikansha, 1990.

_____, *Edo kaiga shiron*. Tokyo: Ruri shobō, 1983.

_____, *Nihon bijutsuin, Gendai genshoku nihon no bijutsu*, vol. 2. Tokyo: Shōgakkan, 1979.

Kobayashi, Tadashi, and Kōno Motoaki, eds, *Bunjin shoga: yoriai shogajō, Edo meisaku gajō zenshū*, vol. 10. Tokyo, Osaka: Shinshindō, 1997.

_____, *Ōkyo, Rosetsu, Jakuchū: Maruyama-Shijō ha, Edo meisaku gajō zenshū*, vol. 7. Tokyo, Osaka: Shinshindō, 1996.

Kōno, Motoaki, *Tani Bunchō, Nihon no bijut-su*, no. 257. Tokyo: Shibundō, 1987.

Kyoto Municipal Museum of Art (Kyoto-shi bijutsukan), *Kyoto gadan, Edo Matsu Meiji no gajintachi*. Kyoto: Aato shuppansha, 1977.

Kyoto National Museum (Kyoto kokuritsu hakubusukan), ed., *Jakuchū: Bunkazai hogohō 50-nen kinen jigyō tokubetsu tenrankai, botsugo 200-nen*. Kyoto: Kyoto kokuritsu hakubutsukan, 2000.

Link, Howard A., et al., *The art of Shibata Zeshin: the Mr and Mrs James E. O'Brien Collection at the Honolulu Academy of Arts*. London: R. G. Sawers Pub.; Honolulu: Honolulu Academy of Arts, 1979.

Matsuo Katsuhiko. 'Kinsei Naniwa gadan no ichigawamen, Moriha josetsu', *Kobijutsu* 49 (Sept. 1975), 42–51.

McMullen, James, *Idealism, Protest, and the Tale of Genji: The Confucianism of Kumazawa Banzan (1619–91)*. Oxford: Clarendon Press, 1999.

Minamoto, Toyomune and Sasaki, Jōhei, eds, *Kyoto gadan no jūkyūseiki*, vol. 2 *Bunka Bunseiki*. Kyoto: Shibunkaku shuppan, 1994.

Mitchell, C. H., *The Illustrated Books of the Nanga, Maruyama, Shijo and Other Related Schools of Japan: A Bibliography*. Los Angeles: Dawson's Bookshop, 1972.

Miyeko Murase, *Iconography of the Tale of Genji, Genji Monogatari ekotoba*. New York, Tokyo: Weatherhill, 1983.

Morioka, Michiyo, and Paul Berry, *Modern Masters of Kyoto: The Transformation of Modern Painting Traditions, Nihonga from the Griffith and Patricia Way Collection*. Seattle: Seattle Art Museum, 1999.

Morris, Ivan, *The Pillow Book of Sei Shōnagon*. New York: Columbia University Press, 1967.

Morrison, Arthur, *The Painters of Japan*. London: T. C. & E. C. Jack, 1911.

Murashige, Yasushi, ed., *Rinpa*, 5 vols. Kyoto: Shikōsha, 1989–92.

Museum of Kyoto (Kyoto bunka hakubutsukan), *Miyako no eshi wa hyakka ryōran: Heian jinbutsushi ni miru Edo jidai no kyōto gadan: Kyōto bunka hakubutsukan kaikan jisshūnen kinen tokubetsuten*. Kyoto: Kyoto bunka hakubutsukan, 1998.

Nagoya City Museum (Nagoya-shi hakubut-sukan), *Nangaka Yamamoto Baiitsu: karei naru kachō sansui no fūga: tokubetsuten*. Nagoya: Nagoya-shi hakubutsukan, 1998.

_____, *Owari no nanga*. Nagoya: Nagoya-shi hakubutsukan, 1981.

Onomichi Municipal Museum of Art (Onomichi shiritsu bijutsukan), *Hirada Gyokuon ten: saikō no gaka*. Onomichi: Onomichi shiritsu bjutsukan, 1998.

Osaka Municipal Museum of Art (Osaka shiritsu bijutsukan), *Kinsei Osaka gadan*. Kyoto: Dōhōsha, 1983.

Rosenfield, John M., 'Japanese studio practice: The Tosa family and the Imperial Painting Office in the seventeenth century'. In *The Artist's Workshop. Studies in the History of Art*, no. 38, ed. Peter Lukehart. Washington, DC: Center for Advanced Studies in the Visual Arts, National Gallery of Art, 1993, 79–102.

Sakai City Museum (Sakai-shi hakubutsukan), *Kinsei no Osaka gajin, sansui, fūkei, meisho*. Sakai: Sakai-shi hakubutsukan, 1992.

St Louis Art Museum, *Ōkyo and the Maruyama-Shijō School of Japanese Painting*. St Louis: St Louis Art Museum, 1980.

Sasaki, Jōhei, *Koga sōran. Maruyama Shijō-ha*. Tokyo: Kokusho kankōkai, 2000.

_____, *Maruyama Ōkyo kenkyū*, 2 vols. Tokyo: Chūō kōron bijutsu shuppan, 1996.

Screech, Timon, *The Shogun's Painted Culture: Fear and Creativity in the Japanese States, 1760–1829*. London: Reaktion Books, 2000.

Seidensticker, Edward G., *Murasaki Shikubu: The Tale of Genji*. London: Secker and Warburg, 1976.

Shimonoseki Art Museum (Shimonoseki shiritsu bijutsukan), *Oda Kaisen ten*. Shimonoseki: Shimonoseki shiritsu bijutsukan, 1995.

Sorimachi, Shigeo, *Nihon eiribon oyobi ehon mokuroku: airurandokoku daburin chesutaa biitii raiburarii zō (Japanese Illustrated Books and Manuscripts of the Chester Beatty Library, Dublin, Ireland)*. Tokyo: Kōbunsō, 1979.

Stanley-Baker, Joan, 'Finger painting in Tokugawa Japan', in *Discarding the Brush, Gao Qipei (1660–1734) and the Art of Chinese Fingerpainting*. Amsterdam: Rijksmuseum, 1992.

_____, *The Transmission of Chinese Idealist Painting to Japan: Notes on the Early Phase*

(1661–1799). Ann Arbor: Center for Japanese Studies, University of Michigan, 1991.

Suntory Art Museum (Santorii bijutsukan). *Kohitsu tekagami to gajō no meihin, kinsei nihon no aato arubamu*. Tokyo: Santorii bijutsukan, 2001.

_____, *Itsuō bijutsukan meihinten Buson to Goshun*. Tokyo: Santorii bijutsukan, 1981.

Suzuki, Kei, *Chūgoku kaiga sōgō zuroku*, 5 vols Tokyo: Tokyo daigaku shuppankai, 1983.

Takei, Sōgen, *Maruyamaha shita-e shū*, 5 vols. Kyoto: Mitsumura suiko shoin, 1997.

Takeuchi, Melinda, *Taiga's True Views: The Language of Landscape Painting in Eighteenth-Century Japan*. Stanford: Stanford University Press, 1992.

Tochigi Prefectural Museum of Fine Art (Tochigi kenritsu bijutsukan), *Shazanrō Tani Bunchō*. Tochigi: Tochigi kenritsu bijutsukan, 1979.

Tōhō, Shoin, ed., *Nihonga taisei*, 16 vols. Tokyo: Tōhō Shoin, 1931–4.

Tokyo National Museum (Tokyo kokuritsu hakubutsukan), ed., *Kindai Nihon bijutsu no kiseki: Nihon Bijutsuin sōritsu 100-shūnen kinen tokubetsuten*. Tokyo: Nihon Bijutsuin, 1998.

Tokyo National Museum (Tokyo kokuritsu hakubutsukan) and Kyoto National Museum (Kyoto kokuritsu hakubutsukan), *Sesshū: Botsugo gohyakunen tokubetsuten (Sesshū, Master of Ink and Brush: 500th Anniversary Exhibition)*. Tokyo: Mainichi shinbunsha, 2002.

Umezawa, Seiichi, *Nihon nanga shi*. Tokyo: Tōhō Shoin, 1929.

Weston, Victoria Louise, 'Modernization in Japanese-style Painting: Yokoyama Taikan (1868–1958) and the *mōrōtai* style'. Ph. D. thesis, University of Michigan, 1991.

Woodson, Yoko, 'Traveling Bunjin painters and their patrons: Economic life, style and art of Rai Sanyō and Tanomura Chikuden'. Ph.D. thesis, University of California, Berkeley, 1983.

Wylie, Hugh, 'Nanga painting treatises of nineteenth-century Japan: Translations, commentary, and analysis'. Ph.D. thesis, University of Kansas, 1991.

Yamakawa, Takeshi, *Ōkyo Goshun, Nihon bijutsu kaiga zenshū*, vol. 22. Tokyo: Shūeisha, 1977.

_____, *Nanga to shaseiga, Genshoku nihon no bijutsu*, vol. 18. Tokyo: Shōgakkan, 1969.

Yamanaka, Yutaka, *Heian jinbutsushi*. Tokyo: Tokyo daigaku, 1974.

Yamane, Yūzō, ed., *Rimpa kaiga zenshū*, 5 vols. Tokyo: Nihon Keizai Shinbunsha, 1977–1980.

Yamane, Yūzō, Naitō, Masato, and Timothy Clark; with contributions by Masaaki Arakawa. *Rimpa Art: From the Idemitsu Collection, Tokyo*. London: British Museum Press, 1998.

Yamanouchi, Chōzō, *Nihon Nangashi*. Tokyo: Ruri shobō, 1981.

Yasumura, Toshinobu, 'Sō Shiseki during the Hōreki era (1751–1764) (*Horeki nenkan no Sō Shiseki*)', *Kokka* 1122 (1989), 38–47.

Yokoyama Taikan kinenkan, *Yokoyama Taikan*, 6 vols. Tokyo: Dai Nihon kaiga, 1993.

Yoshida, Toshihide, 'Yamamoto Baiitsu kenkyū josetsu', in *Nagoya-shi hakubutsukan kenkyū kiyō*, vol. 2, 1979, 15–32.

Yoshizawa, Chū, *Nanga sansui, Nihon byōbu-e shūsei*, vol. 3. Tokyo: Kōronsha, 1979.

_____, *Nihon no Nanga, Suiboku bijutsu taikei*, supplementary vol. 1. Tokyo: Kōronsha, 1976.

Yoshizawa, Chū and Yamakawa, Takeshi, *Nanga to shaseiga. Genshoku nihon no bijutsu*, vol. 18. Tokyo: Shōgakkan, 1969.

Index of Artists
in main section

Please note: Catalogue number 29, 'Painting and calligraphy album', contains the work of various artists, not all of whom are listed here.

Concordance

Accession Number	Catalogue Number
X5361	53
X5365	Supp.27
X5366	27
X5374	Supp.30
X5376	Supp.83
X5377	Supp.19
X5378	46
X5379	Supp.65
X5380	Supp.84
X5385	Supp.43
X5387	11
X5389	Supp.80
X5390	Supp.14
X5391	Supp.40
X5394	Supp.23
X5400	45
X5401	Supp.54
X5403	Supp.24
X5405	Supp.15
X5406	Supp.73
X5407	Supp.55
X5410	Supp.29
X5411	Supp.90
X5414	Supp.78
X5417	48
X5423	Supp.86
X5424	Supp.34
X5425	47
X5426	36
X5428	Supp.59
X5429	Supp.13
X5431	10
X5432	50
X5436	16
X5440	Supp.18
X5442	Supp.32
X5443	49
X5445	Supp.17
X5447	Supp.26
X5454	Supp.74
X5459	Supp.21
X5587	54
1956.537	Supp.3
1956.541	Supp.57
1959.85	51
1959.87	52
1962.114	Supp.1
1962.115	Supp.1
1962.208	Supp.20
1962.209	28
1964.87	Supp.87
1964.89	5
1964.92	Supp.47
1964.95	29
1964.196	58
1965.11	Supp.4
1965.69	44
1965.127	Supp.36
1965.130	Supp.22
1965.131	Supp.41
1965.133	57
1966.4	13
1966.95	Supp.76
1966.96	Supp.94
1966.97	Supp.46
1966.98	4
1966.99	24
1966.100	Supp.35
1966.101	17
1966.102	8
1966.104	Supp.72
1966.106	Supp.7
1966.107	Supp.10
1966.109	Supp.28
1966.110	3
1966.112	12
1966.113	Supp.64
1966.115	6
1966.116	6
1966.117	9
1966.121	Supp.75
1966.122	Supp.77
1966.123	2
1966.124	1
1966.125	1
1966.128	Supp.51
1966.129	Supp.52
1966.132	7
1966.133	Supp.48
1966.137	Supp.89
1966.143	Supp.63
1966.147	14
1966.148	Supp.16
1966.149	18
1966.151	Supp.92
1966.161	41
1967.20	Supp.11
1967.130	Supp.88
1970.94	43
1971.45	Supp.79
1972.33	Supp.69
1972.34	Supp.70
1972.39	Supp.1
1973.18	25
1973.20	Supp.62
1973.21	Supp.12
1973.38	Supp.25
1973.39	Supp.9
1973.40	Supp.60
1973.52	Supp.66
1973.56	Supp.53
1973.57	Supp.39
1973.66	15
1973.82	Supp.49
1974.84	Supp.68
1973.89	33
1973.90	22
1973.91	22
1973.92	21
1973.93	Supp.31
1973.94	Supp.44
1973.96	23
1973.97	Supp.45
1973.98	Supp.8
1973.104	Supp.58
1973.111	39
1973.112	Supp.61
1973.113	Supp.61
1973.115	Supp.56
1973.116	34
1973.126	Supp.93
1973.128	55
1973.130	Supp.33
1973.132	35
1973.134	Supp.82
1973.135	Supp.81
1973.136	37
1973.140	Supp.91
1973.144	20
1973.155	Supp.50
1973.156	19
1973.160	Supp.38
1973.161	Supp.6
1973.162	30
1973.165	38
1973.171	31
1973.174	Supp.67
1973.176	40
1973.180	Supp.71
1973.184	42
1973.185	Supp.42
1973.186	Supp.42
1973.187	26
1973.189	Supp.37
1973.191	32
1973.195	Supp.5
1993.13	56
1996.130	56
2000.113	Supp.85
2002.65	Supp.2

品の手本として、当時日本で高い評価を得ていた明代の画家陳淳（１４８４-１５４４）の作風などを模範としている。中央の真紅からうっすらと薄紅に和らいでいく花弁は、制作当時は鉛白の顔料を加えることにより一層の光沢を放っていたことと思われる。葉は没骨手法を用い、緑と薄紅でさわやかに描かれている。全体的にはのびのびとした自由な印象を鑑賞者に与える作品であるが、細部の描写を注意して見ると、実は隅々まで丹念に制作された作品であることが分かる。

本画帖で最も興味深い一点として「山水」が挙げられる。この作品は渇筆で知られる元末四大家の一人、倪瓚の山水画に倣っている。梅逸は倪瓚の絵画様式を、楊文驄（１５９７-１６４５）や18世紀前半に活躍した伊孚九などの作品を通して学んだ。孚九は元代の大家の作風を復古させた清代の画家で、日本でも活動した。１８０３年には『伊孚九池大雅画譜』が出版されているが、これに辞を寄せたのが梅逸と親交の深かった詩仏であり、梅逸は詩仏を通して孚九の作風に親しんだと推測出来る。梅逸は後年にも多くの倪瓚様式の山水画を描いた。

中国の士大夫の文化に強く憧れた梅逸は、本画帖などの作品を通して中国絵画への理解を巧みに表現し、また同時代に江戸で活躍した文人との交流をアピールすることにより、自らの「文人」としての地位を確立したのである。

（村井則子訳）

していたことが証明された。本画帖は９枚の色紙により構成され、野菜、果実、草花、山水などの主題が、それぞれ著名な中国画家の作風に倣い、巧みに描かれている。これらの主題や作風は、その後も梅逸が取り組んだテーマを多く提示しており、本作品は後期作品との比較対象としても重視すべきものである。

南画は中国の士大夫による南宗画を模範するものとして京都で始ったが、その後江戸でも普及し、梅逸の時代には彼の出身地である名古屋などの地方都市でも盛んに制作された。この時代の南画家の多くは、『八譜画譜』や『芥子園図伝』などの画譜に加え、写生画や長崎派の花鳥画の作風も試みるようになっていた。また中国の士大夫と違い、日本の南画家の中には職業作家として活躍する者も多くいた。梅逸は主に艶麗な花鳥画で知られる画家であるが、山水、菊、蘭といった古典的な文人画の主題も多く手がけた。例えば、本画帖に見られる四季の題材は、その後も梅逸が好んで描いたテーマの一つである。

梅逸は狩野派の山本蘭亭により絵の手ほどきを受けたとされるが、四条派の張月樵(1770-1832)からも多くを学んだ。また同じ名古屋出身で同時代に活躍した復興大和絵の祖、田中訥言(１７６７-１８２３)にも敬意を表している。若年の梅逸は、名古屋や京都以外に金沢でも評判を集め、金沢では谷文晁(１７６３-１８４０)に会った。そして自信をつけたこの２７歳の画家は１８１４-１８１５年頃に江戸に上京し、江戸の文人サークルのメンバーとして活躍するようになる。本画帖はこの頃に制作された。

梅逸は、中国絵画に関する知識を『芥子園図伝』などを通して集め、本画帖に含まれる作品の大部分もこの画譜に模範が見出せる。その一方、梅逸は画譜以外にも実際の中国絵画を目にして学んだ。梅逸は、中国絵画を収集していた名古屋の豪商神屋天遊の下で中国絵画に親しんだが、１８０２年に同じ名古屋出身で文人画家の友人、中林竹洞（１７７６-１８５３）と京都へ旅した際にも、中国の絵画作品を見たと思われる。

本画帖の表題は大窪詩仏により「師古」と筆されている。詩仏は江戸で活躍した漢詩人・書家で、画も得意とした。奥書は詩仏と親交の深かった柏木如亭により、「画不貴形似今人合此言山水及欠花卉是帖写根源」と記されている。詩仏と如亭が共に梅逸の作品に参加したケースは1815年に最も多く、従って本作品の制作年代も１８１５年頃と考えられる。このころより梅逸は、詩仏を始めとする江戸の文人との交際を深め、漢詩、和歌、煎茶、書などを嗜むようになった。

本画帖の第１図は、華やかな色彩家である梅逸が得意とした「牡丹図」である。牡丹は明清代の花鳥画において最も好まれた主題の一つであるが、梅逸は本作

典型的な土佐派の源氏絵と相違する点が多く見られるからである。例えば、土佐派の典型的な顔貌表現の描法といえば引目鉤鼻であるが、本作品に登場する人物の眼は引目でなく瞳がはっきりと描かれている。そして額が広く非常に特徴的な細長い顔形をしている。この顔形は、ハーバード大学美術館蔵の光信作の《源氏物語図画帖》や１８世紀制作の香包（三の丸尚蔵館）等といった一部の土佐派の作品に認められるものの、最も典型的な土佐派の顔貌表現とは異なる。また本画帖の構図は、土佐派の模範から逸脱しているものが大部分を占めている。第９帖「葵」の図は、徳川美術館蔵の光則作の作品などの先例に倣っているが、これは例外であり、「絵合」や「帚木」などその他の構図や場面設定は、土佐派の主流の伝統と一線を画している。

本作品を現存する他の源氏物語図画帖から際立たせている最たる特徴は、五常を詠む和歌が詞書として引用されていることである。これらの和歌４首は、藤原忠通の子で天台宗の僧慈円（1155-1225）により詠まれ、１４世紀に編集された『拾玉集』に収録されている。慈円の和歌を『源氏物語』の解釈に用いる先例としては、１５２８年に出版された三条西実隆による仏教的な『源氏物語』手引書、『源氏物語細流抄』が挙げられる。１７世紀後期から１８世紀になると慈円の５首はさらに広く親しまれるようになり、鈴木春信もこれを主題とした浮世絵シリーズを制作している。

徳川幕府は朱子学に基づく儒学的世界観の普及を奨励したが、その反映として江戸時代には『源氏物語』を登場人物の生き様を儒学的に解釈する作品として読む傾向があった。１７世紀の儒学者熊沢蕃山による『源氏外伝』はこの様な儒学的な『源氏物語』観を代表するものである。しかし１８世紀後半になると、本居宣長を中心とする国学者により儒学的、若しくは仏教的な源氏解釈は否定され、『源氏物語玉の小櫛』などの手引書を通じて、『源氏物語』は日本特有の古道を伝える古典として再解釈されるようになる。本画帖は、国学的な解釈が主流となった江戸時代後期に制作されているが、『源氏物語』を儒学的道徳観と結び付けて読んできた江戸時代の思想的伝統の延長線上に位置付けられる作品である。

山本梅逸筆《師古》

山本梅逸（1783-1856）による本作品は、本展覧会において最も重要な作品であると言える。本画帖は、梅逸が初めて江戸に行った１８１５年頃に制作された貴重な初期作であり、近年の研究により解明されつつある梅逸の中国絵画や文化に対する深い造詣を裏付ける作品として注目に値する。本作品の存在により、梅逸は中国画家の筆様をこれまでの研究が推定したよりも早い時期に習得

詳であるが、金箔や金泥をふんだんに用いた精細な筆致で描かれている。１２枚の色紙を挟んだ前後にはそれぞれ２枚の詞書が添えられている。

平安期の宮廷生活を描いた紫式部の『源氏物語』は日本の古典文学の代表として今日まで広く親しまれているが、日本で最初に制作された画帖も『源氏物語』に題材を取る作品であった。現存する源氏物語図画帖の中で完全保存されている作品の中では、土佐光信（1435-1525）が1509年に制作した《源氏物語図画帖》（ハーバード大学美術館)が最も古い。『源氏物語』を描いた色紙は、古くから絵巻や屏風に貼付けられてきたが、江戸時代になると源氏絵は画帖として楽しむのが最もポピュラーな鑑賞法となった。

江戸時代、源氏物語図画帖は飾り棚本として婚礼調度品やその他祝賀の贈答品として制作され、贈られた女性に古雅な仕来りを伝えるものとして重宝された。一方、アシュモリアンの《源氏物語図画帖》の制作意図は、古雅な風趣を味わうというよりは教訓的な要素が強い。というのも本画帖の詞書は意外にも『源氏物語』からの引用ではなく、一見『源氏物語』とは無関係と思われる儒教道徳の五常の中、仁・義・礼・智の四常を詠んだ和歌が綴られているからである。これら４首の和歌は、各首異なる書家により筆されている。このうち「礼」の和歌を筆した書跡は、冷泉家の１６代目冷泉為泰（1735-1816）のものと確認出来る。

本画帖は、過去において何らかの破損を受け、その際に残された１２枚の色紙を含め保存可能な部分だけが修復され、新たな画帖として表装し直されたものである。（詞書の和歌はこの際に新しく筆された可能性もある。）従って本作品からは制作当初はあったと考えられる何枚らかの色紙が欠落している。しかし、それらの欠落がありながらも新たな画帖として修復されたという事実は、本作品が所有者により長い間大切に所持され、保存されてきたことを物語っている。現在の保存状態は、表紙を含め水によるシミがかなりあるものの、これらは書画自体の保存には影響を及ぼしていない。

本作品の作風は、古典的題材を精密に描くことで知られる土佐派の様式に近く、作家を特定することは出来ないが、土佐派の手法を習得した画家により描かれたものと推定される。土佐派の画家による源氏物語図画帖の歴史は古く、現存作品としては、先に挙げた土佐派の創始者光信の作品以外にも、土佐光吉（1539-1613）の《源氏物語図画帖》（京都国立博物館）や、土佐光則（1583-1638）の《源氏物語図画帖》（徳川美術館）がある。16世紀以降は、土佐派に直接属さない京都の画工房においても、土佐派様式の源氏物語図画帖が制作されるようになり、本作品はこのような工房、若しくは土佐派の周縁で活動した画家により制作された可能性が高い。なぜならば、本作品の作風には、

「コンパクトな名宝：アシュモリアン美術館が所蔵する画帖
2作品をめぐる考察」（要約）

ジャニス・キャッツ

本論文は、アシュモリアン美術館の所蔵品から江戸時代に制作された画帖の二
例として、18世紀末から19世紀初頭に制作された《源氏物語図画帖》と南画家
山本梅逸（1783-1856）の初期作《師古》を考察する。両作品とも本目録にお
いて初めて紹介される作品である。

画帖は特に江戸時代になり盛んに制作された絵画形式であるが、その美術的価
値に対するこれまでの評価は、掛軸、屏風などといった他の絵画形式に対する
評価に比べると高いとは言えない。画帖は大量に生産されたために、手軽で安
易な絵画形式であるというレッテルが貼られてきた。近年の日本美術史研究に
おいても画帖は重要視されておらず、ある作家の代表作として画帖が取り上げ
られることは殆どない。本論文では、自らの制作過程の歴史を記録する絵画形
式という観点より、これまではあまり研究されてこなかった画帖に目を向けて
みたい。

江戸時代に画帖形式が好まれた背景には、アマチュアおよび職業書画家人口の
増加や、街道などの発達に伴い限定された地域を越えた画家の交流が盛んになっ
たことなど江戸絵画史全般に少なからぬ影響を与えた現象が挙げられる。絵画
形式としての画帖の特色は、集められた個々の絵画、画賛、奥書、表具などの
状態を調査することにより、これらの要素が一つの画帖として編集された制作
年代、過程、および目的を特定することが出来ることである。しかしながら、
画帖の制作過程を明らかにするためには、収集された個々の書画作品が同時期
に制作されたものであるかどうか、またそれらは本来画帖に含まれるものとし
て制作されたかどうか等を判断しなければならない。なぜならば、過去に制作
された作品が後世になり収集、編集され、その時点で画帖として表装し直され
る例も多くあるからである。さらに画帖という絵画形式を理解するためには、
複数の書画家による共同制作という表現上の問題も考慮しなければならない。

《源氏物語図画帖》

本作品は１９６５年にR・ソマーヴェル氏よりアシュモリアン美術館に寄贈さ
れた。制作年代は１８世紀末から１９世紀初頭と推定される。『源氏物語』５４
帖の中、１２帖から各一場面、合計１２枚の絵画が収録されており、作家は不

（x.5362 to x.5461）の貴重な二作品をマイケル・ハラリ博士(Dr. Michael Harari)の厚意により獲得した。

　１９７０年代に収集された作品の中で特筆すべきものとしては、先ず、渡辺始興筆《四季草花図》屏風（1970.174-75）を挙げたい。本作品は当館が初めて日本で購入した作品であり、アシュモリアンの日本絵画コレクションを代表する優れた作品である。またこの頃、ユーゴスラビアのポール王子より土佐派の《源氏物語図色紙》（Cat. 44）が寄贈され、デレック・グリッグ氏(Derick Grigs)の浮世絵版画コレクションも収められた。さらに狩野探幽の《山水図屏風》（1977.24）、伝土佐光起の《伊勢物語図屏風》、そしてジェラルド・ライトリンガー氏(Gerald Reitlinger)が日本旅行中に購入した《風流獅子踊り図屏風》（1978.2532）や《三十六歌仙図屏風》（1978.2533）といった屏風作品の数々も収蔵された。

半世紀の収集活動の成果を経て、当館の日本絵画コレクションは、今日ではイギリス国内で大英博物館の次に重要なコレクションという位置を占めるに至った。特に過去２年間は、サックラー財団とオックスフォード大学ウースター・カレッジの協力により、日本絵画の専門家であるジャニス・キャッツ氏を研究員として迎え、日本絵画所蔵品の本格的な目録を作成した。そしてこの間も新しい収蔵品として岸駒や長谷川師盈などの江戸後期の画家による屏風図、長崎派の川原慶賀筆とされる《陶工図》(2002.55)、および明治初期に活躍した渡辺省亭の作品数点などを購入した。

本カタログは当館所蔵品の中から選んだ名品６０点を含む１６０点を掲載する（但し１９９７年に出版された屏風図カタログに掲載された作品は除いた）。この中１００点はキャッツ氏の選出によるが、従来の目録作成の選考基準である真贋判定を考慮しながらも、それに縛られることなく、別の観点から特に注目に値すると判断された作品も紹介する。

（村井則子訳）

格化は、１９５６年に著名な日本史研究家ジョージ・サンソム卿　（Sir George Sansom）が古画の模写作品、古い千弁天画（Supp. 3）、および酒井抱一の落款のある《富士山図》（Supp. 57）などを寄贈したことに始まるといわれている。

さらに１９５０年代後半から１９６０年代にかけて、Ｃ．Ｗ．クリスティー・ミラー氏(C.W.Christie-Miller)やジョージ・ヴァン・ハウテン氏(Georges van Houten)により歌川派の画帖（1961.126）などの江戸時代の絵画作品が収められた。１９６２年には、山田道安作と伝える対幅、左幅《寒山図》と右幅《拾得図》(Supp. 1) が、東洋美術館の初代館長で中国絵画専門家のウィリアム・コーン氏より寄贈され、一時は雪舟作とまで言われた中央幅《達磨図》(Supp. 1) も氏の没後、コーン夫人により当館へと収められた（現在これらの三幅対の作者は不詳となっている。）

当コレクションの名品の一つに明治日本画の大家、横山大観作の《湖上の雨》（Cat. 58）がある。これは１９１１年に詩人であり日本美術研究家でもあったローレンス・ビニィヨン氏(Lawrence Binyon)が画家自身より譲り受け、ビニィヨン氏の娘ヘレン・ビニィヨン氏(Helen Binyon)により１９６４年に当館に収められた作品である。またそれまでアシュモリアン美術館の日本絵画コレクションの全ては寄贈品により形成されていたが、この年には美術館の直接購入による日本絵画の収集活動も開始され、初の購入作品として山本梅逸筆の画帖（Cat. 5）などが購入された。（この作品については本目録に所収されたジャニス・キャッツの論文を参照。）その他、土佐派系の画家による《源氏物語図画帖》（Cat. 45）（前掲論文を参照）、河鍋暁斎の《盆踊り図》(Supp. 22)、鈴木松年の《山水図》（Cat. 57）などの作品もこの時期に収蔵された。

アシュモリアン美術館の日本絵画コレクションの形成における最大の転期は１９６６年に訪れた。この年当館はジャック・ヒリエー氏(Jack Hillier)の南画コレクションの獲得に成功したのである。さらに同氏の円山四条派コレクションも１９７３年に当館のものとなった。ヒリエー氏はそれまでのイギリスにはない高いレベルの日本絵画理解に基づいて収集活動を長年行い、彼の日本絵画に対する深い造詣は、多くの著作および収集された作品の質の高さに表れている。ヒリエー氏やラルフ・ハラリ氏(Ralph Harari)などのコレクターは多数の作品をケーガン・ポール（Kegan Paul）美術商より購入したが、それらの多くは浮世絵専門家のリチャード・レーン氏(Richard Lane) より日本からロンドンへと送られたものである。ハラリ氏のコレクションの大部分は後に大英博物館に収蔵されたが、当館も葛飾北斎の逸品《春日大社参詣図》（Cat. 53）、および《扇面画帖》

「アシュモリアン美術館の日本絵画コレクションの歩み」（要約）

オリバー・インピー（日本美術部門学芸員、１９６８年ー２００３年）

アシュモリアン美術館はオックスフォード大学所有の美術品および考古学コレクションを所蔵している。その歴史は古く、１７世紀にエリアス・アシュモル(Elias Ashmole)が、ジョン・トラデスカント(John Tradescant)親子の「珍品陳列室」（cabinet of curiosity）を購入し大学へ寄付したことにさかのぼり、ヨーロッパ最古と考えられている博物館である。
１６８３年にブロード街に開館した当初の建物は、現在は大学博物館として残っている。創設後約２００年間、アシュモリアン博物館の所蔵品は、オックスフォード大学内外で様々な教育用途に使われたが、１８９４年に美術・考古学関係の所蔵品が、１８５４年に開館した大学美術館に吸収されたことより、「アシュモリアン博物館」は「アシュモリアン美術館」へと変身を遂げた。その際、自然史分野の所蔵品は大学博物館へ、民族学関係の所蔵品はピット・リバース博物館へと移された。

当館の東洋美術部は１９６１年に設立された。その中心はウィリアム・コーン(William Cohn)氏が１９４６年に創立した東洋美術館のコレクションで、アシュモリアン美術館がすでに所有していたアジア美術品や、ボードリアン・ライブラリー(Bodleian Library)の所有品の一部も加えられた。東洋美術部の設立の背景には、ハーバート・イングラム卿(Sir Herbert Ingram)の膨大な中国陶芸コレクションが、１９５６年に大学へ寄贈されたことも指摘できる。現在、東洋美術部は中国・韓国、日本、インド亜大陸・東南アジア、そしてイスラム圏の四部門から成り、1854年にボーモント街(Beaumont Street)に建てられた新ギリシャ様式の建物内、一階正面入口向かいのスペースに、当コレクションの重要な一部門として堂々と展示されている。

１９世紀後期から２０世紀初頭にかけてイギリスにおいて形成された日本美術コレクションの多くがそうであったように、２０世紀半ばまでにオックスフォード大学に収められた日本美術の殆どは、根付、印篭、鍔（つば）、小柄（こづか）などの江戸時代や明治初期に制作された工芸品であった。これらの大部分は、裕福な外国人観光客を相手にする日本の古美術商やロンドンの美術商から購入された。仏像、（浮世絵を除く）絵画、江戸時代以前の工芸品といった日本の古美術を蒐集する傾向は、アーサー・モリソン(Arthur Morrison)等日本に滞在したイギリス人によるコレクション以外では極めて稀であった。アシュモリアンの日本絵画コレクションの本

アシュモリアン美術館蔵の日本絵画

ジャニス・キャッツ

アシュモリアン美術館、オックスフォード

アシュモリアン美術館蔵の日本絵画